Norman Rockwell

and

THE SATURDAY EVENING POST

THE EARLY YEARS

by STARKEY FLYTHE, JR.,
FORMER EXECUTIVE EDITOR of
THE SATURDAY EVENING POST

 MJF BOOKS
NEW YORK

We are grateful to a number of persons and organizations whose assistance and cooperation were indispensible to the production of this book. Our thanks go to:

Arthur Abelman, Esq.
James E. Barrett—Production Manager, *Saturday Evening Post*
Frederic A. Birmingham—Managing Editor and Associate Publisher, *Saturday Evening Post*
Starkey Flythe, Jr.—Executive Editor, *Saturday Evening Post*
William S. Gardiner—Director of Licensing and Royalties, *Saturday Evening Post*
Beurt SerVaas—Chairman, Curtis Publishing Company
Dr. Cory SerVaas—Editor and Publisher, *Saturday Evening Post*
Dee Smith—Editorial Associate
Margaret Westermaier—Editorial Associate
David Wood—Curator, Old Corner House (Stockbridge, Mass.)
Irwin H. Avis—Art Consultant

Published by MJF Books
Fine Communications
Two Lincoln Square
60 West 66th Street
New York, NY 10023

Library of Congress Catalog Card Number 94-77-498
ISBN 1-56731-061-3

Printed and bound in Italy

MJF Books and the MJF colophon are trademarks of Fine Creative Media, Inc.

10 9 8 7 6 5 4 3 2 1

CONTENTS

Dedicated to

Norman and
Molly Rockwell

and

THE CURTIS
PUBLISHING COMPANY

THE SATURDAY EVENING POST

Rockwell was twenty-two when he walked into the *Saturday Evening Post* offices in Philadelphia. The *Post* was 188 years old. It had witnessed the star treks of contributors like Edgar Allan Poe, Nathaniel Hawthorne, Washington Irving, Mark Twain and Bret Harte in its pages, and was not used to being impressed by anybody, much less a gangling, pigeon-toed, underweight artist whose main physical feature seemed to be his Adam's apple. "Rockwell, you have the eyes of an angel and the neck of a chicken," a lady friend had told him. But the *Post* was impressed and has been ever since. For sixty years he brought forth new and brighter visions of his home town, these United States.

The Saturday Evening Post began as a broadside called the *Pennsylvanian Gazette*, edited, published, written and sold by one Benjamin Franklin who printed his first issue on Christmas Eve, 1728. A fiercely independent sheet, it had an editor who did not mind tickling the nose of his august majesty, George III, and if John Hancock's name was the biggest signature on the Declaration of Independence (it appeared for the first time in print in the July 10, 1776 *Gazette*) Franklin's was a great deal better known to the King.

When George Washington was inaugurated as first president in 1789, it was reported, with typographical huzzahs, in the *Gazette*. The paper changed its name to *The Saturday Evening Post* in 1821, and during the nineteenth century published fiction masterpieces, congressional records, speeches by the presidents, news and poetry. It looked, however, very much like a six-page newspaper. Then, in 1897, Cyrus Curtis bought the *Post* and with editor George Horace Lorimer created the prototype for the national mass circulation magazine. By the 1920's 60 per cent of all the magazine advertising revenue in the country was going into Curtis publications. Lorimer hired the best writers and the best illustrators. Week after week the magazine bulged with the pictures of Frederic Remington, N. C. Wyeth, William James Glackens, John Sloan, J. C. Leyendecker, and Norman Rockwell. Stories by Hamlin Garland, Stephen Crane, Joel Chandler Harris, Conan Doyle, Rudyard Kipling, Joseph Conrad, F. Scott Fitzgerald, William Faulkner, Sinclair Lewis and Agatha Christie were so exciting that *Post* readers hardly paused to consider they were enjoying immortal stuff. Each issue was an unpretentious feast, a paradoxical gathering of greatness wrapped up in what appeared to be the reader's next-door neighbor. People learned to read by the *Post*, and many a tycoon got his start hawking the "five-cent textbook" in the streets of his hometown.

A museum, if it is lucky, may see a million people a year. There, Rembrandt and Rubens and Velazquez wait in solitary splendor for people to come by and mispronounce their names while commenting that "the mouth seems crooked." But four million people see the *Post* cover every week; not in solitary splendor but in doctors' waiting rooms, train stations, on street corners, in the hands of high-pressure urchins, in living rooms, libraries and yes, even bathrooms. "Two million subscribers and then their wives, sons, daughters, aunts, uncles, friends. Wow!" said Rockwell when he considered the possibilities in 1916.

Television now has the bulk of the advertising revenues, but one has only to pause before a newsstand to see that the magazine industry is alive and well, even exuberant, and the *Post* is still there, aetat, 247. It suspended publication in 1777 when the British occupied Philadelphia and again in 1969 for two years. Rockwell, moved, sketched Ben Franklin weeping at the demise of his creation. But when the magazine came back, in 1971, there was Rockwell, in the flesh, on the cover. Among the artists who have painted *Post* covers are Andrew Wyeth, Grant Wood and Felix Topolski. None of them created quite the stir Rockwell did. The *Post* and Rockwell seem made for each other. But for that matter, America and Rockwell seem to be one of those marriages made in heaven.

Starkey Flythe, Jr.

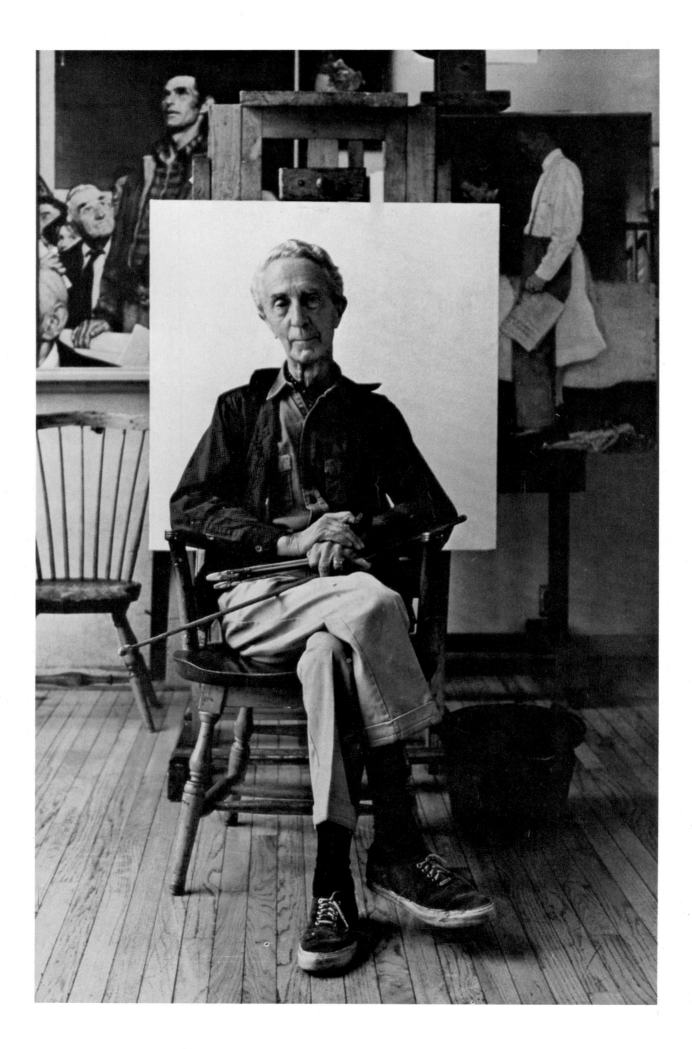

NORMAN ROCKWELL

Norman Rockwell

This set of books is a tribute, a tribute to a man whose face is familiar to many of us, whose name is known by most of us and whose creations are a part of all of us.

It is a show of appreciation to a man who is as American as Uncle Sam, as devoted as the Boy Scouts and as talented as the masters of the Renaissance.

It is a salute to one of America's most beloved men—Norman Rockwell —artist, illustrator and historian.

These books contain all the covers that Mr. Rockwell painted for *The Saturday Evening Post*. It is the first time that a complete, full-size, full-color collection of Norman Rockwell's *Post* covers has been assembled and made available to all collectors. The covers are a truly remarkable history. They are a storybook of our country, encompassing over sixty years of everyday happenings, a living, vibrant, unvarnished documentation of America.

In 1943 a fire in Norman Rockwell's studio in East Arlington, Vermont destroyed many of his original canvases, memorabilia and *Saturday Evening Post* covers. In 1969, *"The Post"* temporarily ceased production (it was reorganized in 1971 and continues today to be published monthly), and many of its archives were lost or removed. Copies of these magazines and covers are now as rare as the original oils.

To be able to accumulate, categorize, restore, edit and reproduce these covers in a fashion as close as possible to the original covers is a labor of love, and a special note of appreciation must go to Mr. Starkey Flythe Jr. of the Curtis Publishing Company, whose time, effort and incredible knowledge was invaluable to us. We also thank "The Corner House" (now the Norman Rockwell Museum) of Stockbridge, Massachusetts where many Rockwell treasures are permanently displayed for the public to enjoy.

In 1972 Bernard Danenberg Art Galleries of New York compiled an exhibit of *Post* covers, as well as original Rockwell oils and drawings, and toured the country with this collection, generating monumental interest and adding millions of new Rockwell fans to the rolls. Throngs of younger generation admirers revealed the agelessness of these artistic treasures. People hurried to their attics and basements to search for old *Post* magazines so that the covers could be preserved and enjoyed.

It was as a result of this exhibit and the massive interest of those seeing it, as well as an appeal from serious Rockwell collectors, that we decided to reproduce the original covers in three volumes, exactly as they appeared in print, thus preserving for future generations the art and illustration of this gifted American.

Seeing and reading these volumes is more than a moment's entertainment; to watch the sheer enjoyment of people getting to know Rockwell is to understand what our books are all about.

"People love studying other people." That says it all, and we hope that the pages which follow provide such a medium of love and insight to all who open these books.

Dr. Donald R. Stoltz

"The Baby Carriage"

Rockwell's first cover was different from those of the other Post cover artists who week after week concocted "situations." First, Rockwell used real boys as models, and his real boys were anatomically correct. "You can't paint a house until it's built," admonished George Bridgman, Rockwell's great teacher at the Art Students League. Rockwell had poured over Bridgman's book, *The Human Machine,* an illustrated treatise on the muscles and motions of the body, and had come to understand motor cause and effect. The figures in the composition move naturally. The baby-sitter pushes against the carriage with the proper displacement. The baseball players are fitted into the composition without appearing to be squeezed. And Rockwell is pictorially aware of the requirements of *The Saturday Evening Post* logo, its famous parallel bars and cover lines below.

Two-color process—the *Post* covers were in duotone, usually red and black, until 1926 when Rockwell painted the first color cover—challenged artists to signal the potential magazine buyer's eye with red to solid black, then to lead the eye through gradations of emotion and tone, the subtlety of which was restricted by the limits of the two colors. The accuracy of the perambulator, the twist of the boy's baseball glove as though he were ostentatiously snagging a pop fly, and the overstating of the facial expressions display a sense of humor based on convincing emotion which promises a wider range of possibility than American magazine covers had yet witnessed.

"The Circus Barker"

Rockwell's second cover appeared two weeks later. It was one of the two he had sold to the magazine for the astronomical sum of $75 each. Before, his total monthly wage as art director and illustrator at *Boys' Life* had been $50 per month. In the picture Rockwell initiates a point of view which manages to make the viewer feel he is part of the scene. Later it appears in *Freedom from Want,* in *The Storyteller,* and in the illustration of *The Horseshoe Forging Contest.* The viewer is confronted with the action of the scene as if he were a participant, not merely an observer. The reality of the girl's hair ribbon, the boy's suspenders, the pigtails, is the reality of standing behind someone at eye level in a crowd.

Eugene Sandow, the strong man, was a German turn-of-the-century physical culturist who appeared at the Columbian Exposition in Chicago in 1893. Billy Paine, the boy who poses for Sandow, and for the preceding cover, was one of the artist's favorites. Paine's death, at age thirteen, resulted from his doing a stunt in a second-story window. Rockwell used him in fifteen *Post* covers and said, "He was the best kid model I ever used."

The use of live models presented difficulties, especially in children and animals. Holding a pose was difficult, but maintaining an expression—a necessity in the exaggerated cartoon setups where humor was the main point for newsstand sales—was almost impossible for a child or animal and Rockwell sometimes resorted to giving feline models a whiff of ether to create the appearance of an enduring lethargy.

THE SATURDAY EVENING POST

An Illustrated Weekly
Founded A°. D°. 1728 by B. j. Franklin

JUNE 3, 1916 5cts. THE COPY

FRANCE AND THE NEW AGE—By Will Irwin

"Low and Outside"

The contrast convivially presented between youth and age was a favorite cover topic in the early years of the century, and one that Rockwell has used to advantage ever since. There appears to be no generation gap in having a good time, and what might have been a rather mean comment—the grandfather who obviously is unable to tie his own shoe, or in this case, remove his own spats, being confronted (or rather not confronted) with a pitch bound to make him bend and stretch—could be, in less skillful hands, an ungenerous view of age. This and the following cover did not please *Post* editor George Horace Lorimer and his art directors, perhaps because the gag depends more on something that is about to happen or has already happened outside of the picture. And Lorimer, a stickler for getting his money's worth out of artists, was disappointed to be getting only two figures, then one figure, where before he got three and six. It seems Rockwell tried to make up for the covers' sparsity in the following two covers (October 14 and December 9, 1916) by giving Lorimer more faces per square inch than was compositionally pleasing, then ridiculing himself by peopling his cover with monkeys, devils, ducks, snowmen and Chinaman masks.

The silhouettes of the batter and catcher, the two fingers indicating the ball count, lack some of the dramatic impact Rockwell was to build so effectively in future covers. Lorimer ordered the characters of the players changed five times either because the old man was too rough, or the boy too small in contrast. Rockwell began to see his first successes were not to be repeated easily.

"Backfence Graffiti"

Portrayal of small-town, barefoot boys with cheeks of tan began to appear as Rockwell's forte. He had been born in New York (Amsterdam Avenue), and his knowledge of country life was small. He was painting in New Rochelle by this time and the town was often confronted by the spectacle of the young painter carting to the studio he shared with a cartoonist, bits of rural Americana, fence boards, flea-bitten mutts and clothes that had graced less graceful times than those of 1916 when washing machines and soap powders were beginning to make themselves happily felt.

Rockwell begins for the first time to experiment with background; the situation comedy begins to move inside. Architecture lends itself as a frame to give depth and a sense of place to what had before been simply a silhouette. The joke is, after all, not terribly funny, and in terms of Rockwell covers, it is puzzling because the following year, on *Country Gentleman* covers, the same models are showing interest in girls while here, Red is ready to repeat the atrocities of World War I, which in 1916 were being written about inside the magazine, on the villain who linked his name with the Venus, Hatty Perkins. The amusement is obvious— Rockwell has all his life made sure his audience "gets" it (he does so by asking any passerby to act as critic)—but the sentiment, the honest feeling that would come to be associated with Rockwell's covers is missing.

At the bottom of the picture, another *Post* favorite whose career was to run almost as long as Rockwell's, P. G. Wodehouse, makes an early appearance. His first *Post* story was in 1915. His last in 1975.

THE SATURDAY EVENING POST

An Illu
Fo d A. D lin

SEPT. 16. '16

5c. THE COPY

RED HEAD
LOVES
HATTY PERKINS

O YOU
TEE

Beginning
PICCADILLY JIM—By Pelham Grenville Wodehouse

"Family Night Out"

Movies were emerging as America's greatest contribution to the world of art, though few people in the cinema's vast audience thought of it as anything other than entertainment. Film companies were also beginning to advertise in magazines and publisher Cyrus Curtis was not above giving an advertiser an editorial boost.

An early experiment in the effects of light and shadow provides Rockwell with some of the lessons that he would use in the great compositions—*The Four Freedoms, The Right To Know*—of a later period. The family, watching Chaplin in a movie theater, has its faces lit up by the flickering screen, but the emotions are registered in different ways. Far behind is the tradition of early American limners who painted families, the members of which all appear to have the same face. The youngest child is amazed—early movies were called magic lanterns—while the grandfather, his hand on his grandson's shoulder, is quietly delighted. The triangular composition raises some questions about the family since families usually sit in rows in movie theaters, but again, because of Rockwell's firm grasp on the obvious, the viewer does not object.

"Dressing Up"

Rockwell was to paint twenty-five Christmas covers. Here, he is being too realistic for it to occur to him that Santa Claus was to millions of *Post* readers a real person. By 1922, he would see Father Christmas as real, and would for the next twenty-one years never deviate from that reality.

A wealthy gentleman, his pockets already bulging with presents and toys, tries on the mask that is sure to transform him from Wall Street to Wonderland. The view is already a bit nostalgic, for by 1916 such novelty shops were becoming a rarity.

Rockwell has admitted he is not at his best with pretty girls. By their nature they have no hard-earned wrinkles, no freckles, no cowlick-laden red hair, and these characteristics are Rockwell specialties. Reality is not the cosmetic to the pretty girl that it is to the heart, but as usual, Rockwell's accomplishments belie his modesty.

THE SATURDAY EVENING POST

DEC. 9, 1916

An Illu...
Fou...in

5c. the Copy

"The Suitor"

The agonies of growing up, the realization that girls at that certain age mature faster than their male counterparts and are consequently interested in older men descend all at once on this young supplicant with his dance card and its dangling pencil. Who could ever forget those pencils? They proliferated on bridge score cards, and dance programs, were too narrow to fit any pencil sharpener and were, of course, the only pencil in sight when urgent messages demanded recording.

Dancing, courting and rather formal parties were very much a part of American life in the years before the 1920's, which freed the country for better or worse.

Of the first twenty-five covers Rockwell did for the *Post*, twenty-two deal with childhood, partly because it was what Rockwell knew best, and partly because the editors saw that covers with children attracted family readership, a desirable commodity for attracting potential advertisers.

THE SATURDAY EVENING POST

An Illustrated Weekly
Founded A.° D.° 1728 by B̶e̶n̶j̶ Franklin

JANUARY 13, 1917

5c. THE COPY

"A Salute to the Colors"

Patriotism has always been a Rockwell stronghold. In this, his first patriotic cover for the *Post,* the unseen flag passes by to the three-fingered salute of the Boy Scout and the doffed hat of the veteran. The pretty bystander appears again that year as a schoolmistress entertaining a suitor under the watchful and possibly blackmailing eyes of an errant student, and in 1918 as a mother watching her son having his locks shorn. Feelings still ran high from the Civil War, and such a cover risked hurting the *Post's* readership in the South. An earlier *Post* editor in the 1850's had been a strong Southern sympathizer, and later editors had tried to avoid the issue.

Rockwell's relation with the Boy Scouts is of longer standing than that with the *Post.* He illustrated several of the Boy Scout handbooks, and his calendars, painted since 1923, have been fixtures in schools and clubhouses all over the country.

THE SATURDAY EVENING POST

An Illustrated Weekly
Founded A.D. 1728 by Benj. Franklin

MAY 12, 1917

5c. THE COPY

WHAT OF THE EAST—By SAMUEL G. BLYTHE
THE SUB-DEB—By MARY ROBERTS RINEHART

"The Clubhouse Examination"

A second patriotic cover followed in a month. The recruiter, Billy Paine again, is decked out in bits and pieces of soldier and boy scout. The arrangement is a partial spoof of the James Montgomery Flagg poster of Uncle Sam saying "I want you" which was to become a sort of national graffito on U.S. walls in 1917. Flagg said he had used himself as his model, though the revelation came almost forty years later when the poster was undergoing a revival as a classic before Flagg's death in 1960. As official military artist Flagg created fifty-six posters during World War I including "Tell That to the Marines," "Wake Up America" and "Together We Win." Flagg was to World War I what Rockwell would be to World War II. The efforts of youth to measure up were a source of endless merriment to Army and Navy recruiters all over the country, and Rockwell has caught the spirit of boys lying about their age, standing on tiptoe to make the five-foot marker, and, as in his own case, stuffing themselves with bananas, whipped cream and sandwiches to make up the weight.

THE SATURDAY EVENING POST

ted Weekly by Benj. Franklin

5c.

JUNE 16, 1917

MEN
WANTED
FOR
A ARM...
FIZICA...
EGZA...
WATI
HITE
RECROODING...

5 ft.
NESISSARY HITE

Norman Rockwell

In This Number: Carl W. Ackerman — Maximilian Foster — Will Irwin — Basil King
Charles E. Van Loan — Elizabeth Jordan — Nalbro Bartley — Eleanor Franklin Egan

"After School"

In the 1940's, Rockwell visited a country school. The picture which appeared in the November 2, 1946, issue is reminiscent of Winslow Homer's painting of the same subject. The horizontal inside composition was always a favorite of Rockwell since covers dictated vertical layouts and he had to take great pains to focus his composition so it would not conflict with the magazine's name at the top and its list of contents at the bottom. He was to do other pictures of classroom scenes, including *First Day of School*, September 14, 1935; *First in His Class*, June 26, 1926; and *Happy Birthday, Miss Jones*, March 17, 1956. In this picture, a young man for some misdeed has stayed after school —the clock says quarter till five—to write on the board an infinite number of times that knowledge is power, only to find a thrilling example in the power he will soon be able to exercise over his mentor. The lives of unmarried schoolmistresses were very carefully monitored by school boards all over the country, these women being more closely chaperoned than most of their pupils. During the Depression women were seldom allowed to teach if their husbands were gainfully employed, the theory being that in a reduced work force, one breadwinner per family was the limit.

THE SATURDAY EVENING POST

An Illustrated Week~~
Founded A? ~~~~ 17~~

OCTOBER 27, 1917

5c. THE COPY

FOLLOWING THE RED CROSS—By Elizabeth Frazer

"Pardon Me"

Black patent leather dancing pumps, largely a thing of the past now, were lethal weapons. Tea dances for young people flourished, usually held Saturday afternoons in club-houses or front parlors across the land. Sometimes there was live music but ordinarily it was canned, produced with thick records, often grooved only on one side, from a large machine that looked more like a mahogany refrigerator with Louis XV legs than a phonograph. One young person usually attended the machine, seeing that it was wound, returning the records to their sleeves of dark green cardboard in the brown volumes inscribed with His Master's Voice, and between records, watching the endless spectacle of the dance. That is the view the reader gets, intimate yet detached. The girl, like many of Rockwell's early cover characters, is over-reacting—were she a proper young lady, she would have gone on dancing —and of course, a faux pas would hardly have knocked her paper party hat off. Model Billy Paine manages to convey awkwardness with supplication, boyishness with budding manhood.

THE SATURDAY EVENING POST

An Illustrated Weekly
Founded A⁰. D¹⁷²⁸. By Benj. Franklin

NOTICE TO READER. When you finish reading this copy of The Saturday Evening Post place a U. S. 1-cent stamp on this notice, hand same to any U. S. postal employee, and it will be placed in the hands of our soldiers or sailors at the front. No wrapping, no address. A. S. Burleson, Postmaster General.

JANUARY 26. 1918 — 5cts. THE COPY

Captain Schlotterwerz—By Booth Tarkington. **England After the War**—By Isaac F. Marcosson

"Meeting the Clown"

Circuses were fair game for *Post* artists. Between the early years of the century and the 1960's circus covers proclaimed the wonders of the big top to hundreds of small towns where the circus never visited. The wonder of this boy symbolizes the wide-eyed amazement of the countryside at the stellar attractions of Barnum & Bailey and Ringling Brothers. The blasé pose of the clown as he reads the sports section, paper folded the way big-city subway riders fold their news, astonishes the boy. That the dog (Lambert, Rockwell's own pet) could be asleep among such wonders is cause for true amazement. Lambert, Rockwell recalls, was a thoughtful type who, when placed in position on the stand, would sit for hours with his head cocked to one side, thinking, dreaming of rabbits and hidden bones. The dog, wearing a hat similar to his master's, is barely cognizant of his glorious place in the exotic hoopla of the circus.

THE SATURDAY EVENING POST

An Illustrated Weekly
Founded A°. D°. 1728 by Benj. Franklin

MAY 18, '18 5c. THE COPY

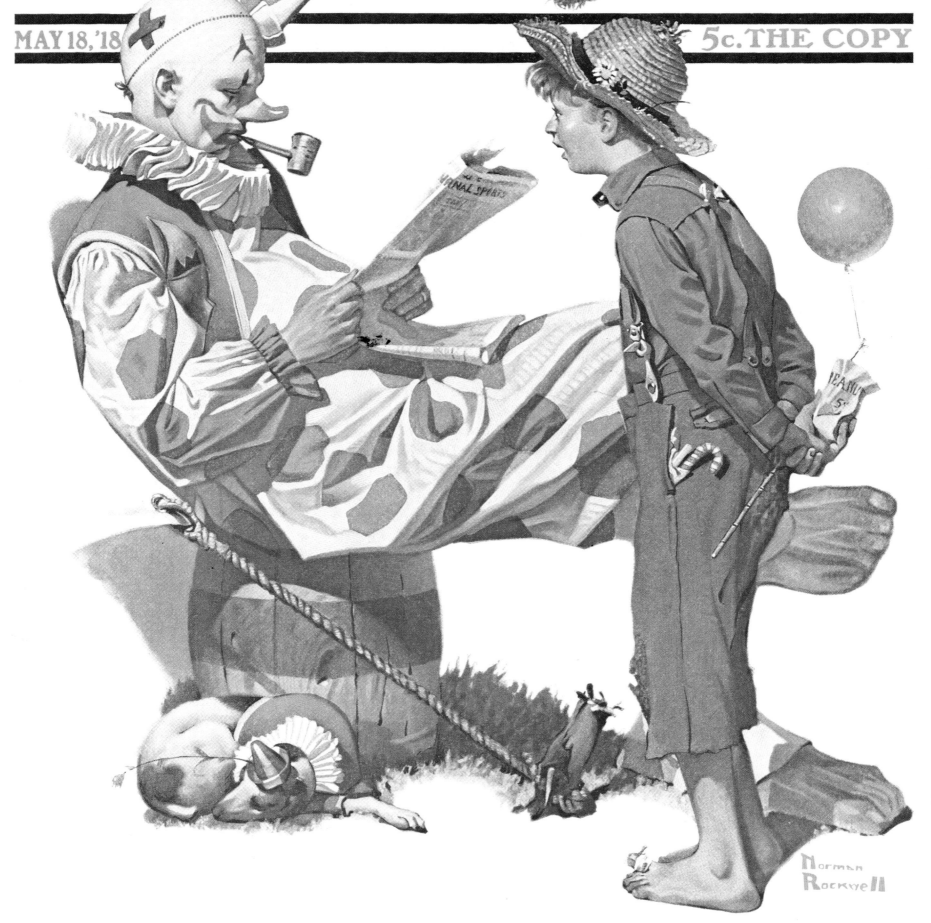

All American — By Irvin S. Cobb

"Giving to the Red Cross"

Sweetly sentimental covers were very much in vogue when Rockwell began what amounted to a new realism not unlike the stories and novels of Balzac, Dickens and Zola, though admittedly upbeat. "Giving to the Red Cross" shows traces of the sentiment which persisted well into the 1930's. It also demonstrates how the artist picked up the topics of the day for his covers. "I couldn't read a newspaper without finding an idea for a cover," Rockwell relates. James Montgomery Flagg's posters of beautiful Red Cross nurses in flowing capes inspired every little girl in the country. Street corners bloomed with miniature Sister Kenneys whose appeal was irresistible even to gentlemen of means, one of whom here will hopefully disprove the myth of the widow's mite. The cover marks the second appearance of a Rockwell dog, a feature which was to become as familiar as redheaded, frecklefaced, barefoot boys. Little Florence Nightingale's companion is a wellbred canine, an aristocrat which would disappear by the following year, replaced forever by the enduring mutt who would cajole boys away from their studies with dreams of fishing and baseball, would get them into unspeakable difficulties, and would do as much to inspire a nation's love for dogs as any of the great animal stories by *Post* authors Albert Payson Terhune, and Eric Knight of "Lassie Come Home" fame.

THE SATURDAY EVENING POST

An Illustrated Weekly
Founded A.D. 1728 by Benj. Franklin

SEPT. 21, 1918

5c. THE COPY
10c. in Canada

THE ZERO HOUR—By GEORGE PATTULLO

"Thinking of the Girl Back Home"

Rockwell was twenty-four when he tried to enlist in the Navy. Seventeen pounds underweight and rejected by the service doctors as "not fit for military duty," he stuffed himself with bananas, doughnuts and warm water. Years later Rockwell wondered how he stomached the unholy alliance. It worked, though, and he spent the duration in the dangerous waters of Charleston, South Carolina, where his superiors, discovering he was a *Post* cover artist, had him at his easel portraying visiting foreign admirals, local admirals and a few officers of lesser rank who demanded pictures for their wives and sweethearts back home, which of course wasn't very far away. Rockwell finally finagled a trip to Ireland, but the ship was turned around in mid-ocean, Rockwell always suspected, by the commander of his old Charleston base who gloried in having a celebrity under his thumb. Rockwell has signed the picture, U.S.N.R.F. He seems, here, for the first time, in control of a larger emotion. Other *Post* artists of the time had contrived settings of doughboys mooning over their girls' portraits, but Rockwell has dissipated any mawkishness. With the simple props of a porthole and the stamped envelope, he has managed to convey distance, both spatial and psychological. The older sailor, tattooed and seasoned by years at sea, suddenly wonders whether he has missed something by seeing so many girls in so many ports. Rockwell, who by this time had married Irene O'Connor, suggests that he is missing a great deal.

THE SATURDAY EVENING POST

An Illustrated Weekly
Founded A° D¹ — Franklin

Vol. 191, No. 29. Published Weekly at Philadelphia. Entered as Second-Class Matter, November 18, 1879, at the Post Office at Philadelphia, Under the Act of March 3, 1879.

JAN. 18, 1919

5c. THE COPY
10c. in Canada

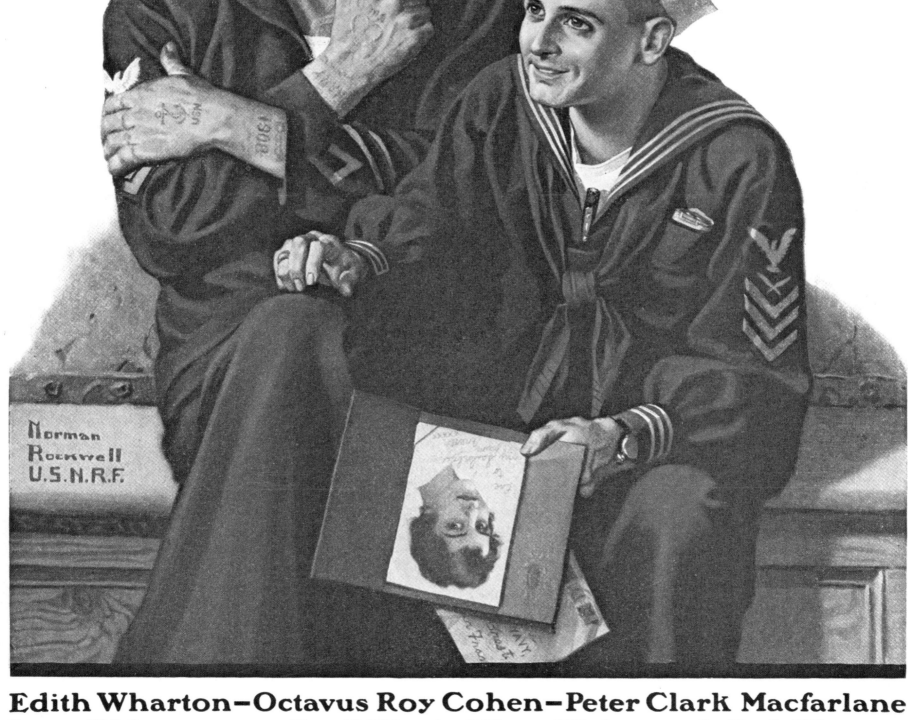

Norman
Rockwell
U.S.N.R.F.

**Edith Wharton—Octavus Roy Cohen—Peter Clark Macfarlane
Isaac F. Marcosson—Basil King—Albert W. Atwood—Rob Wagner**

"When Johnny Comes Marching Home Again"

When the war was over, psychologically shocked young men came home to an America that was beginning, a generation and a half after the Civil War, to regard all war as something "over there." But to the men who had sat it out in trenches filled with ice-cold muddy water, staring a few hundred yards across no man's land to Germans who were often grandsons of their next-door neighbors back home, America would never be the same. It had to become a world power, *the* world power, in order to make the world right. The people weren't ready for it, and the Senate sent Woodrow Wilson down to defeat while pretty girls strewed rose petals in the paths of returning boys who wondered how home could be so naive. Rockwell's hero is surrounded by boys, and there is a wide gulf between the facial expression of the man and those of the children. The man is not idealized—his uniform is well worn, his hat rumpled—and he has seen what must have seemed to him Armageddon. Rockwell's contemporaries were drawing the veteran as an Arrow collar man in uniform, a starched and handsome mannequin whose real sentiments about the war were well disguised if he possessed any.

Prophetically, Rockwell broaches the subject of man's inability to get along with man, nationally, internationally, a subject which, in the 1970's, did a great deal to end the Vietnam war. He enters into the serious realm of the well-being of the world which was to produce his World War II masterpieces and to lift magazine illustration into the heady areas of fine art and significant human emotion.

THE SATURDAY EVENING POST

An Illustrated Weekly
Founded A°D° 1728 Benj. Franklin

Vol. 191. No. 34. Published Weekly at Philadelphia. Entered as Second-Class Matter, November 18, 1879, at the Post Office at Philadelphia, Under the Act of March 3, 1879.

FEBRUARY 22, 1919

5c. THE COPY
10c. in Canada

Norman Rockwell

So This is Germany—By George Pattullo

"Courting Under the Clock at Midnight"

Romance is always a strong element in Rockwell's illustrations, as it is in most magazine work. All the world loves a lover, especially when he is slightly ridiculous and the girl is oblivious to time, tide and the cuckoo clock, which is just about to strike the witching hour summoning the witch, probably in the person of the young lady's mother. Rockwell painted young lovers watching the moon rise, on top of the world, on cloud nine. And he painted older lovers too. Dancing, reminiscing before the fire, and, on one cover, lost in a sea of April Fool malaprops. And always, the slight edge, the ironical edge which frames the larger view, obliterates any bathos. This is one of the most important aspects of Rockwell's genius, his ability to see his cover as part of something larger—the history of a country, a person's emotional expansion, or the creation of a national pride.

THE SATURDAY EVENING POST

Illustrated Weekly
Nº 1728 by Benj. Franklin

Vol. 191, No. 38. Published Weekly at Philadelphia. Entered as Second-Class Matter, November 18, 1879, at the Post Office at Philadelphia, Under the Act of March 3, 1879.

MAR. 22, 1919

5c. THE COPY
10c. in Canada

"Playing Party Games"

The party scene has changed very little from the party scene of last year. The same Eton collar, black stockings, plastered-down hair, party dress. If anything, the joke is a little less funny. It is obvious that the dog, adorned with a ribbon for the occasion, will bark when the popper pops. And it is obvious that it won't make nearly the noise the girl is preparing herself for. "You've got to make your ideas foolproof to succeed in illustration," Rockwell once told an audience of young students. "People are always trying to read various meanings into your work, so you can't be subtle. You've got to be obvious. You've got to please the art editor and the public." There lies a difficulty. Art editors are usually people with wide experience in fine art and in illustration. Their taste and discernment have been sharpened by years of working with the best. Their levels of judgment are often higher than the standard of the magazine, and certainly higher than the public's. Yet, if the art editor is truly sophisticated, he knows that in public taste often lies an astonishingly broad and rich accumulation of sensible and sensitive ideas. In Rockwell, an artist emerged who dared to respect the feelings and thoughts of his audience, and to believe, as did the *Post* editors, that "the public always wants something a little better than it asks for."

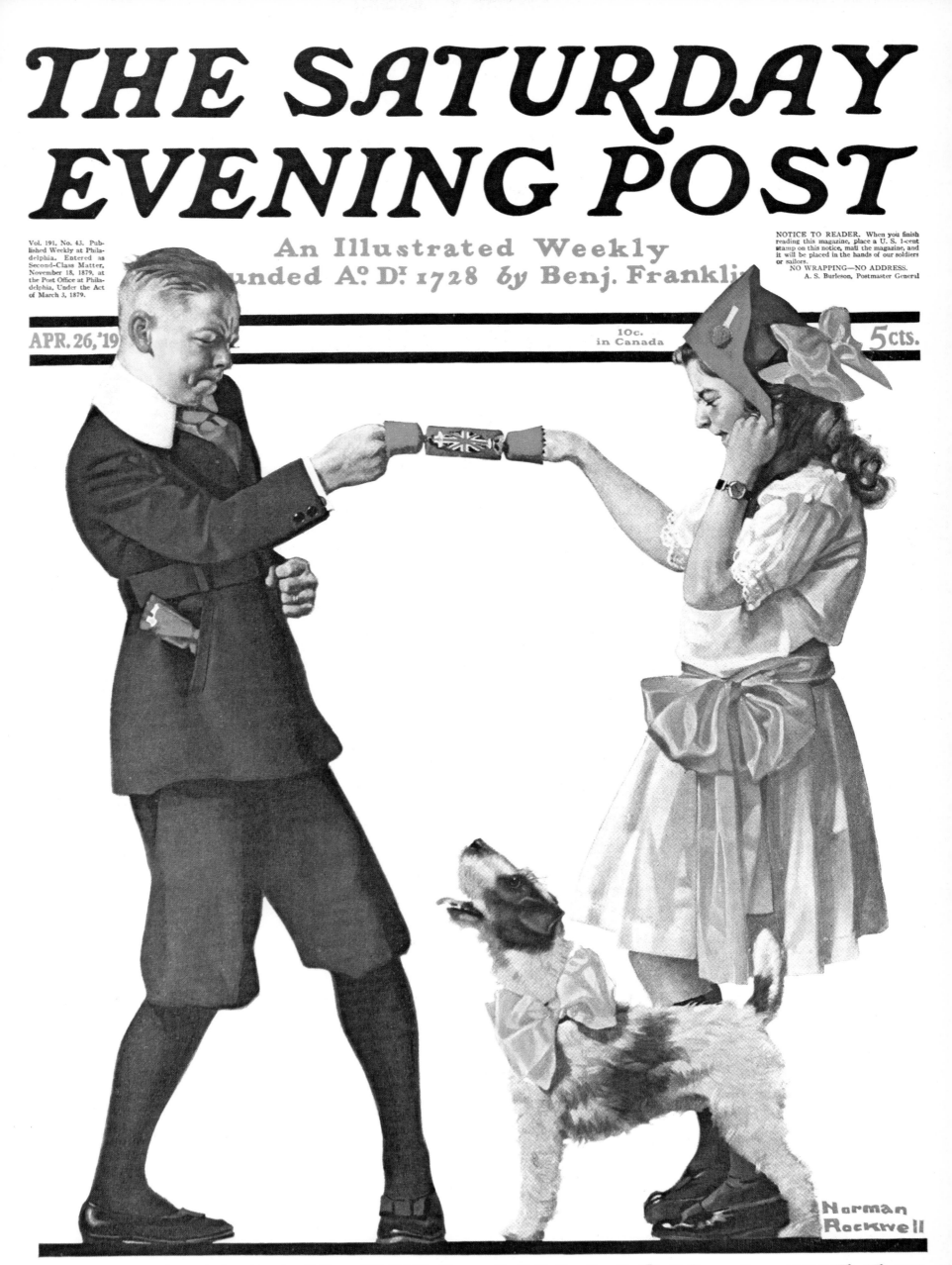

THE SATURDAY EVENING POST

Vol. 191, No. 43. Published Weekly at Philadelphia. Entered as Second-Class Matter, November 18, 1879, at the Post Office at Philadelphia, Under the Act of March 3, 1879.

An Illustrated Weekly
Founded A°. D°. 1728 by Benj. Franklin

NOTICE TO READER. When you finish reading this magazine, place a U. S. 1-cent stamp on this notice, mail the magazine, and it will be placed in the hands of our soldiers or sailors.
NO WRAPPING—NO ADDRESS.
A. S. Burleson, Postmaster General

APR. 26, '19

10c. in Canada

5cts.

Norman Rockwell

MORE THAN TWO MILLION A WEEK

"The Recitation"

Graduation in 1919 was an ordeal that accounted for more school dropouts than marriage or the army. Even the great mind of Winston Churchill once went blank and the prime minister had to excuse himself and sit down. "I never got up again to make a speech without first having memorized every word of what I was going to say."

The *Post*, faced with the problem of running 52 topical covers a year, resorted to seasonal stratagems. Graduation, summer, fall, Thanksgiving, Christmas, winter, St. Valentine's Day, Easter, spring, vacation, were good frames within which to paint a masterpiece that would be on view for seven days, and possibly be partially obscured by addressee labels, or other newspapers and magazines stacked on top at a newsstand. Rembrandt never had to worry about such things but Rockwell worked for a boss, for a company even, and as such was painting on commission. Pleasing people—his audience and his employers—without being middle-of-the-roadish is one of Rockwell's great talents. People who meet him are always surprised to discover he is not remotely like the Statue of Liberty, the Capitol Dome or any of our other national monuments, but a gently self-mocking, hard-working citizen who has certain beliefs and is just serious enough about them to laugh at them once in a while.

THE SATURDAY EVENING POST

Vol. 191, No. 50. Published Weekly at Philadelphia. Entered as Second-Class Matter, November 18, 1879, at the Post Office at Philadelphia, Under the Act of March 3, 1879.

An Ill... ... Weekly
Founde... ... Benj. Franklin

NOTICE TO READER. When you finish reading this magazine, place a U. S. 1-cent stamp on this notice, mail the magazine, and it will be placed in the hands of our soldiers or sailors.
NO WRAPPING—NO ADDRESS.
A. S. Burleson, Postmaster General

JUNE 14, 1919

5c. THE COPY
10c. in Canada

Norman Rockwell

In This Number: Juliet Wilbor Tompkins—Nina Wilcox Putnam—Everett Rhodes Castle
Mary Roberts Rinehart—Temple Bailey—Sinclair Lewis—Pelham Grenville Wodehouse

"Leap Frog"

I'm really almost religious about the *Post*. Years ago I used to kneel down and pray before starting a cover. Now, when you look at some of them, you begin to wonder about the power of prayer."

The connection between Rockwell and the *Post* is of such long standing that it is difficult to discover who influenced whom. The style in which Rockwell excelled was very much the *Post* style, and the magazine continued to use cover illustrations for years after *Life* (the old humor version of that magazine), *Judge* and others had gone out of business and surviving publications had long since turned to photographs. One wonders what Rockwell's fate might have been—and the magazine's—without each other. Too big an artist for an advertising agency, too universal merely to illustrate stories for other magazines, too much of an intangible to associate himself with mere money, he would have survived, succeeded even, but to most Americans it wouldn't have been the same.

In a cover like "Leap Frog," we partake of the universal experience of being out of school, of summer, youth, the sweet possibilities of existence. If this drawing were an advertisement, saying something to the effect that such-and-such cereal allows you to revel in the joys of life through a nutritional mix of corn, wheat and rye, it wouldn't be the same. Granted, the *Post* was a commercial enterprise, but at a nickel it seemed more than a bargain; it seemed part of the joy of life itself.

THE SATURDAY EVENING POST

Vol. 191, No. 52. Published Weekly at Philadelphia. Entered as Second-Class Matter, November 18, 1879, at the Post Office at Philadelphia, Under the Act of March 3, 1879.

An Il~~~~~ Weekly
Founded A~~~~~ Benj. Franklin

JUNE 28, 1919

5c. THE COPY
10c. in Canada

Norman Rockwell

Julian Street — Ben Ames Williams — William Ashley Anderson — George Kibbe Turner
Henry Watterson — Rob Wagner — Herbert Quick — Alice Duer Miller — Grace Torrey

"Runaway Pants"

When Rockwell was working on one of his biggest projects, the illustration of Huckleberry Finn and Tom Sawyer, he went to Hannibal, Missouri to get the feel of the life the boys led, to buy old clothes the boys might have worn, and to talk to people who had actually known Mark Twain. "I was surprised to find that Twain was a rather sickly child, that he did few of the wild things Huck and Tom did." Twain's inventory of childhood properties was probably a good deal like Rockwell's. "I was no athlete," he recalls, "but I could draw pretty well, and I saw a future in that and a certain popularity."

Very few of Rockwell's covers involve athletic contests, a topic the other *Post* cover artists made capital of. Yet, when Rockwell does show characters in action, there is demonstrated a great ability to put the body in motion, to indicate speed and stress. Rarely does he rely on the comic strip artist's devices of streaks painted behind the characters, or flying objects, although here, the boy's hat is loose, perhaps to complete the diagonal of the composition. The dog is beginning to assume the position of a deus ex machina (or devil ex machina), a fulcrum in the action which ensues.

THE SATURDAY EVENING POST

Vol. 192, No. 6. Published Weekly at Philadelphia. Entered as Second-Class Matter, November 18, 1879, at the Post Office at Philadelphia, Under the Act of March 3, 1879.

An Illustrated Weekly
ed A°. D°. 17 Benj. Franklin

NOTICE TO READER. When you finish reading this magazine, place a U. S. 1-cent stamp on this notice, mail the magazine and it will be placed in the hands of our soldiers or sailors.
NO WRAPPING—NO ADDRESS
A. S. Burleson, Postmaster General

AUG. 9, 1919

5c. THE COPY
10c. in Canada

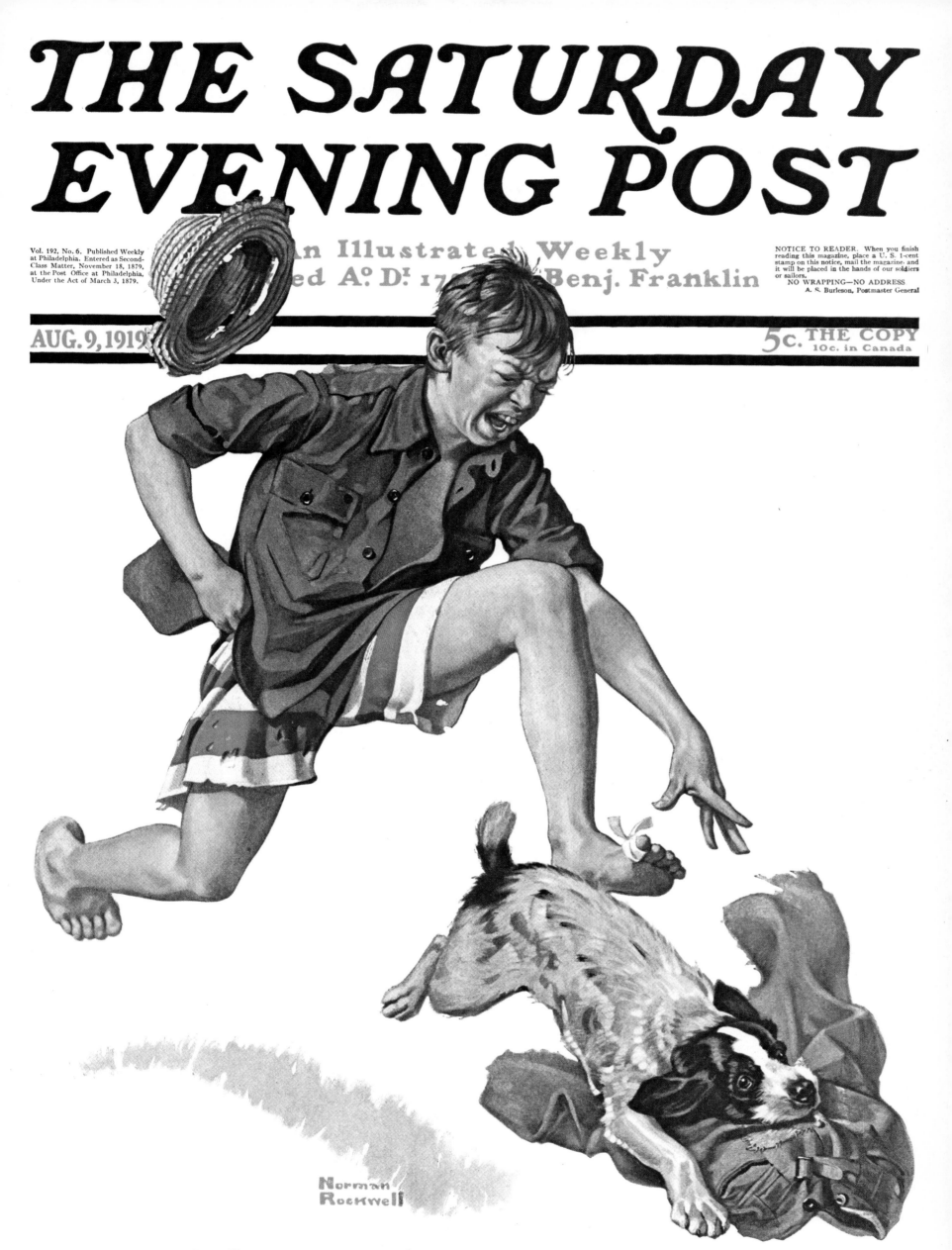

Norman Rockwell

John J. Coincidence—By Irvin S. Cobb

"Taking a Break"

I believe Buddy Ogden, the boy who posed for this cover, grew up to become an All-American fullback," Rockwell remembers. Ogden also posed for the laughing boy in the recitation cover. Nostalgia, both small and grand, is an ever-present element in Rockwell's designs. The longing for summer one feels with the coming of fall, the remembrance of the pleasure and innocence of youth, the reluctance with which one takes up work, combine to create a sort of lethargic ideal, in strong contrast to the preceding cover. By this time Rockwell was averaging a cover almost every six weeks. Buddy Ogden and Billy Paine often got into tiffs as to which was the favorite model. Ogden won the fights but Paine appeared on more covers. Rockwell used to pay them three dollars a sitting, and he once reminisced, "I earned the money."

THE SATURDAY EVENING POST

Vol. 191, No. 10. Published Weekly at Philadelphia. Entered as Second-Class Matter, November 18, 1879, at the Post Office at Philadelphia, Under the Act of March 3, 1879.

An Illustrated Weekly
Founded A.D. 1728 by Benj. Franklin

NOTICE TO READER. When you finish reading this magazine, place a U. S. 1-cent stamp on this notice, mail the magazine, and it will be placed in the hands of our soldiers or sailors. NO WRAPPING—NO ADDRESS. A. S. Burleson, Postmaster General

SEPT. 6, 1919

5c. THE COPY
10c. in Canada

In This Number

**Joseph Hergesheimer — Samuel G. Blythe — L. B. Yates — Will Irwin
Ring W. Lardner — William Hamilton Osborne — Stephen French Whitman**

© SatEvePostCo. 1919

"Important Appointment"

Balancing a model against an office interior in two bold vertical thrusts the artist has managed to convey the story instantly. "I paint storytelling pictures which are quite popular but unfashionable," Rockwell said in 1962, "but I like doing what I do and know not how to do anything else. I would love to be a Rembrandt but I never will be by a long, long way." But in unveiling interior scenes and motives Rockwell was to have a lot in common with the Dutch master. Here with the swivel chair, the desk and diploma he has managed to display a man's life and work, and though it would be pointlessly absurd to compare "The Anatomy Lesson of Dr. Culp" with this picture, there is something of the same recognition of wisdom in the physician, the intelligence of taking one's own advice, the lively inquisitiveness of the doctor's expression, the invitation to heal thyself. The viewer is invited to close the door on his work-a-day world.

The viewer stands behind the doctor, yet since none of the waiting room is delineated, it is golf that the viewer sees, not the boredom of waiting. "Step over the frame and live in the picture," advised Thomas Fogarty, one of Rockwell's masters at the Art Students League, and a superb etcher and illustrator in black and white. "Otherwise, you're just picking over somebody else's work."

THE SATURDAY EVENING POST

An Illustra... Weekly
Founde... ...enj. Franklin

Vol. 192, No. 12. Published Weekly at Philadelphia. Entered as Second-Class Matter, November 18, 1879, at the Post Office at Philadelphia, Under the Act of March 3, 1879.

SEPT. 20, 1919

5c. THE COPY
10c. in Canada

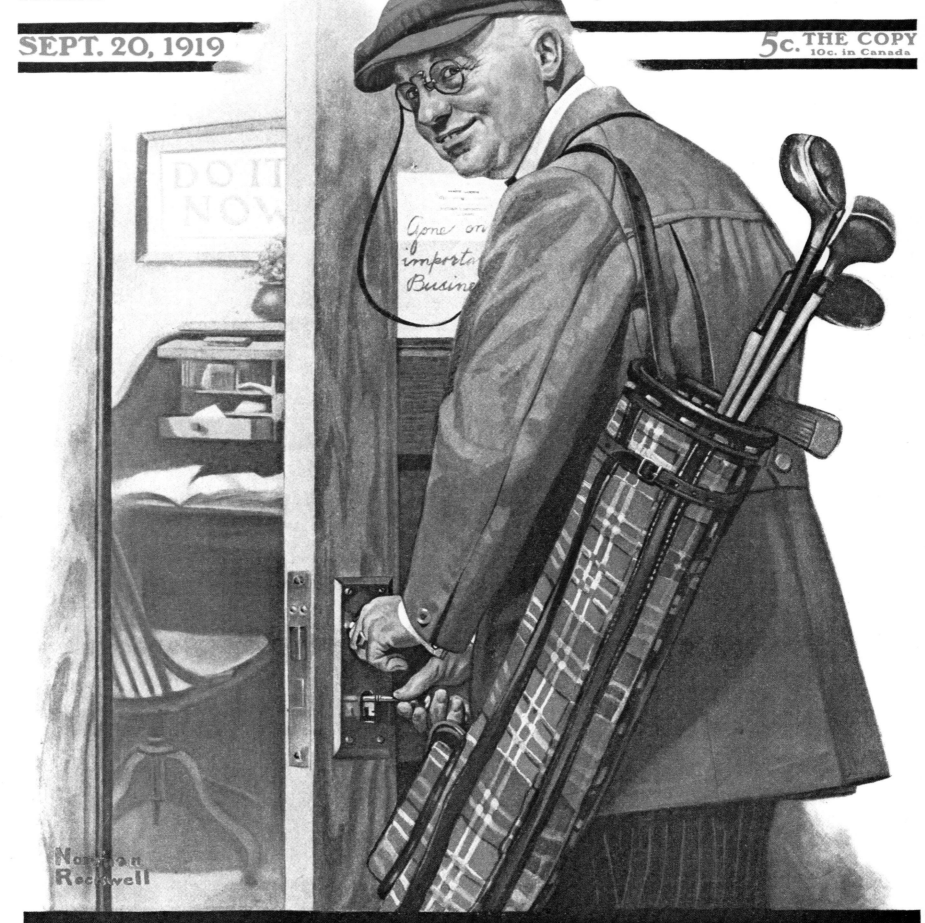

Norman Rockwell

Beginning **The Peddler** — By Henry C. Rowland

"Dog Gone It"

The A-frame construction of the cover predicts the relatively harmless outcome of the boy's forebodings. Innocuous space plus eminent time catalyzed by the Dog-Star equals mild humor. Nothing more. The gag-type cover was to reign a good fifteen years more for Rockwell, and even after that to reappear in the Thirties and Forties with fairly reliable steadiness. The cartoon—in its classic sense a cartoon was a sketch made by the artist for a more finished composition, the cartoon usually being painted over or covered up by the finished work—still dominates most *Post* covers, though by the Thirties cartoons will be beefed up until they in effect become posters. Posters are almost always created to make an announcement or to sell something. The possibilities of poster art are demonstrated in the great works of Toulouse-Lautrec and later French masters. The integration of design with message in eye-stopping directness combines the psychology of advertising with the innate sense of what the artist believes is beautiful and appealing.

"Why do you always use the same mutt in your covers?" Lorimer asked Rockwell. "I have a good dog and he's a good model, and I use him because it's easier." "Well," said Lorimer, "I have a photograph of a spitz dog. Put him on one of your covers." The spitz—then very much in fashion—duly appeared. Later, a *Post* employee told Rockwell, "Why that's Mr. Lorimer's dog! Where did you ever get a picture of him?" Rockwell's mutt appears tailed, tailless, spanieled and Airedaled throughout the years following World War I.

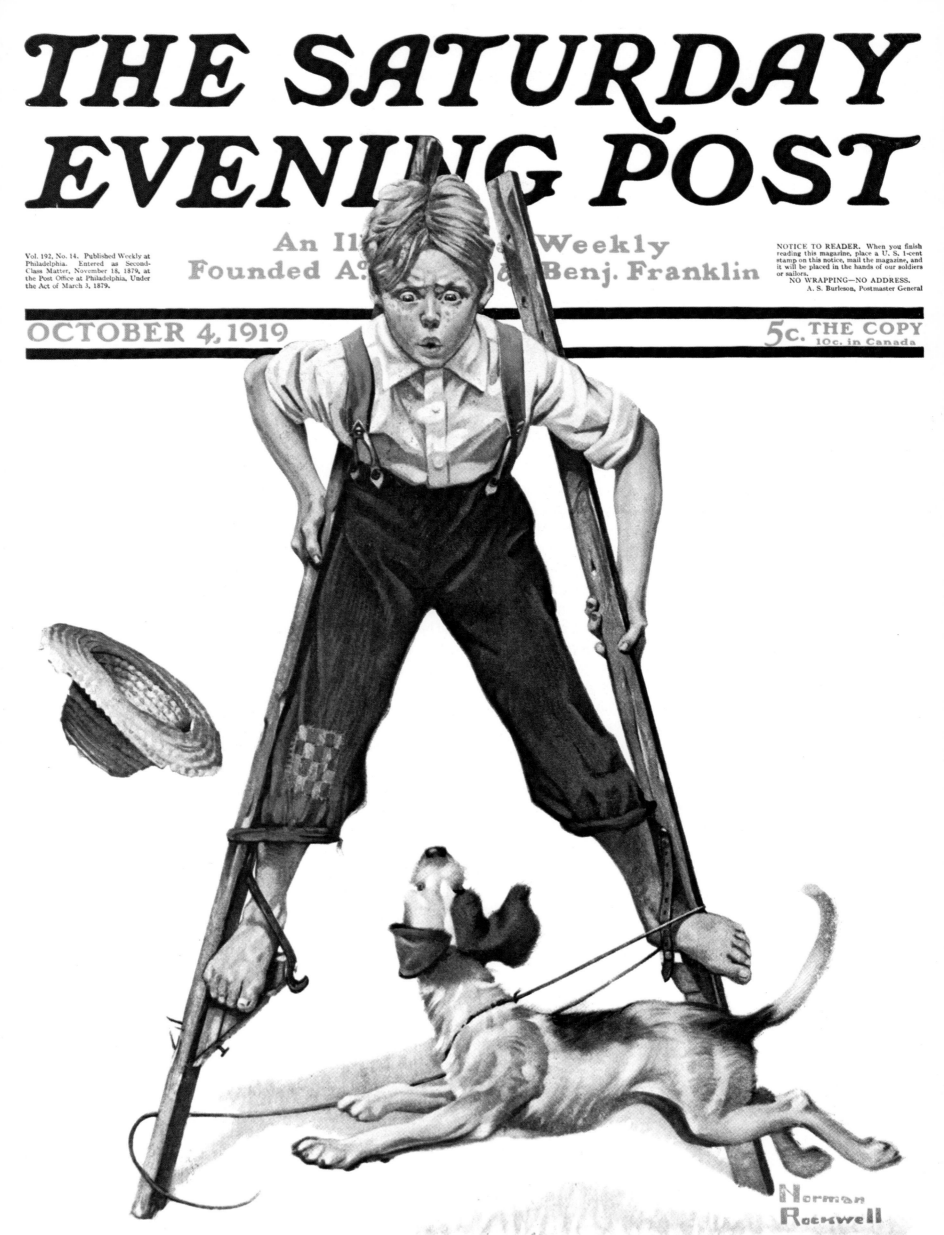

"Grandpa"

The genius with which Rockwell balances two opposing emotions with Dickensian bravado will turn, in the years to come, into an honestly sentimental revelation of the joys and sorrows of life—again the larger picture, which sent Rockwell towering over his contemporaries. A glance at the cover line introduces the paradoxical sophistication and small-townness which always characterized the *Post*. With bitter sarcasm, Sinclair Lewis was to ridicule in story after story for the *Post,* and in his masterpiece *Babbitt,* Main Street and the average American which Rockwell at the same time was glorifying on the covers. The *Post* was never known for great literature even though, week after week, it published it. The *Atlantic, Harper's* and other literary journals published scholarly criticism of authors who were usually making their living in the pages of the *Post.* This never offended Lorimer or his boss Curtis who felt the American public would swallow anything, even caviar, if, week after week, it always looked like the same pill. "Paint my cars any color as long as it's black," Curtis' friend Henry Ford once said, and he and Curtis had a great deal in common, both as managerial giants and purveyors of taste in the new America of expanding necessities where what the country needed was a good five-cent cigar if five-cent cigars were what you were selling.

THE SATURDAY EVENING POST

Vol. 192, No. 25. Published Weekly at Philadelphia. Entered as Second-Class Matter, November 18, 1879, at the Post Office at Philadelphia, Under the Act of March 3, 1879.

An Illustrated Weekly
Founded A?. D?. 1728 by B̶. ̶ ̶ ̶ ̶lin

DEC. 20, '19

5c. THE COPY
10c. in Canada

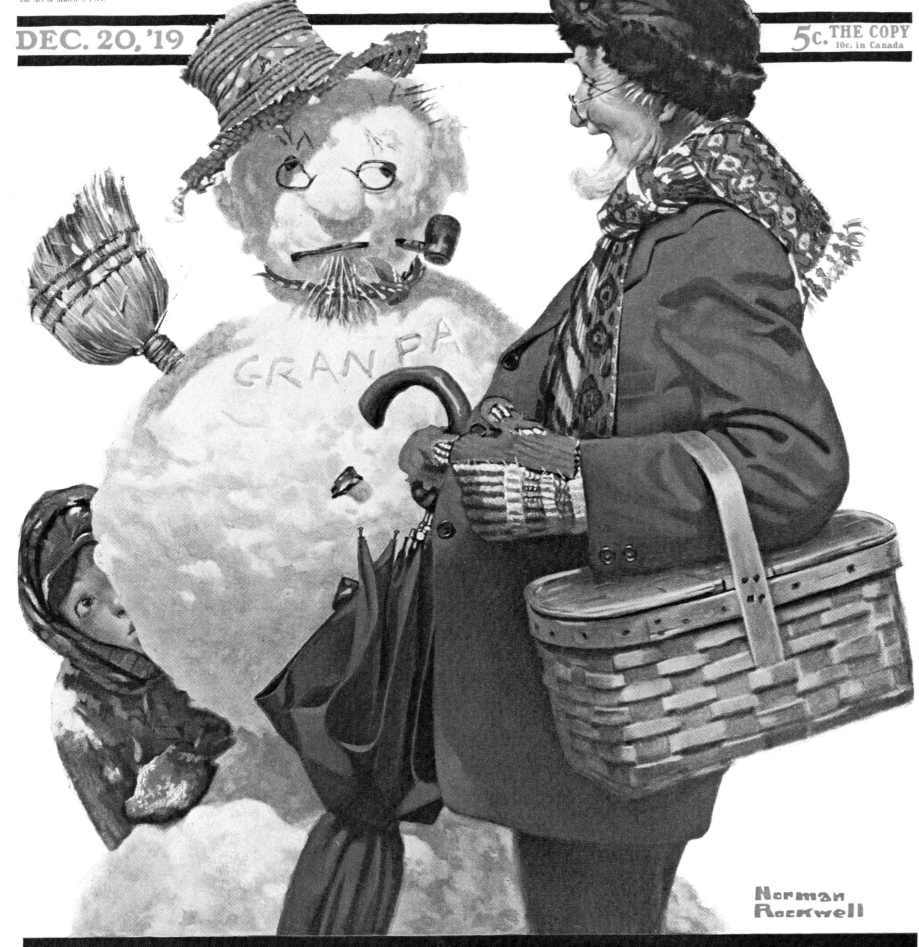

Norman Rockwell

Elizabeth Frazer — Sinclair Lewis — Rita Weiman — Will Irwin — Charles Collins — Keene Abbott

"Pen Pals"

The Twenties dawned on Rockwell with no perceptible realization that anything at all was dawning, much less what amounted to a new age for America, a coming of age, and a going away from naivete and innocence. Rockwell was making money. He went to Europe six times, studying, sketching, observing the sameness in human nature, and putting it to work in his covers. He saw no reason to change, or more accurately, he changed for no reason. He lived in New Rochelle, which housed a veritable colony of *Post* artists. Chief among them was the great Joseph Christian Leyendecker, whose career spanned the years 1899 to 1943. He and his brother, F. X. Leyendecker, had studied in Paris and had proven that the art of illustration was respectable, more respectable in a way than fine art, and that it existed independent of one's position in society; further, that it was one's work that counted, not to whom an artist was married or who his father was. Charles Dana Gibson also lived in New Rochelle, and, using his wife, the beautiful Irene Langhorne from Virginia, as a model, had created the American girl. Gibson went everywhere, followed the rich and with his pen became rich himself. The Leyendeckers never went out of the house, according to Rockwell, who became Joe Leyendecker's friend as he came under the influence of his art. "I never met Leyendecker," Lorimer once said. "All our business was conducted by phone with his agent." The agent was Rex Beach, the original for Leyendecker's glorification of the American male, the Arrow collar man. Leyendecker was infinitely more sophisticated than Rockwell and through his friendship with Leyendecker, Rockwell began to see there was no sin in being sophisticated, or in being guilelessly sincere—that took real sophistication, Leyendecker told him.

THE SATURDAY EVENING POST

An Illustrated Weekly
Founded A? D̶i̶ ̶ ̶ ̶ ̶ ̶by Benj. Franklin

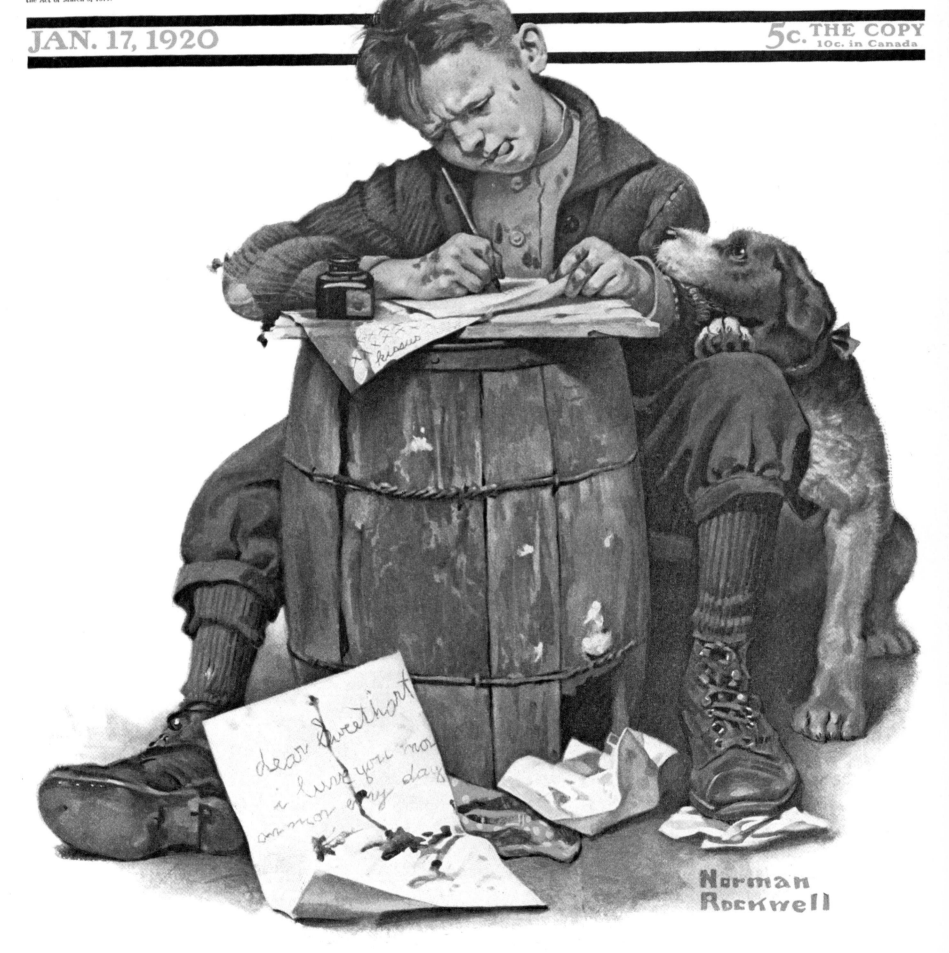

Vol. 192, No. 29. Published Weekly at Philadelphia. Entered as Second-Class Matter, November 18, 1879, at the Post Office at Philadelphia, Under the Act of March 3, 1879.

JAN. 17, 1920

5c. THE COPY
10c. in Canada

Harry Leon Wilson—Irvin S. Cobb—Frank Ward O'Malley—Grace Sartwell Mason
Corinne Lowe—Harry Snowden Stabler—Hugh Wiley—Alonzo Englebert Taylor

"The Skating Lesson"

About this time Rockwell illustrated a Boy Scout handbook. High diving boards, campfires, sticks being rubbed together, buckets, Scouts doing good deeds comprised the bulk of the material. Rockwell has a lively talent for enlivening what are essentially stick figures. He rags the lines, stressing the push and pull of the figures, delighting more in happy appearances and instant effects than in the purity of the lines. In "The Skating Lesson," he has resisted the obvious gag of making the girl heavier and less attractive than the model. The lightness of the design reflects the figures of the Boy Scout handbook. The lines have an almost instructive purpose as if he were telling his audience how to light a campfire or rescue somebody from the ice. "It has never been natural for me to deviate from the facts of anything before me," Rockwell says, "so I have always dressed the models and posed them precisely as I have wanted them in my picture; then I have painted the thing before me. If a model has worn a red sweater, I have painted it red—I couldn't possibly have made it green. I have tried again and again to take such liberties, but with little success." Rockwell has taken such liberties, of course, painting male models as females (January 12, 1929), changing dogs' spots, and varying expressions and costumes on models so recognition is obscured. He works this magic without any of the self-satisfied pleasure usually associated with clever illustration. He sees the actual reality of the models then moves into his own larger version of reality, the life at home, in a sense, the national (without propaganda) life.

THE SATURDAY EVENING POST

Vol. 192, No. 32. Published Weekly at Philadelphia. Entered as Second-Class Matter, November 15, 1879, at the Post Office at Philadelphia, Under the Act of March 3, 1879.

An Illustrated Weekly
Founded A. D. 1728 by Benj. Franklin

FEBRUARY 7, 1920

5c. THE COPY
10c. in Canada

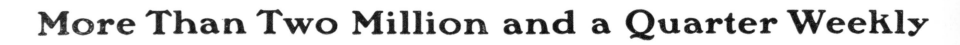

Norman Rockwell

More Than Two Million and a Quarter Weekly

"The Housekeeper"

The idea of a maid or cook seems an anachronism today when most people do their own work, but *Life* and *Judge,* and the *Post,* to a certain extent, were for years full of jokes about domestics. A type of humor evolved with as specialized a vocabulary and as predictable a character as the gravediggers in *Hamlet.* Keeping the cook happy was a national pastime. For a hundred dollars a month it was possible to have staff; and even modest families had a hired girl.

Rockwell's departing culinary genius is modeled on the covers of Leyendecker, who delighted in creating coats of arms for *hoi polloi,* poking a little fun at Europeans with their rigorous class structure. Leyendecker was also expert in incorporating a graphic design as part of the human comedy he was depicting. Rockwell's coat of arms is emblazoned with shamrocks, suggesting that the cook is Irish, dollar signs indicating her reasons for leaving, and a rolling pin which may have been used as a weapon in defending the kitchen. The mock daintiness in the way she holds her pocketbook, the uplifted head, and the hat give us her longing after gentility, her hurt feelings. The heftiness of her figure hints at her value.

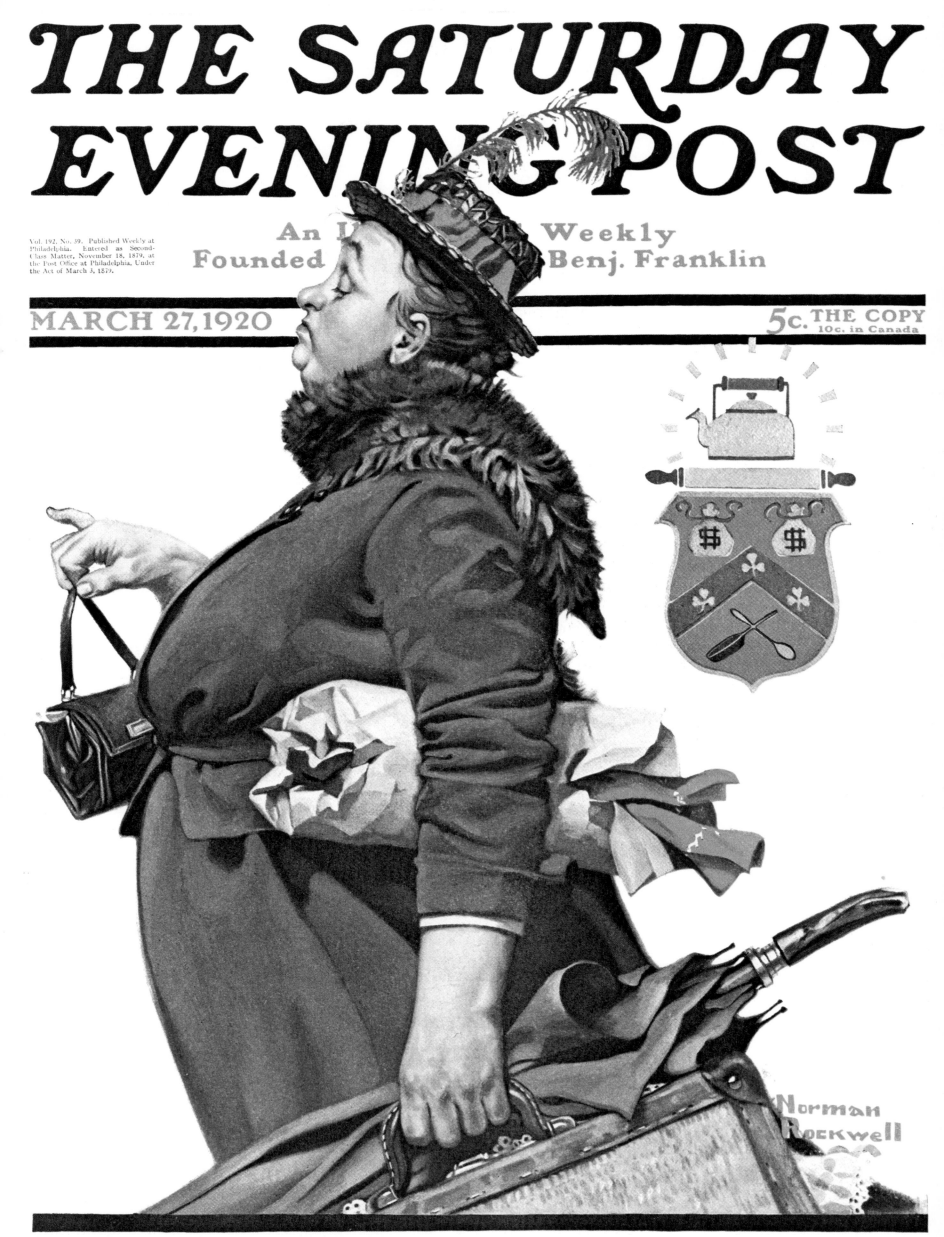

THE SATURDAY EVENING POST

Vol. 192, No. 39. Published Weekly at Philadelphia. Entered as Second-Class Matter, November 18, 1879, at the Post Office at Philadelphia, Under the Act of March 3, 1879.

An I____ ____ Weekly
Founded ____ ____ Benj. Franklin

MARCH 27, 1920

5c. THE COPY
10c. in Canada

Norman Rockwell

Hugh Wiley — Herschel S. Hall — Kenneth L. Roberts — Frederick Orin Bartlett
Lucia Chamberlain — Nina Wilcox Putnam — Will Irwin

"Ouija Board"

Ouija boards were enormously popular in the Twenties. If the board didn't answer life's burning questions it moved the suitor closer to his girl's hand.

Coles Phillips, the master of the pretty girl cover, devised a way of drawing attention to a girl's face by encircling the part of the cover he wanted to emphasize. This circle was to become a *Post* trademark. Rockwell uses it for the first time here. He used it twice more in that year and all through the Twenties and Thirties it was a regular feature of his work. It finally disappeared about the time of Lorimer's death in 1937. Sometimes the circle was blank, sometimes peopled with images of the character's dream, sometimes it was the main composition with another figure looking in. Like the restrictive space of the cover itself, it was an endless challenge to Rockwell's ingenuity.

THE SATURDAY EVENING POST

Vol. 192, No. 44. Published Weekly at Philadelphia. Entered as Second-Class Matter, November 18, 1879, at the Post Office at Philadelphia, Under the Act of March 3, 1879.

MAY 1, 1920

5c. THE COPY
10c. in Canada

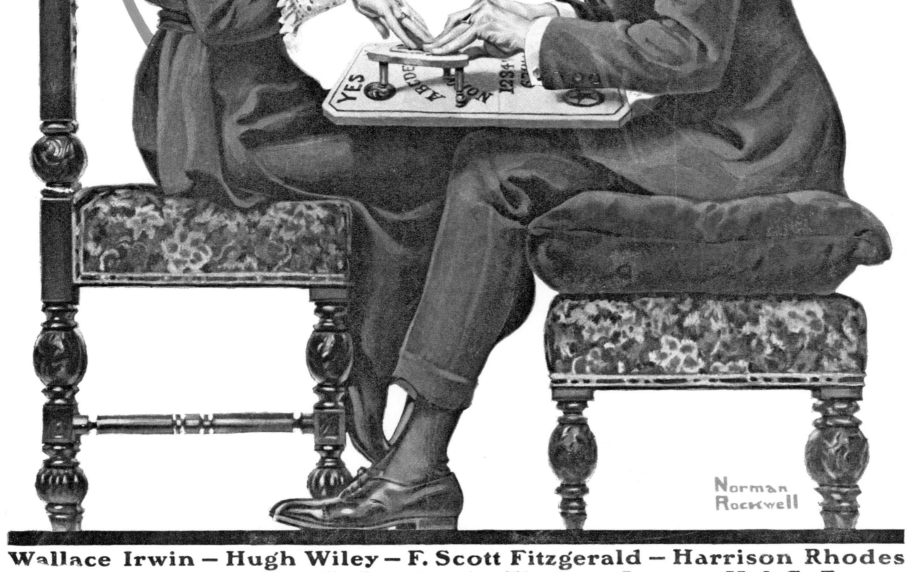

Norman Rockwell

Wallace Irwin — Hugh Wiley — F. Scott Fitzgerald — Harrison Rhodes
Graeve — Henry C. Rowland — Thomas Joyce — Hal G. Evarts

"The Stowaway"

Travelers have always been grist for Rockwell's mill. Air, sea, and road provide him with subjects who are enjoying themselves (the woman taking her first plane trip, June 4, 1938), subjects not enjoying themselves ("Ocean Voyage," September 8, 1923) and subjects undergoing a change in personality, even of a temporary nature. A normally honest boy commits a crime which causes rules and regulations to come under scrutiny both for their logic and compassion. What train conductor could toss that dog in the baggage car.

THE SATURDAY EVENING POST

Vol. 192. No. 46. Published Weekly at Philadelphia. Entered as Second-Class Matter, November 18, 1879, at the Post Office at Philadelphia, Under the Act of March 3, 1879.

An Illustrated Weekly
Founded A° D...... Benj. Franklin

MAY 15, 1920

5c. THE COPY
10c. in Canada

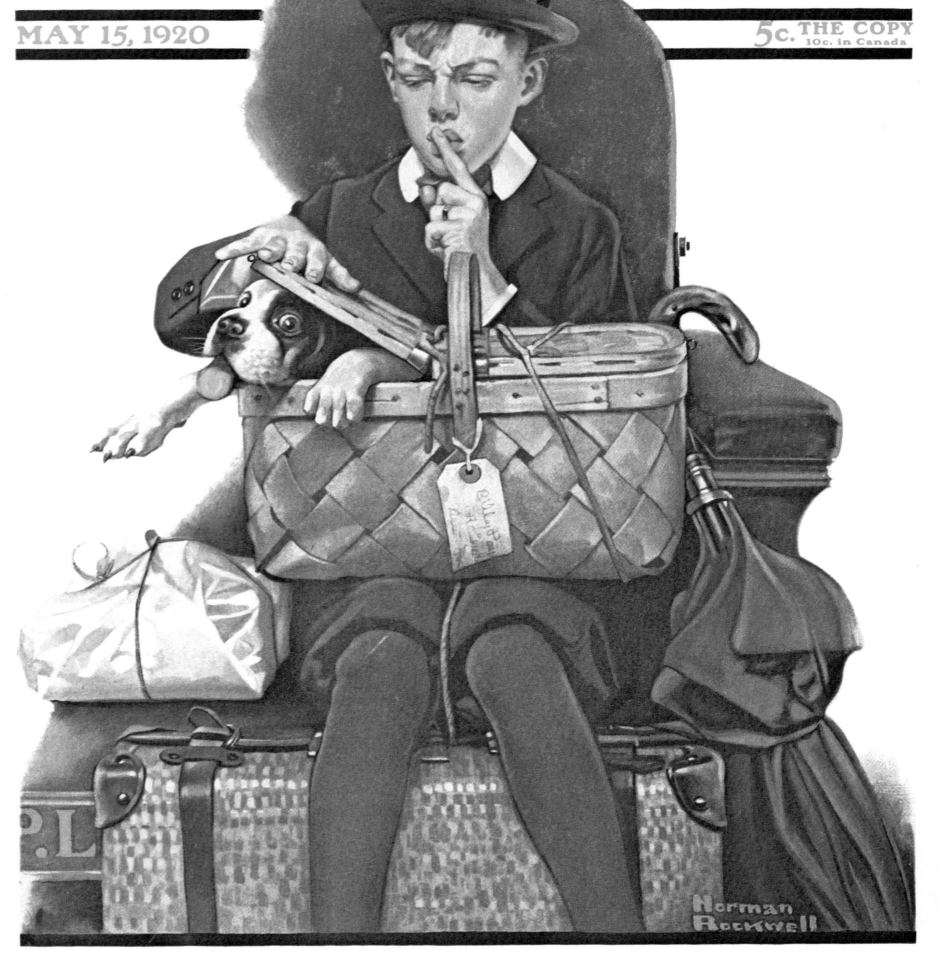

Beginning: **The Man From Ashaluna**—By Henry Payson Dowst

"Three's Company"

Rockwell's way of dealing with sex is in terms of a cover artist, refined, deeply sympathetic. In his July 14, 1951 cover, which shows a father explaining the facts of life to his son, a cat obligingly drapes her progeny over the living room furniture to make it easier, but both lecturer and audience are uncomfortable. In the 1920 cover, the boy whose time is being beaten in the girl's eyes by his dog is unaware of how far from a debonair caller he really is. The dog points it up. That is the surface of the painting. Beneath, we sense the real strangeness of the world he is entering. We are in the boy's shoes. The girl is remote, seen through the side window of the door, ready, waiting, in a sense, for her life as an adult to begin, surprised that the life to come is not peopled by knights in shining armor but simply by the same people of her youth, only bigger and maybe even sillier. In each new cover Rockwell's sympathy and understanding of the human condition deepen. Laughter is tempered by wistfulness.

THE SATURDAY EVENING POST

Vol. 192, No. 51. Published Weekly at Philadelphia. Entered as Second-Class Matter November 18, 1879, at the Post Office at Philadelphia, Under the Act of March 3, 1879.

strated Weekly
Foun ... 1728 by Benj. Fra

JUNE 19, '20

5c. The Copy
10c. in Canada

Norman
Rockwell

George Pattullo — Alfred Noyes — Hugh MacNair Kahler — Henry Milner Rideout
Elizabeth Frazer — Octavus Roy Cohen — Kenneth L. Roberts — Edward G. Lowry

"Excuse My Dust"

"This July 31st cover was one of the most popular I ever did," says Rockwell. The Ford that is passing the more expensive car, the wild abandon of the family (within the limits of 30 mph), and the elegant nickel radiator cap of the Peerless create a feeling of competition in which Everyman in America is beginning to break out of his so-called place, to enjoy the possibilities of mass production. Lorimer permitted Rockwell to drop the second line of the famous logo in this composition and to outline a square which he used with success in two covers the following year, and in the July 19, 1924 cover, a successful effort to repeat the popularity of this cover. The models were a family in New Rochelle, Dave Campion and his wife and son. Campion ran a news store. Containing his feeling of pride when he sold the *Post* with his picture on it must have been almost impossible.

THE SATURDAY EVENING POST

Vol. 193, No. 5. Published Weekly at Philadelphia. Entered as Second-Class Matter, November 18, 1879, at the Post Office at Philadelphia, Under the Act of March 3, 1879.

An Illustrated Weekly
Founded A? D? 1728 by Benj. Franklin

JULY 31, 1920

5c. THE COPY
10c. in Canada

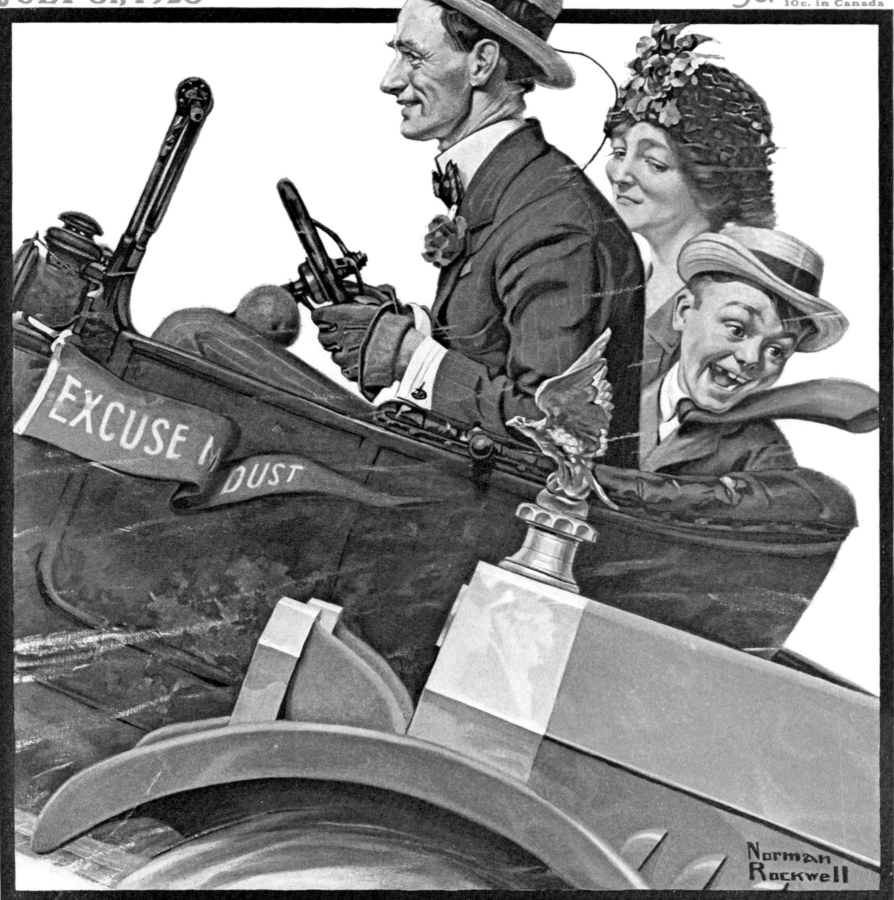

EXCUSE M DUST

Norman Rockwell

**Helen Topping Miller—Don Marquis—William J. Neidig—Grace Lovell Bryan
Henry Payson Dowst—Admiral Smirnoff—Jay E. House—Jefferson Winter**

"The Cave of the Winds"

At the beginning of any modeling session that involved children, Rockwell would set a stack of nickels on a table next to the easel. Every twenty-five minutes, he would transfer five of the nickels to the other side saying, "Now, that's your pile." It helped eliminate the restlessness. This is one of the last covers Rockwell was to paint in which design is a weak element and the narrative element has the upper hand. All through the later years of the Twenties and Thirties the strong poster effect dominated his work for the *Post*. In the Forties, especially in his wartime covers, the story would return as the major element. The painter had studied illustration with Thomas Fogarty, whose definition of illustration was "an author's words in paint." Covers, however, are not authors' words, and it is in this that Rockwell surpassed all his contemporaries, and even his predecessors who made up what he called "the golden age of illustration." Rockwell created his own stories, freezing his characters in a moment of surprise or glee or chagrin in such eloquent detail that the reader could complete the story from his own perceptions and experience.

THE SATURDAY EVENING POST

An Illustrated Weekly

Founded A. D. 1728 by Benj. Franklin

Vol. 193, No. 9. Published Weekly at Philadelphia. Entered as Second-Class Matter, November 18, 1879, at the Post Office at Philadelphia, Under the Act of March 3, 1879.

AUG. 28, '20

5c. THE COPY
10c. in Canada

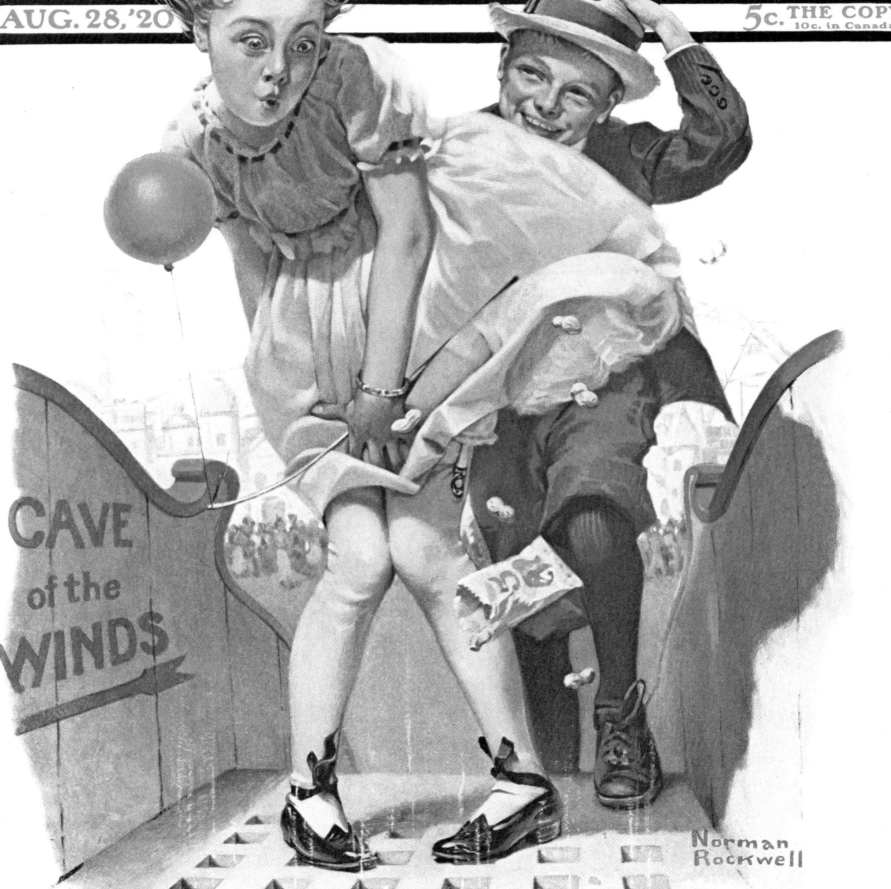

CAVE
of the
WINDS

Norman
Rockwell

**Holworthy Hall—George F. Parker—Arthur Train—Princess Cantacuzène
Victor Shawe—Anthony Wharton—Thomas Beer—Maude Radford Warren**

"Political Opponents"

Political covers appeared throughout Rockwell's career. The magazine had to be careful not to offend either party or readers. When Adlai Stevenson was running against Eisenhower in the 1950's, Rockwell painted portraits of both. The theme here of a warring couple was repeated on the October 20, 1948 cover with a couple at breakfast championing Truman and Dewey. The December 4, 1944 cover shows John Q. Citizen in the voting booth pondering over the choice of Roosevelt and Dewey. In his 1920 cover Rockwell demonstrated abilities as a portrait artist of known faces with the newspaper cover of Harding, something *Post* readers would not see again until the Lindbergh cover and then not until the political portraits of the Fifties and Sixties. Every cover was a portrait in that it was a picture of a model, but his success with the portrait—a field he could have made himself famous in, though in a more limited way—was a triumph of illustration over photography at a time when magazine illustration was largely confined to use with fiction stories inside the pages of the issues. Rockwell also painted Kennedy, Johnson, Nixon, Humphrey and Goldwater.

THE SATURDAY EVENING POST

An Illustrated Weekly
Founded A° D! 1728 by Benj. Franklin

Vol. 193, No. 15. Published Weekly at Philadelphia. Entered as Second-Class Matter, November 18, 1879, at the Post Office at Philadelphia, Under the Act of March 3, 1879.

OCTOBER 9, 1920

5c. THE COPY
10c. in Canada

Norman Rockwell

Irvin S. Cobb — Mary Brecht Pulver — Nina Wilcox Putnam
George Pattullo — Helen Topping Miller — Samuel G. Blythe

"Halloween"

Shoes, objects most artists seem to be tired of by the time they got their brushes to these plebian objects, are often storytelling features in Rockwell's work. The patent leather "Mary-Janes" peeking out from the spook's sheet proclaim this creature from another world is no other than the tyke next door. Perhaps because of his experience as art director of *Boys' Life,* Rockwell was always better at depicting boys than girls, and has here covered up his weakness with a sheet. The model for the grandfather appears in other covers. The circle has been painted in with black, increasing the drama and impact in what might have been no more than a trivial incident.

THE SATURDAY EVENING POST

Vol. 193, No. 17. Published Weekly at Philadelphia. Entered as Second-Class Matter, November 18, 1879, at the Post Office at Philadelphia, Under the Act of March 3, 1879.

Founded A·D·1728 by Benj. Franklin

OCT. 23, 1920

5c. THE COPY
10c. in Canada

HALLOW~E'EN

Norman Rockwell

Hugh MacNair Kahler—Bertram Atkey—Maude Radford Warren—Princess Cantacuzène
Richard Washburn Child—Forrest Crissey—Rebecca Hooper Eastman—Albert W. Atwood

"Santa's Children"

After a hiatus of four years Rockwell painted another Christmas cover, beginning the tradition which would continue until 1956. The famous circle is filled with the faces of expectant children, good beyond even the credulous eyes of St. Nicholas. The book in Santa's hand appears again and again and is surely not without a religious connotation of the roll to be called up yonder one day. Later Christmas covers refer to "extra good boys and girls," and the 1924 Christmas cover actually shows a Santa up in the sky making benevolent notes in his book while smiling down on a farm lad doing his chores. The old English lettering in the word Christmas jarred the usual type faces used by the *Post* but the art directors at Interwoven Socks for whom Rockwell did ads were delighted and Lorimer advised Rockwell to charge twice as much for an ad as he did for a *Post* cover.

THE SATURDAY EVENING POST

Vol. 193, No. 23. Published Weekly at Philadelphia. Entered as Second-Class Matter, November 18, 1879, at the Post Office at Philadelphia, Under the Act of March 3, 1879.

An Illustrated Weekly
Founded A⁰. D¹. 1728 by Benj. Franklin

DEC. 4, 1920

5c. THE COPY
10c. in Canada

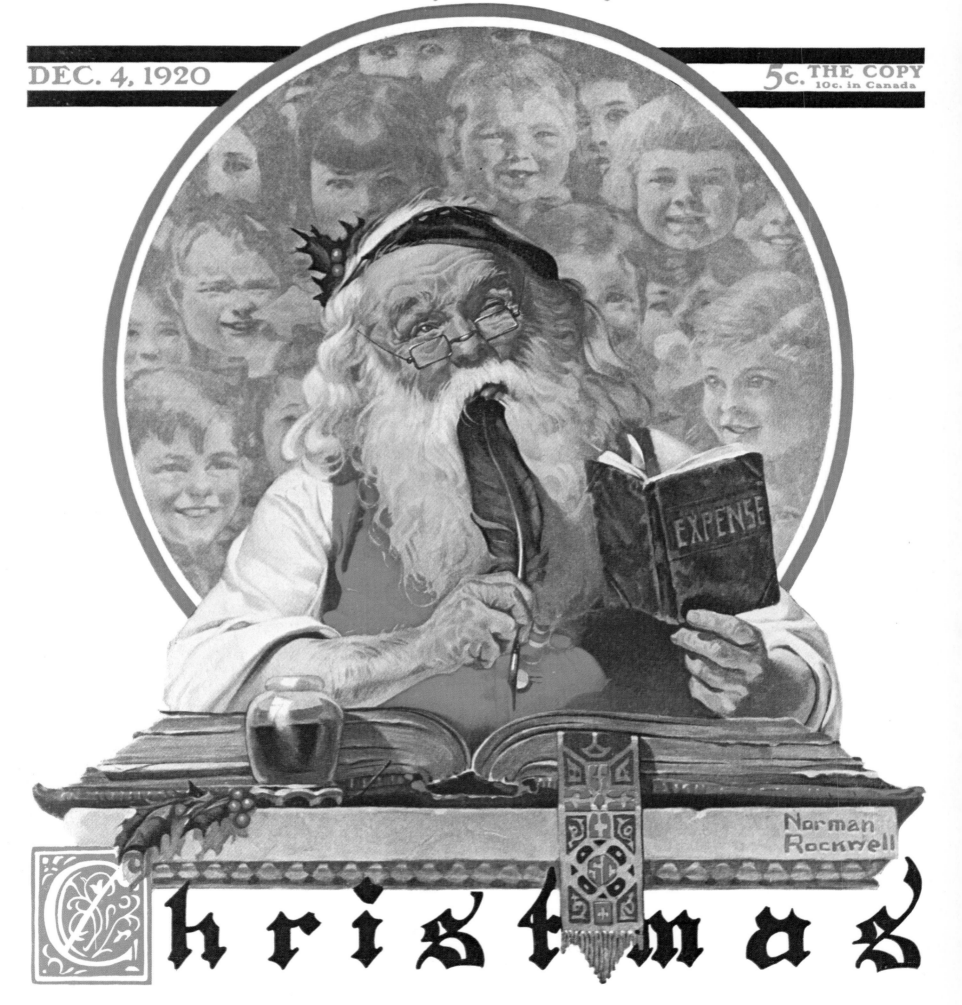

Norman Rockwell

Christmas

"Mom's Helper"

Howard Pyle was a master illustrator at depicting pirates and piratical scenes of which there was a ready market in series books for boys. Rockwell admired Pyle, his research in digging up proper costumes and in learning about Spanish galleons, his style and bravura. He paid several tributes to Pyle, the last in October 24, 1959, when in the famous ancestor cover, Rockwell painted the initials H.P. on the sea chest which is the source of the boy's ancestry. In the days before television dime novels provided the only adventure and excitement boys got, and as an indication of their influence, major English novelists were once asked which books had colored their thinking and writing—the interviewers expected them to reply Shakespeare, Milton and Keats—and the authors answered the adventure books of their boyhood.

In the 1921 cover, the potatoes suffer as the suspense mounts in the tale. Rockwell's characters dream, imagine themselves pirates, or in his later work, movie stars, but the honesty and capability of their faces usually triumph over their wishful thinking. They may be mischievous, but they are not anarchists.

THE SATURDAY EVENING POST

Vol. 193, No. 31. Published Weekly at Philadelphia. Entered as Second-Class Matter, November 18, 1879, at the Post Office at Philadelphia, Under the Act of March 3, 1879.

An Illustrated Weekly
Founded A. D. 1728 by Benj. Franklin

JAN. 29, 1921

5c. THE COPY
10c. in Canada

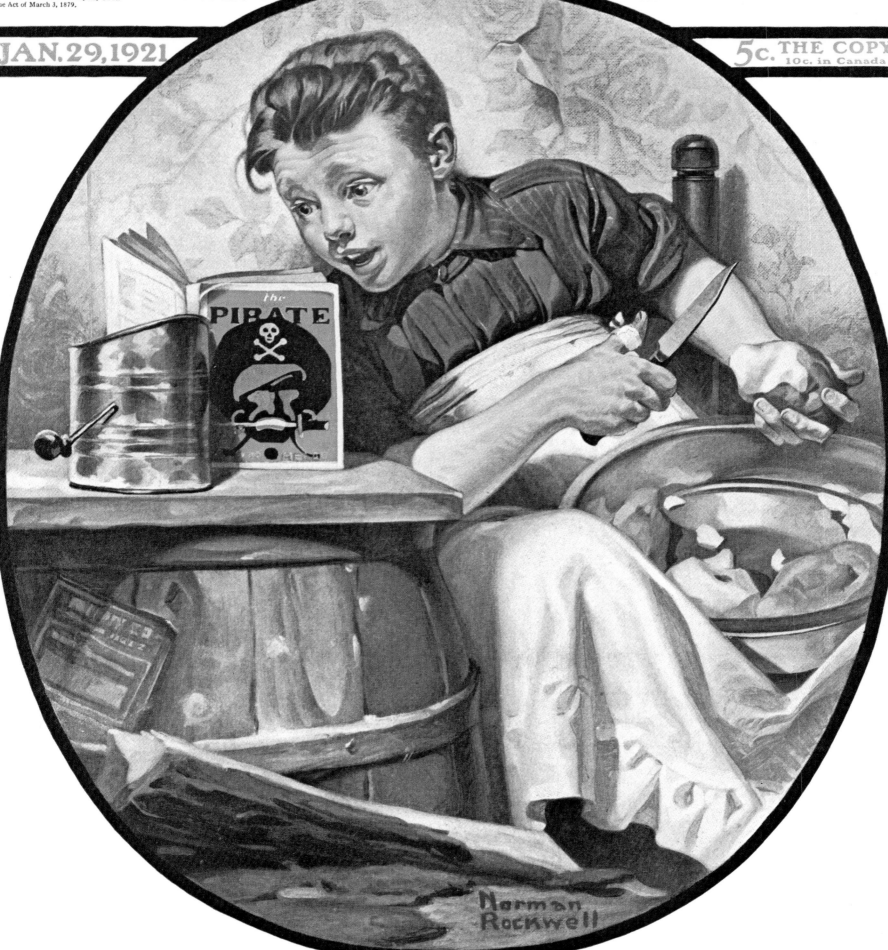

GEORGE PATTULLO—THOMAS BEER—J. R. SPRAGUE
ARTHUR TRAIN—HERSCHEL S. HALL—L. B. YATES

"The Fortune Teller"

The ouija board couple peer into their future via palmistry. In October they will be courting on the sofa which ill conceals the girl's little brother. They were to appear together one more time, in a 1925 cover of two buggy-riding spooners. A nod to the flapper, Rockwell would not, with the exception of two other covers, even acknowledge as the uniform of the 1920's, the breastless, lengthless, unflattering chemise that was the antithesis of small-town decorum. In the original painting the girl is wearing green silk stockings and a pink dress. The ostrich feather fan was standard equipment on every wrist at every dance, and the menu, the remains of which may be seen lower right, was the same: creamed anything in a patty shell. There is probably no better example of the conflict in this period of Rockwell's art than this. Rockwell likes clothes that have been suffered in, likes character, wrinkles which have been earned. He seems here a little shy of touching the female form. Her shoes, for example, are merely points, extensions of her legs. The young man's, though, are worked out in detail. There is nothing pretty about the way his feet turn inward. They are feet that have not enjoyed the dance.

THE SATURDAY EVENING POST

Vol. 193, No. 37. Published Weekly at Philadelphia. Entered as Second-Class Matter, November 18, 1879, at the Post Office at Philadelphia, Under the Act of March 3, 1879.

An Illustrated Weekly
Founded A.º D.� 1728 by Benj. Franklin

MARCH 12, 1921

5c. THE COPY
10c. in Canada

Norman Rockwell

The Big Four of the Peace Conference

By Robert Lansing
Former Secretary of State

"No Swimming"

No Swimming" is one of Rockwell's most important early covers. It demonstrates his mastery of the figure under emotional stress at the same time it is under physical stress. The running figure has no time for the exaggerated pantomime of some of the earlier covers. The viewer is less moved by the story than by the actors, though they conform to the narrative demands made on them by the sign. For once, the picture could really do without the dog although his dark form gives weight to the base line and helps create the sense of motion. The dog is a little too anxious to participate, he plays his role too well. Oddly, Rockwell uses the square frame in covers with action—the two tin lizzie covers (July 31, 1920; July 19, 1924), a carriage cover (Dec. 5, 1925)—as well as in the fairly stylized portrait of Dec. 3, 1921 or the stationary violinist of April 28, 1923 where it seems more appropriate. But in this, his thirty-sixth cover, illustration and the *Post* format were his territory, and his judgment was sound.

THE SATURDAY EVENING POST

Vol. 193, No. 49. Published Weekly at Philadelphia. Entered as Second-Class Matter, November 18, 1879, at the Post Office at Philadelphia, Under the Act of March 3, 1879.

Illustrated Weekly

Franklin

JUNE 4, 1921

5c. The Copy
10c. in Canada

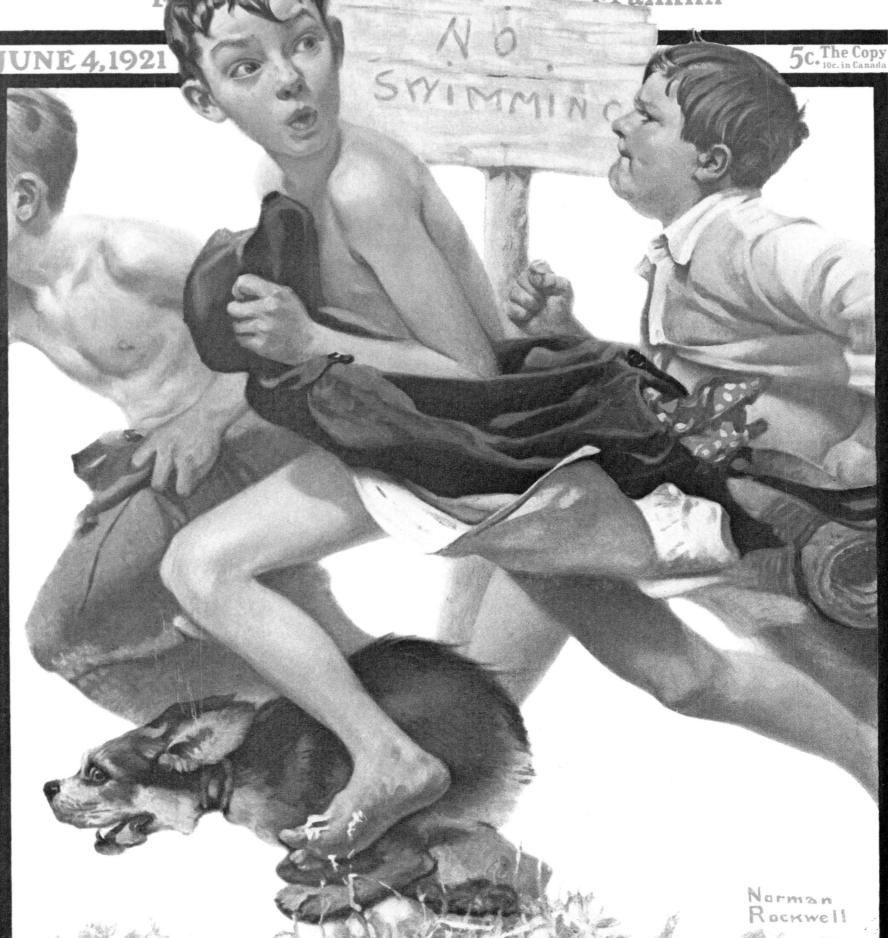

NO SWIMMING

Norman Rockwell

Gifford Pinchot—Henry C. Rowland—Harrison Rhodes—Lawrence Perry
Octavus Roy Cohen—Mary Brecht Pulver—E. G. Lowry—Frederick Collins

"The Portrait"

Rockwell hired a woman to bring her child to be used as a tearful model in order to repeat what every parent goes through when a photograph is made of baby. This child, however, was inexorably cheerful. Finally the mother said, "You want the kid to cry?" Rockwell said, "Yes." With that she pulled a pin from her bosom and jabbed him. After that he could not be silenced and Rockwell proceeded with his portrait of a portrait.

Years later Rockwell made a sketch of what he imagined the studio of Mathew Brady, the great Civil War photographer, looked like with Abraham Lincoln posing slightly in front of the head clamp. In later years he often borrowed themes from his early covers to treat with gravity and maturity. Here the emotion is more than facial; the little body of the child fairly trembles with rage, and the mortification of his older brother is enough to break the clamp.

THE SATURDAY EVENING POST

Vol. 194, No. 2. Published Weekly at Philadelphia, Entered as Second-Class Matter, November 18, 1879, at the Post Office at Philadelphia, Under the Act of March 3, 1879.

An Illu... ...Veekly
Founded A°. D... ...nj... ...anklin

JULY 9, 1921

5c. The Copy
10c. in Canada

Norman Rockwell

Beginning

The Girl With the Golden Heels—By Kenyon Gambier

"Distortion"

Rockwell took his models to the carnival in the summer, where they won a kewpie doll at the shooting gallery, lost fifteen cents at the fish pond and saw the whole town from the top of the ferris wheel. The food was great—every boy was required to eat at least five hot dogs. Strolling down the midway, they could see all the wonders of the far-off world—the Elephant Man, the Fat Lady, the Bearded Girl and the man with the elastic face. It was all splendid, even the mysterious mirror that fascinated little boys. They were at first skeptical, beholding their elongated images from a distance. They slowly crept closer and their reflected appearance changed. Finally they decided that they liked the mirror and examined it from all angles, soon learning the controls—which direction made them taller, which made them skinnier. If they stood in just the right place, maybe they could see how tall they would be when they grew up.

THE SATURDAY EVENING POST

Vol. 194, No. 7. Published Weekly at Philadelphia. Entered ⸱ as Second-Class Matter, November 18, 1879, at the Post Office at Philadelphia, Under the Act of March 3, 1879.

AUG. 13, '21 10 cents in Canada 5 cts.

Norman Rockwell

Samuel Merwin — Will Irwin — L. B. Yates — Maxwell Struthers Burt
Kenneth L. Roberts — Alice Duer Miller — Elizabeth Alexander

"God Bless You"

Interior decoration was not Rockwell's forte in the Twenties and Thirties, but if there is furniture in a painting, it is accurately depicted. This typically Twenties settee which has been painted in imitation teak is draped with a Chinese silk hanging. It might have been found in any house in town or city though it would hardly have been in a farm dwelling. Farmers demanded sturdier stuff. The ouija board couple is modestly dressed though in party attire, and the little brother, hero of many *Post* covers, past and to come, has mustered a perfect sneeze.

In the Forties with the change of logo and format, the new covers demanded interior scenes. Rockwell obliged and confesses he scoured antique shops in New England for bits and pieces of authentic Americana, much of which later furnished his own house.

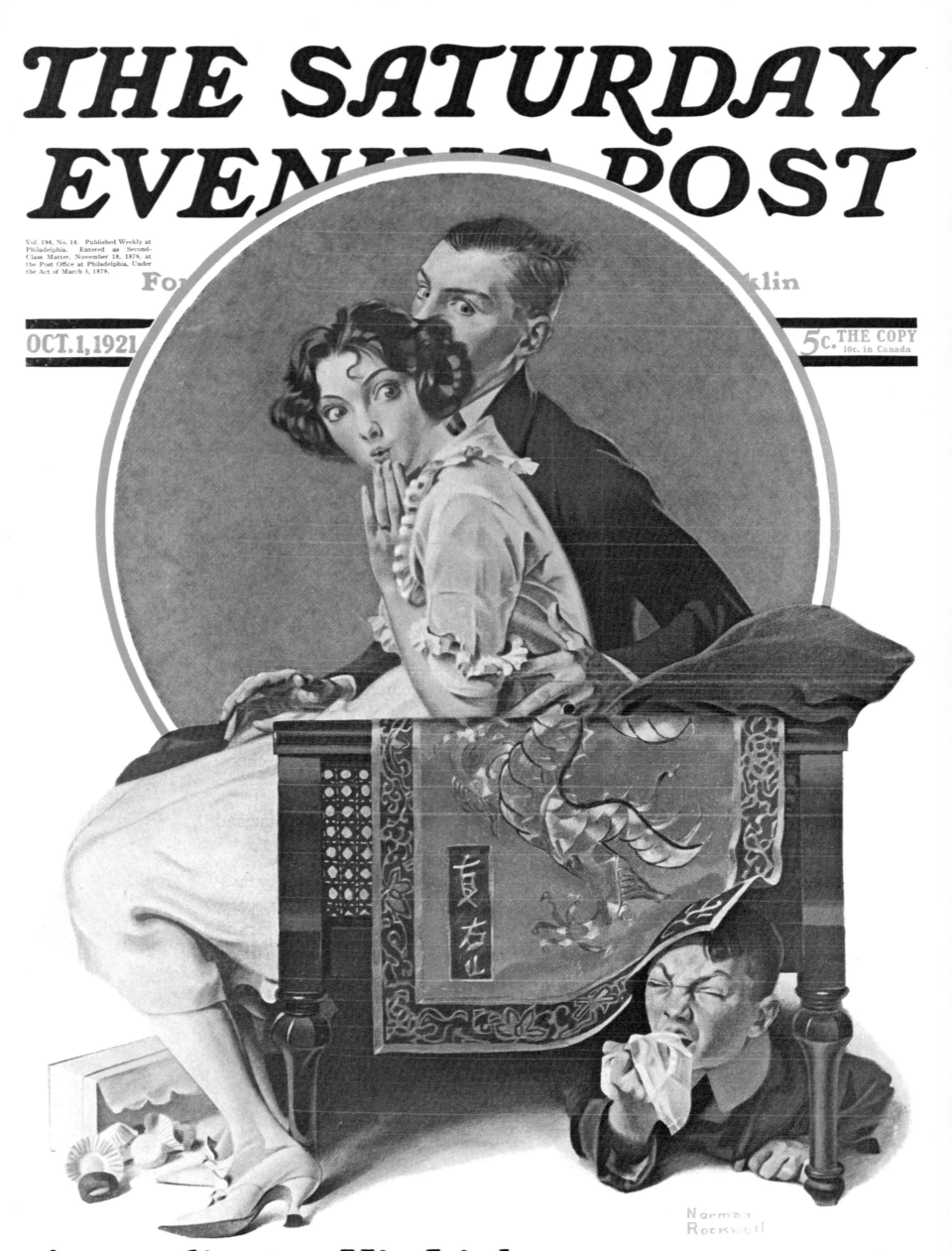

"Merrie Christmas"

Rockwell's father used to read Dickens to him as a child, and the Dickensian character was very much in tune with Rockwell's own. Dickens' *Dombey and Son* was serialized in the nineteenth-century *Post,* and it was a natural direction to turn for an artist who appreciated craggy faces and the Pickwickian temperament. To the 1970's, which instinctively reach back to a simpler, happier time because of the complexities of modern life, it may seem strange that Rockwell in the 1920's was doing the same. Part of the tradition of illustration as opposed to fine art is conjuring up the past. Fine art almost always dwells on the present while illustration romanticizes the past. Christmas was fixed as a Victorian celebration largely by Dickens and by the American artist Thomas Nast who gave America its image of Santa Claus. Blazing yule logs, red noses from eggnog and nippy English weather, a tree, family warmth, the jubilant pause on the shortest but the happiest day of the year, are all mirrored in this jolly coachman's eyes and smile. Rockwell did eight covers in the Dickensian style. They have been reproduced countless times, on calendars, in books, and inevitably on Christmas cards.

THE SATURDAY EVENING POST

Vol. 194, No. 23. Published Weekly at Philadelphia. Entered as Second-Class Matter, November 18, 1879, at the Post Office at Philadelphia, Under the Act of March 3, 1879.

An Illustrated Weekly
Founded A⁰. D�ⁱ. 1728 by Benj. Franklin

DECEMBER 3, 1921

5c. THE COPY
10c. in Canada

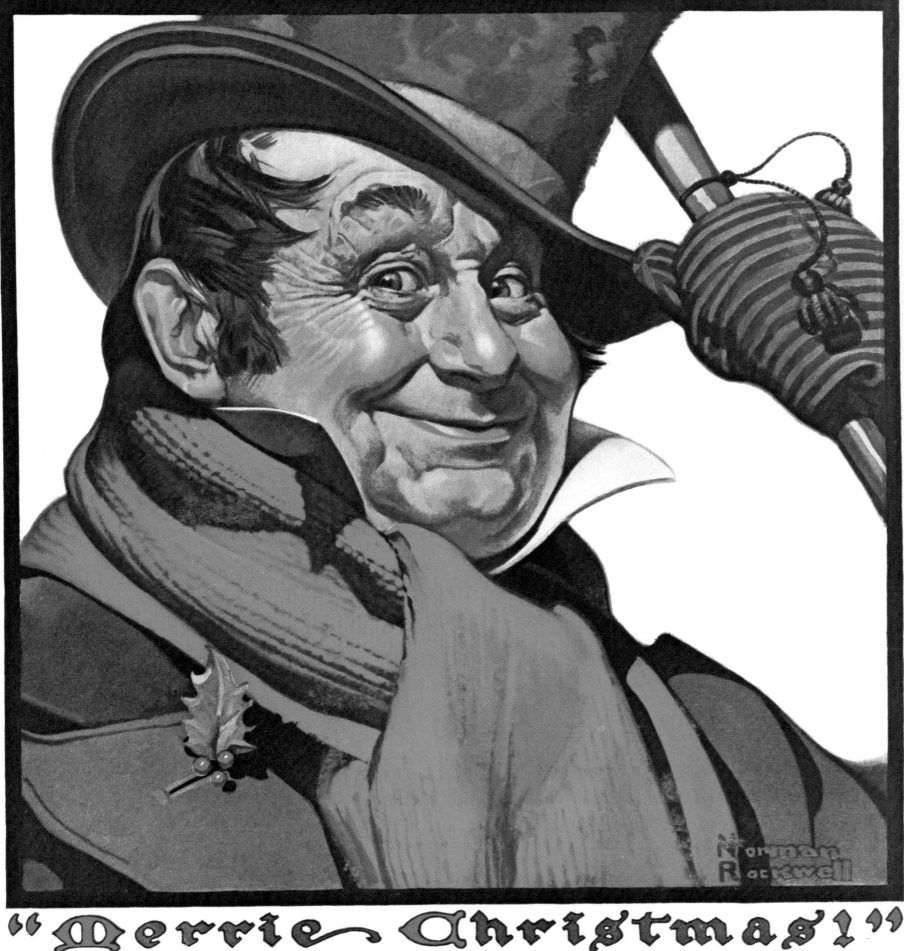

"Merrie Christmas!"

"Stereoscope"

Even though this is very much a cover in the early, cartoon style—the style persists even after the introduction of color—there is a richness, an aptness in the handling of chiaroscuro not seen in his previous work. The dark shading of the boy's pants, the white collar and cuffs of his blouse, and the shadowing of the dog's underparts are evidence of Rockwell's consummate skill in the handling of tonal values of pigment. By now he was twenty-eight and had been a full-time professional for ten years. The composition is secure, solidly anchored on the white ground, and the figure is sharp and distinct, the weight and pose of the boy anatomically convincing.

THE SATURDAY EVENING POST

Vol. 194, No. 29. Published Weekly at Philadelphia. Entered as Second-Class Matter, November 18, 1879, at the Post Office at Philadelphia, Under the Act of March 3, 1879.

An Illust... ...ly
Founded A⁰. D¹.Franklin

JAN. 14, 1922

5c. THE COPY
10c. in Canada

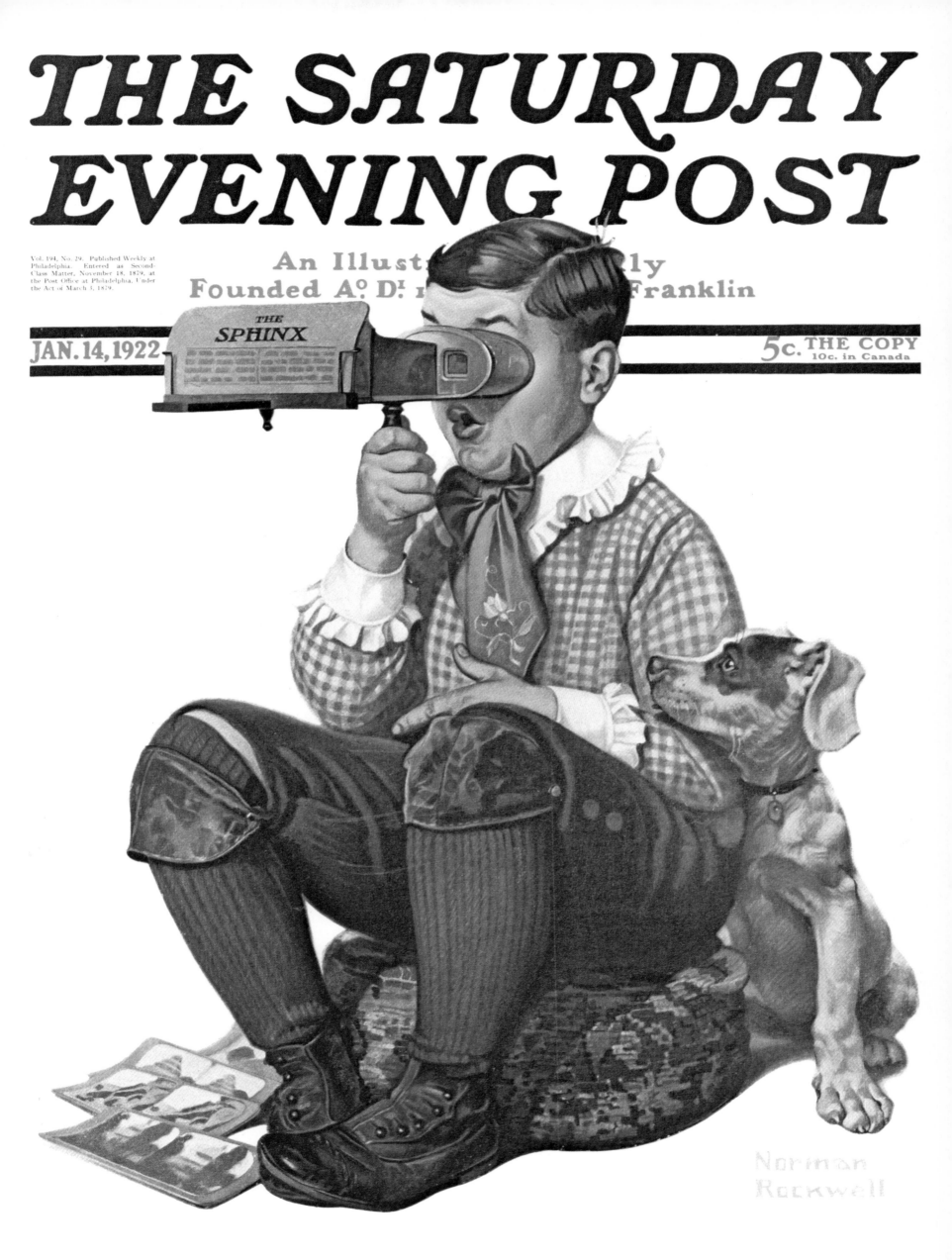

More Than Two Million and a Quarter Weekly

"Keeping Up with the News"

Thousands of letters from postal employees all over the country poured in to *The Saturday Evening Post* objecting to the nosy impression given of their occupation. Which might suggest guilt complexes rather than indignation. The post office depicted here is clearly a crossroads town, a hamlet barely large enough to support twenty boxes for letter sorting. And the postal clerk is scarcely a pleasant sort. He would embezzle in a bank—nothing large—rubber bands. He is the character born to get his nose into other people's affairs. Creating types is another aspect of Rockwell's genius. Every one of his characters broaches Everyman. They can never do a single act, they perform on the universal level. Who can resist a postcard? How convenient of printers to put the legend explaining the picture on the side with the message. Then how easy it is to find out "the historical details" as well as the news. "...if you are interested in the characters that you draw, and understand them and love them, why, the person who sees your picture is bound to feel the same way," Rockwell said a year after this was painted.

"Threading the Needle"

The marital status of the sitter is apparent. He is a bachelor, and the task he is performing, darning his socks, is an effort which has not previously been greeted with success if one can judge from the condition of his clothes. A lone button survives on his vest. His trousers have adopted the contour of his legs and the left knee gives every indication of imminent departure from the confines of the cloth. Only the house cat clings to the material with true fidelity. The chair has seen better days too, but despite tatters and ruin, the bachelor holds his head high to see how much more the traffic will allow.

Rockwell often painted in the parallel bars of the logo to show the art director where he wanted them to cross his subject matter. In this case the bars are whited out about two inches from the back of the head on the left and omitted for an equal distance in front of the hands. This focuses attention on the threading of the needle very much the way Vermeer, an artist Rockwell admired and studied, initiates the viewer into the intimate moments of the household. The cover led to a series of ads Rockwell did for Interwoven Socks; one of the ads shows this same model, turned out in a valet's uniform. He is unpacking his master's valise and admiring his silk socks. The model is the same man who drove the Ford in the July 31, 1920 cover.

THE SATURDAY EVENING POST

Vol. 194, No. 41. Published Weekly at Philadelphia. Entered as Second-Class Matter, November 18, 1879, at the Post Office at Philadelphia, Under the Act of March 3, 1879.

An Illustrated Weekly
Founded A. D. 1728 by Benj. Franklin

APRIL 8, 1922

5c. THE COPY
10c. in Canada

Norman Rockwell

Earl Derr Biggers—Perceval Gibbon—Dorothy DeJagers—Maryse Rutledge
Hugh MacNair Kahler—Princess Cantacuzène—Joseph Hergesheimer

"The Champs"

"...a sort of self-portrait because in those days I, like lots of other youngsters, went in for physical culture very seriously. However, as I grew older and wiser, I decided it was better to keep the figure I had, for '...be it ever so homely, there's no shape like your own,'" said Rockwell. Shakespeare, being a playwright, makes numerous references to the theater and Rockwell, being a painter, often depicts life trying to live up to art. Other covers, November 4, 1922, February 11, 1939, March 1, 1941, September 16, 1944, March 2, 1946 and March 6, 1954, show characters seeking perfection as Hollywood or Uncle Sam envisions it, the longing after Jupiter Everyman feels. In these covers we see a sort of play within a play where the eye travels back and forth between ideal and aspirant, between the picture and the would-be subject. The amusement we feel is tempered with a subtle longing for that painful but optimistic time when we all believed we could be more manly or more beautiful.

"Listen, Ma!"

The faces of old people intrigued Rockwell as they have always interested painters of the narrative tradition including the Dutch genre painters and some of the Barbizon painters like Jean-Francois Millet. The old have lived longer, have more stories to tell, and the stories are portrayed on the surface, are visible, are obvious, all invaluable traits in the art of illustration. The couple's listening preferences are seen in the newspaper program indicating the time of the opera broadcast. The tortoise-shell comb in the woman's hair suggests in her lifetime she has been more than a listener. One can imagine her as a fiery Carmen or a teasing Manon Lescaut. By 1922 most people had parlor sets so this crystal radio with earphones is a look back. A model remembers Rockwell himself listening to the World Series from a crystal set while he painted.

THE SATURDAY EVENING POST

An Illustrated Weekly
Founded A° D! 1728 by Benj. Franklin

MAY 20, 1922

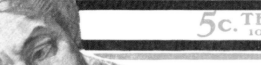

5c. THE COPY
10c. in Canada

Vol. 194, No. 47. Published weekly at Philadelphia. Entered as second-class matter November 18, 1879, at the Post Office at Philadelphia, under the Act of March 3, 1879.

John Taintor Foote—Josephine Daskam Bacon—George Kibbe Turner
C. E. Scoggins—Perceval Gibbon—George Pattullo—Chester S. Lord

"A Patient Friend"

Rockwell has deepened the circle by centering it with a window and imprisoning the main character within while the antagonist beckons from outside the frame. The direct facial confrontation is treated simply and feelingly and there is almost a waste of emotional power in the choice of incident. Usually Rockwell treats his early outdoor scenes as though they were indoors, but here he has painted a branch over the window to hint at the spell summer casts. The twist of the dog's head, the rusticity of the fishing gear, the supplicating paw speak the joys of summer all of which are pitted against the obligation of the boy's book. In later covers, the circle will open up to the romance and adventure of books. Rockwell's philosophy is just large enough to allow for inconsistencies.

THE SATURDAY EVENING POST

Fou...lin

June 10, '22

5c. The Copy
10c. in Canada

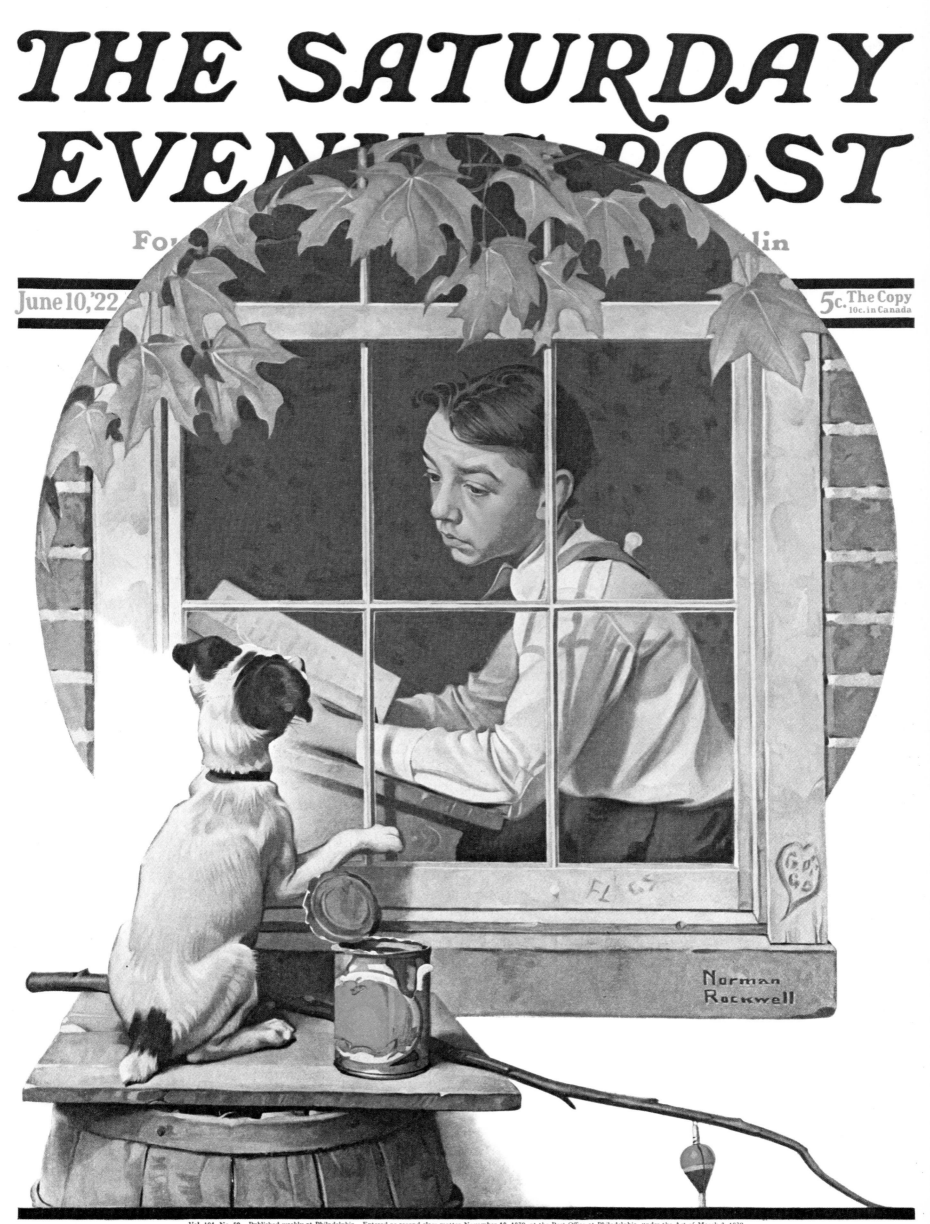

Norman Rockwell

Vol. 194, No. 50. Published weekly at Philadelphia. Entered as second-class matter November 18, 1879, at the Post Office at Philadelphia, under the Act of March 3, 1879.

Beginning **The Reminiscences of a Stock Operator—By Edwin Lefèvre**

"Ship Ahoy"

There is a painting in Rockwell's collection titled "Looking Out to Sea," painted in 1919, showing essentially the same subject as this cover, the old sea captain leaning on his grandson, the bright panoply of sea and sky beckoning child and man. Between these two pictures, one sees the vast differences between cover art and fine art. The painting embraces all outdoors. Sea gulls clatter in the sky, houses fringe the port from which the wind-gorged clipper ship departs. Whitecaps, gull wings, clouds and sails catch the lightness of the air which laughs at the shore-bound people. In the cover, suggestion is all. The circle is a ship's helm. We can only guess at the view at the end of the telescope. The parrot hints at exotic lands. The boy's sailor suit symbolizes the fantasy of desire, the longing to be somewhere else. The illustrator's task is in many ways more difficult than the fine artist's. He has less space, both actual and psychological, in which to build a mood and tell a story. Economy must be his watchword. He must often use character traits in place of characters, and he must face the effects of superimposed type and the quality of reproduction since his audience never sees his creation in the original.

"The Rivals"

Although the characterization and style of painting are not here influenced by Leyendecker as they are, say, in the April 8, 1922 cover—highly stylized painting, flecks of bright colors mixed in with the drabber pigment, subjects sharply outlined—the use of the coat of arms, the over-door pediment and the fence imply that Leyendecker's pervasive influence, so strong on illustrations of the Twenties and Thirties, is making itself felt in Rockwell's pictures too. Leyendecker died in obscurity, though he was the most famous illustrator of his day. Rockwell admired him so much he used to wait in the street before his mansion in New Rochelle just to catch a glimpse of him. He finally summoned the courage to ask Leyendecker to dinner. Just as the turkey was being brought in, it fell onto the floor and rolled under the table. More to escape the humiliation of the scene than to recover the turkey, Rockwell dived under the table. He was joined there by Leyendecker who tasted the stuffing and said, "My cook can never cook turkey. This is wonderful! A real treat." Mrs. Rockwell called them out, and they were fast friends for twenty-five years.

Although these cover characters are less sophisticated (at the same time more real) than Leyendecker's, we are left with the feeling of easy familiarity, the sense of our own childhood as well as the experience of having known these rivals in other tableaux. It is not just that the models have been used before; it is that we see—in their shoes, bow legs, hats, postures and expressions—the habits of their lives. Their pasts flash before our eyes, characters meant for minor dramas, but characters no less endearing for that.

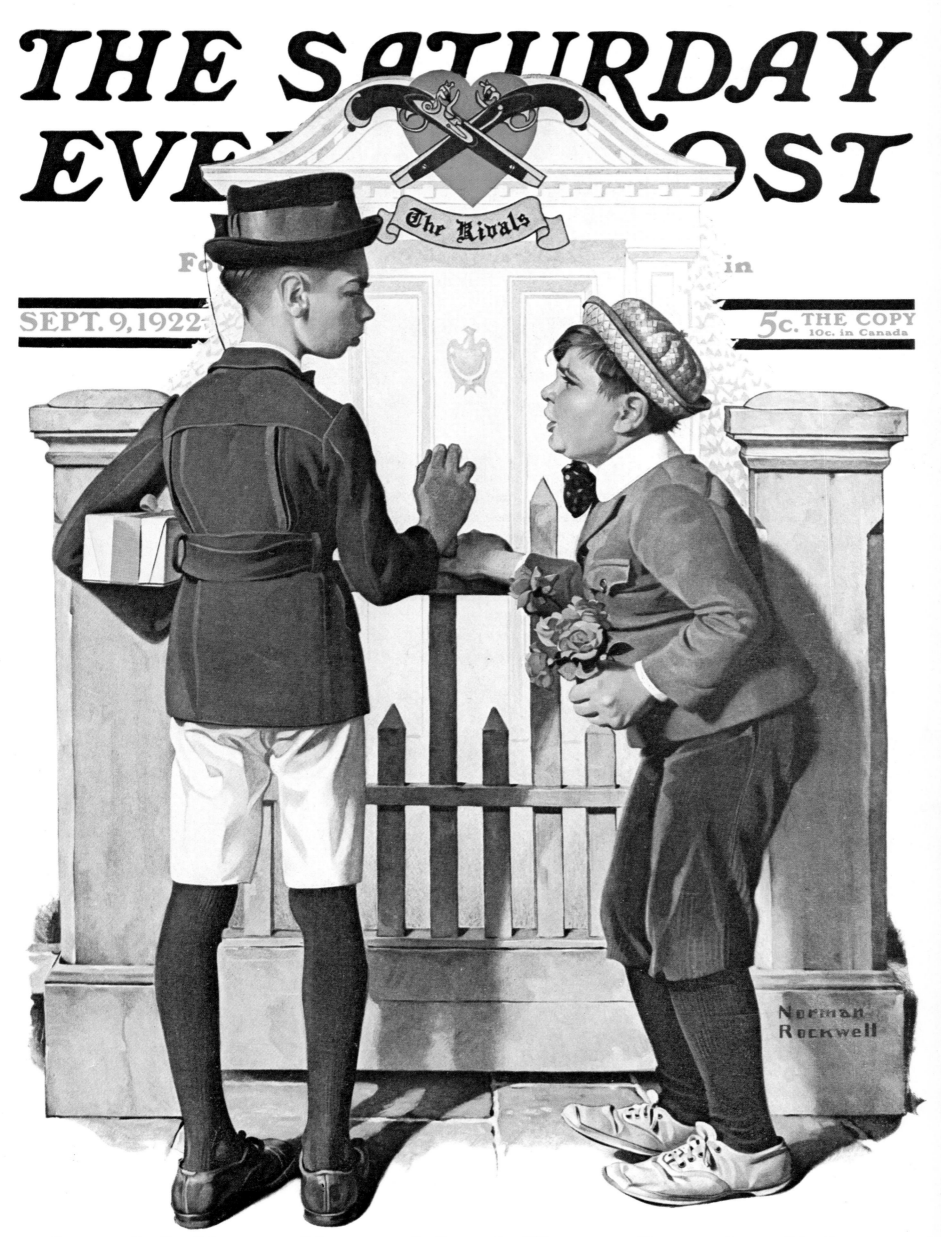

"Daydreams"

Cinderella is a classic story. No one has picked up a broom, or done a menial task without pausing for a moment in hopes of being discovered by a Hollywood talent scout or by the good fairy who rewards diligence in such matters. Movies by now had come into their own, and glamour, both male and female, was a reality to millions of Saturday night moviegoers. Press-agent spiels ran thick with tales of discovery; the funny, quickie flicks of the comic stars were giving way to longer romances in which men were as likely to put guns to their temples for girls as the audience was liable to put popcorn to its lips. The idea of this picture is repeated 30 years later in the March 6, 1954 cover. Dreams and yearnings do not age.

THE SATURDAY EVENING POST

An ... ly
Found ... anklin

NOV. 4, 1922

5c. THE COPY
10c. in Canada

J. P. Marquand—Will Irwin—Thomas Beer—Maximilian Foster
Samuel Hopkins Adams—Hugh MacNair Kahler—Will Payne

"Santa's Helpers"

This is the first of Rockwell's great Christmas covers, the first one in which he is convincingly aware of the magic of the season and its dramatis personae. The elves are real. The number of shopping days before Christmas is to them a rallying cry of panic. They haul, they pull, they paint, they shove. And their patron saint sleeps. They have a sort of wet-hen furiousness about their efforts. They would not be pleasant to children. They would be annoyed by sentiment. It is only their task that motivates them; ends are nothing to them, means everything. They smoke; one may assume they curse and they get the job done. On time. We may forgive their boss for dozing, for he has a long drive ahead, but it is certain his employees will not pardon him.

"Grandpa's Little Ballerina"

Music plays a large part in Rockwell's developing cover themes. December 8, 1923, April 28, 1924, August 30, 1924, May 16, 1925, April 16, 1927 and many other covers show the delights and frustrations of Terpsichore's art. Violinists, buglers, string quartets, accordionists, singers—choristers, barbershop quartets, carolers—and flautists woo, wail and wheedle, sometimes for pleasure, sometimes to gain their objectives. Here the motive is pure charm, the eternal Rockwell theme of youth and age responding to each other, the awakening of the body to the sounds of music. The response of children to music is instinctive; they do not have to be taught to dance. There is a delicacy in the way the child lifts her skirts, a stalwart loveliness in the cellist's hands, the curve of the wrist, the raised little finger. Age and youth speak to each other through the language of music.

THE SATURDAY EVENING POST

strated Weekly

Fou___ ___ 1728 by Benj. Franklin

Volume 195, Number 32

FEB. 3, 1923

5c. THE COPY
10c. in Canada

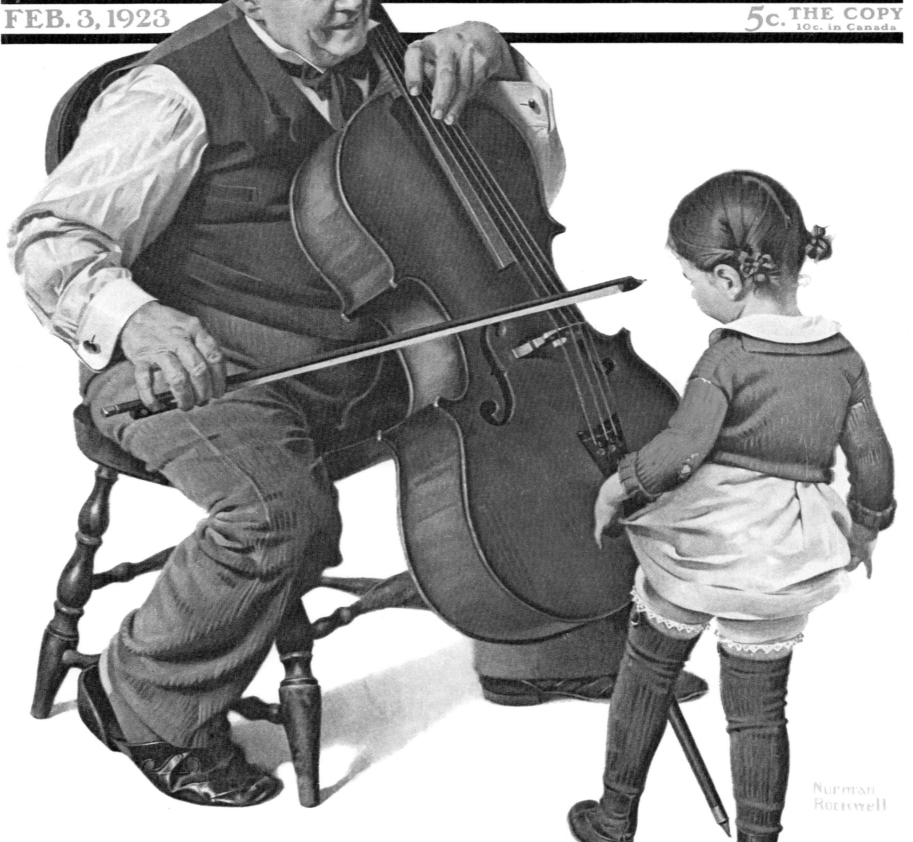

Beginning

Leave it to Psmith—By P. G. Wodehouse

"Puppy Love"

If you want a friend in this world, get a dog," said Harry Truman long after it was general knowledge to Rockwell and a few other *Post* cover artists. "The commonplaces of America are to me the richest subjects in art," Rockwell says. "Boys batting flies on vacant lots; little girls playing jacks on the front steps; old men plodding home at twilight, umbrellas in hand—all of these things arouse feeling in me. Commonplaces never become tiresome. It is we who become tired when we cease to be curious and appreciative. We may fly from our ordinary surroundings to escape commonplace, but we go along. After a moment's excitement with a new scene, it becomes commonplace again. And we find that it is not a new scene which we needed, but a new viewpoint." The new viewpoint is a Rockwell constant. One thinks of Thornton Wilder's *Our Town* in which Emily, dead and gone, cries out to her family to lock happy moments in their hearts against the onslaught of time. It is Emily's vision that Rockwell shares, the precise value of the small events which make up the large event we hope for and which never comes unless we have learned to esteem the little occasions.

THE SATURDAY EVENING POST

An Illustrated Weekly
Founded A°. D¹. 1728 by Benjamin Franklin

MARCH 10, 1923

5c. **THE COPY**
10c. in Canada

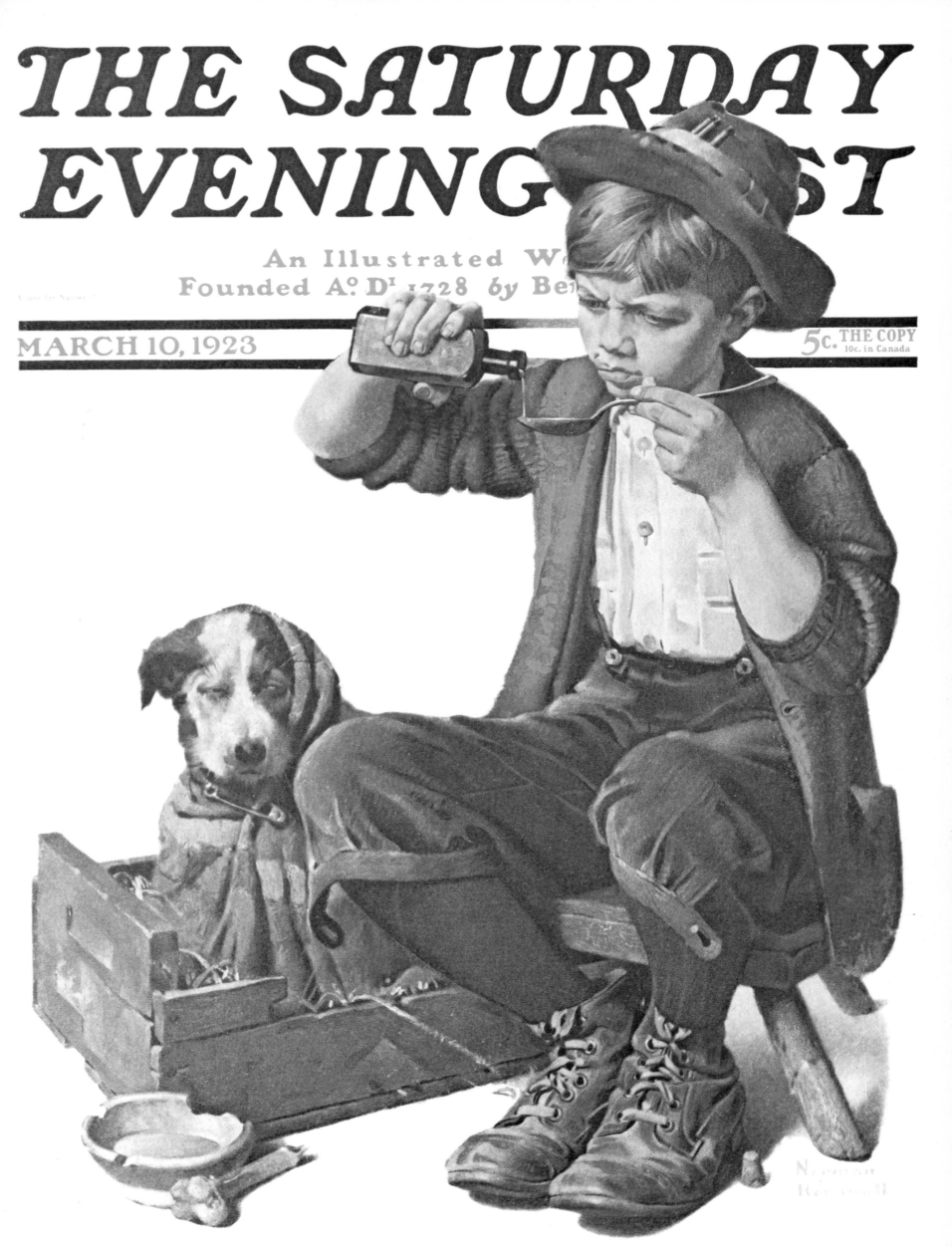

General Pershing—Sir Basil Thomson—Roland Pertwee—Will Payne
Hugh Wiley—Floyd W. Parsons—Richard Connell—Ben Ames Williams

"The Virtuoso"

René Prinet's "Kreutzer Sonata," the famous painting of a violinist sweeping up the pianist in his arms which appeared for many years in Tabu perfume advertisements, has inspired much parody but few sincere imitators. But in this cover Rockwell is indebted to that well-known confrontation and to other pictures of the romantic school. The older musician stirs uneasily in his reverie. He counts, waiting for his own entry into the piece, but at the same time his mind wanders far afield. Lost youth, failed opportunities cast the shadow on his face while the spotlight touches the possibilities of the young violinist.

Rockwell worked as a supernumerary at the Metropolitan Opera House while he was going to the Art Students' League. It is odd with the wealth of experience he gained there, the myriad anecdotes he heard about Caruso, Louise Homer and other golden voices, he made small use of these subjects on *Post* covers. The answer is that the magazine strove for the mass audience, modern instances its readers could identify with, not first nights at the opera or concerts. Rockwell painted no other subjects in full dress after this except waiters.

THE SATURDAY EVENING POST

Volume 195, Number 44

For

APR. 28, '23

5c. THE COPY
10c. in Canada

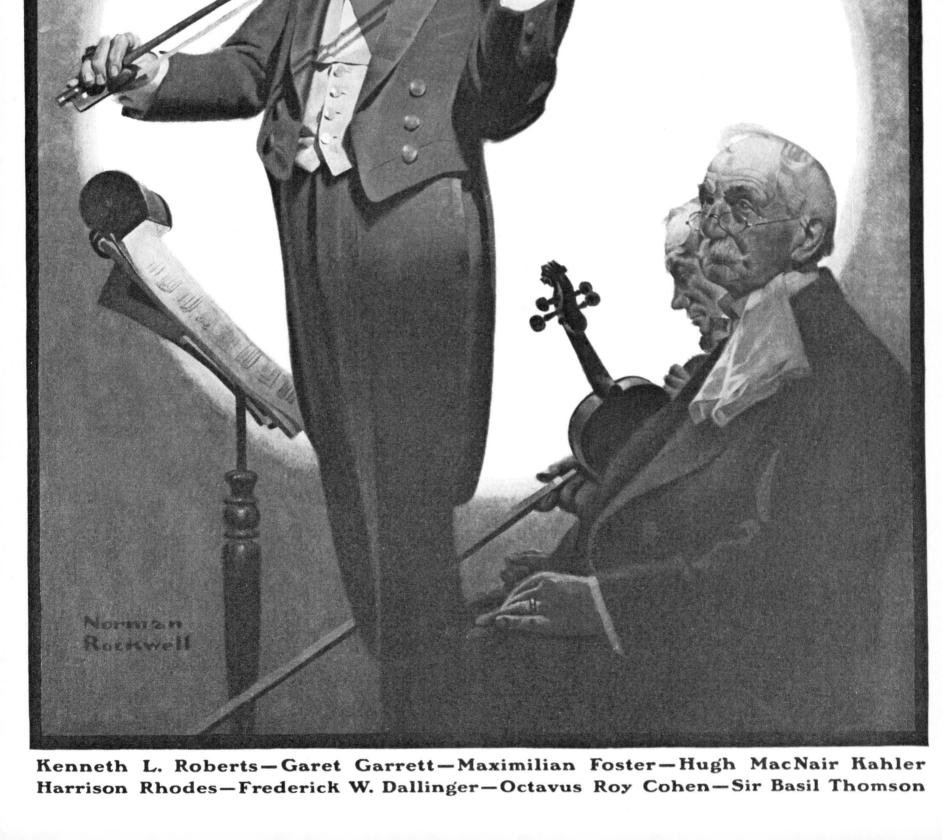

Kenneth L. Roberts—Garet Garrett—Maximilian Foster—Hugh MacNair Kahler
Harrison Rhodes—Frederick W. Dallinger—Octavus Roy Cohen—Sir Basil Thomson

"Between the Acts"

A look behind the scenes at the big top reveals the hours of disciplined practice that result in a show which delights the circus-goers in the ring. The pup learns his lesson under the stern eye of the older dog who manages a degree of dignity despite the absurdity of the costume. As the famous cover circle was a spotlight in the previous Rockwell cover, hoops stretched with paper for dogs to jump through define it here. Rockwell painted larger canvases of circus scenes and, again, it is interesting to note the differences between cover impressions and pictures in which space and time give him a chance to develop a theme and to elaborate on his story, very much in the way a paragraph might be compared with a novel. One painting he did about this time appeared on a *Life* cover. It shows a clown wiping away the tears of a runaway boy. Tenderness gradually restores the boy's faith in the proper course of school, parents and older brothers who may have been the cause of his leaving.

Other circus pictures appeared in a 1935 story Rockwell illustrated for author Don Marquis. Deep reds, eloquent gestures and a translucent tent canvas background illuminate and deepen the drama of the scene. The circus supplied Rockwell with the sense of fantasy and depth of character he liked.

THE SATURDAY EVENING POST

An Ill____ ___ We___y
Founded A°. ____ __ __ __anklin

Volume 195, Number 48

MAY 26, 1923

5c. THE COPY
10c. in Canada

Norman Rockwell

Thomas Beer—Medill McCormick—George Randolph Chester—Hugh MacNair Kahler
larence B. Kelland—Henry H. Curran—Edwin Lefèvre—George Agnew Chamberlain

"Summer Vacation"

Years later, considering the difficulties in posing a model on his head, Rockwell recalled he had used a trick for this cover. "I had the boy sit in a chair, extend his legs and hold his hands over his head. Then I put a light on the floor and painted the boy. When the finished picture was turned upside down, there he was somersaulting." Despite the trick, it is a bold and vibrant composition. It is as though he is reaching out into the corners of the allotted cover space with his figure, daring to be light and gay, tongue in cheek. Again there is the influence of Leyendecker who liked inscribing legends as part of his design for *Post* covers. Rockwell balances the boy with the circle. Somersaulting, a spontaneous expression, is used here—spontaneously —to express relief from the nine-month gestation period of school that finally produces summer in young people's lives.

THE SATURDAY EVENING POST

Volume 195, Number 52

Four kli

JUNE 23, 1923

5c. The Copy
10c. in Canada

George Pattullo—Hugh MacNair Kahler
Sir Philip Gibbs—Will Payne—Sir Basil Thomson
Clarence B. Kelland—Ellis Parker Butler—Norval Richardson

"Harvest Time"

Rockwell painted a number of covers for *The Country Gentleman,* another Curtis publication. The magazine was dedicated to rural life and the assignments fulfilled a longing in Rockwell for the pure joys of a sylvan existence. He also learned much pastoral lore and created a number of famous characters—notably Cousin Reggie and his country kin. The contrast here between the rough-hewn hands of the farmer and the delicacy of the fledgling is gently portrayed. The scythe handle and the spray of wheat complete the bucolic impression while the hovering mother bird informs us of the happy outcome. The artist's mastery at changing the character of his models is evinced by his handling of the farmer; it is the same man who was snoopily reading other people's mail in the February 16, 1922 cover.

THE SATURDAY EVENING POST

Volume 196, Number 7

Fou__ __trated Weekly
__ by Benj. Franklin

5c. THE COPY
10c. in Canada

AUGUST 18, 1923

"The Ocean Voyage"

Pop Fredericks was a favorite model. An unsuccessful actor who had had a part in *Abie's Irish Rose* but was replaced by a more famous name when the play caught on, Pop felt he had been cheated by fame, and that all the great actors of his time were jealous of him so they kept him off the stage. Fredericks and another actor Rockwell occasionally used had a contest as to who could pose the longer. The first actor casually announced he had posed eight hours straight without a rest for Joseph Leyendecker. Pop said eight hours was a trifle, and informed Rockwell he would surpass the feat the following day. He sat down in a deck chair with a clock (he was posing as this sea sick voyager), and sat still for eight and one-half hours. Rockwell brought him his lunch on a tray and handed him a bedpan several times. Fredericks' opponent hinted he had dozed off during the posing session —a sign of unprofessional conduct in the model's code—and vowed he would do ten hours, but he couldn't find an artist to cooperate.

THE SATURDAY EVENING POST

An Ill—— —ly
Founded A° 1—— Franklin

Volume 196, Number 10

SEPT. 8, 1923

5c. THE COPY
10c. in Canada

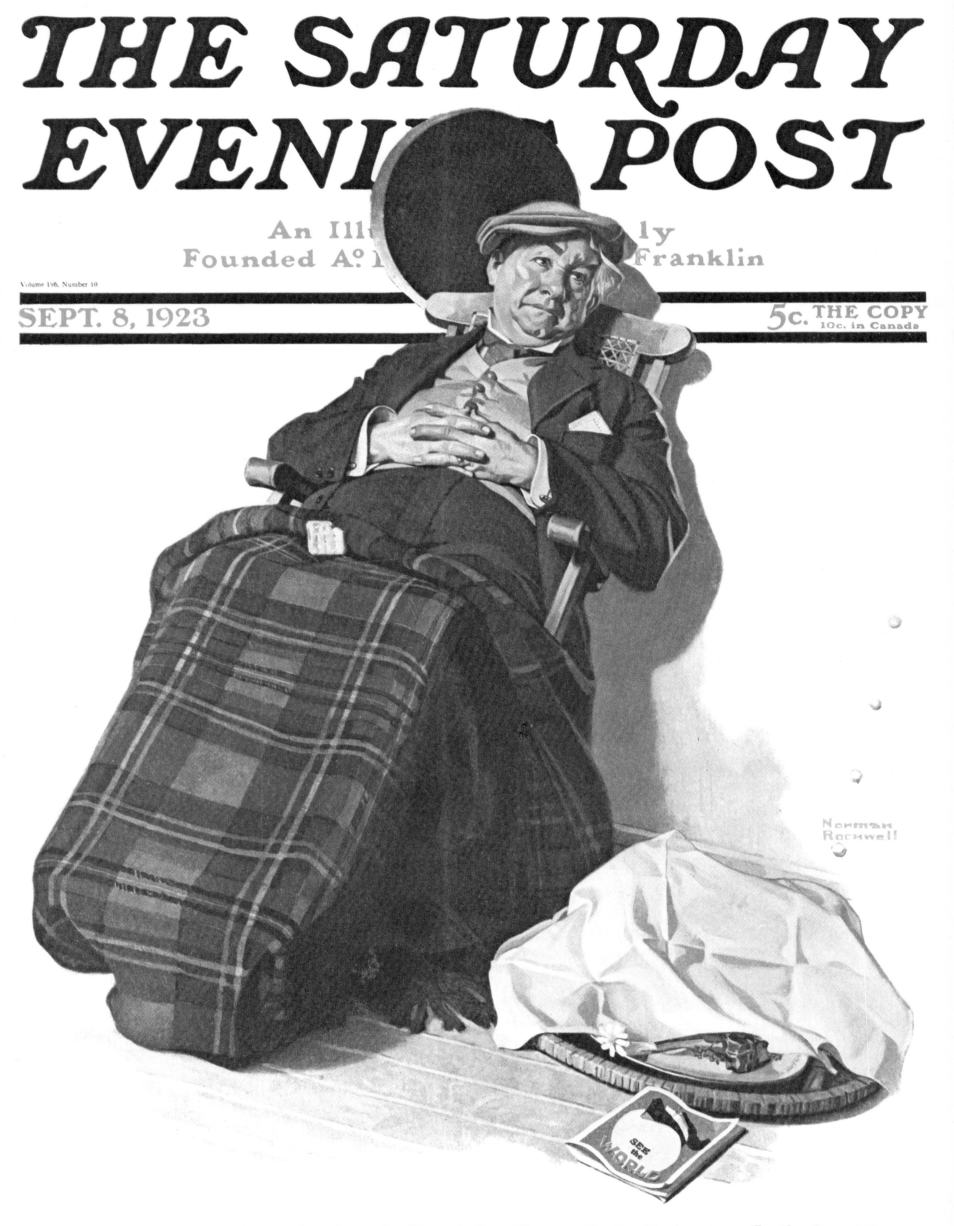

Norman Rockwell

"Lands of Enchantment"

In a sense we were mourners, for the golden age of illustration was dying," Rockwell wrote about the period when Edwin Austin Abbey, Frederic Remington and Howard Pyle were disappearing from the scene and the day of "illustrated classics"— beautiful editions of Dante, Shakespeare and Walter Scott were no longer the staple of every library shelf. These men, according to Rockwell, had a sense of mission and sincerity. They researched details with attention but treated subjects with such finesse that readers were scarcely aware of the accuracy of the Spanish galleons and romantic castles. Rockwell pays these illustrators tribute with the precision of his castle, the trappings of the horse. But the Walter Mitty rider is the sign of the new illustration which the mass magazines demanded. Popular appeal. Humor. Reader identification.

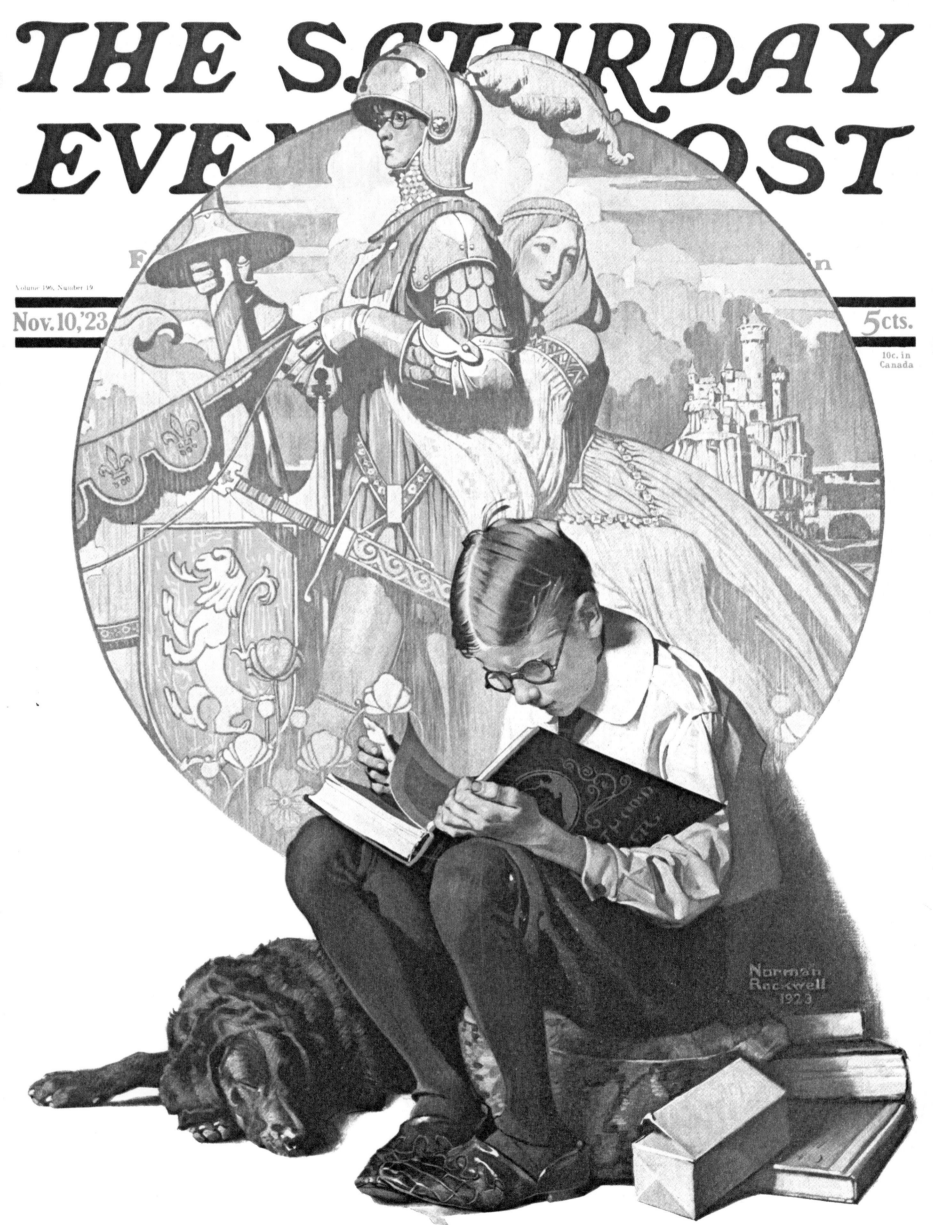

THE SATURDAY EVENING POST

Volume 196, Number 19

Nov. 10, '23

5 cts.

10c. in Canada

Norman Rockwell 1923

Alice Duer Miller—Samuel G. Blythe—John A. Moroso—Charles Brackett
Kenneth L. Roberts—Elsie Singmaster—Isaac F. Marcosson—Hal G. Evarts

"The Christmas Trio"

"**P**osing for this cover was the nearest these carolers ever came to musical performance!" said Rockwell about the three models. Pop Fredericks plays the shawm; Dave Campion of Interwoven Sock memory fiddles. There is a strong element of Renaissance art in the straining and projection of the heads which recalls Piero della Francesca and other fifteenth-century fresco artists who adorned the chapels and palaces of Italy. But the characters are pure Dickens as the circle is pure England. The soft tones of the half-timbered buildings in the circle are similar to the castle and background in Rockwell's preceding cover. He often worked so fast and furiously to meet the demands and deadlines of the magazine that he repeated surfaces and tones in succeeding issues. No one complained.

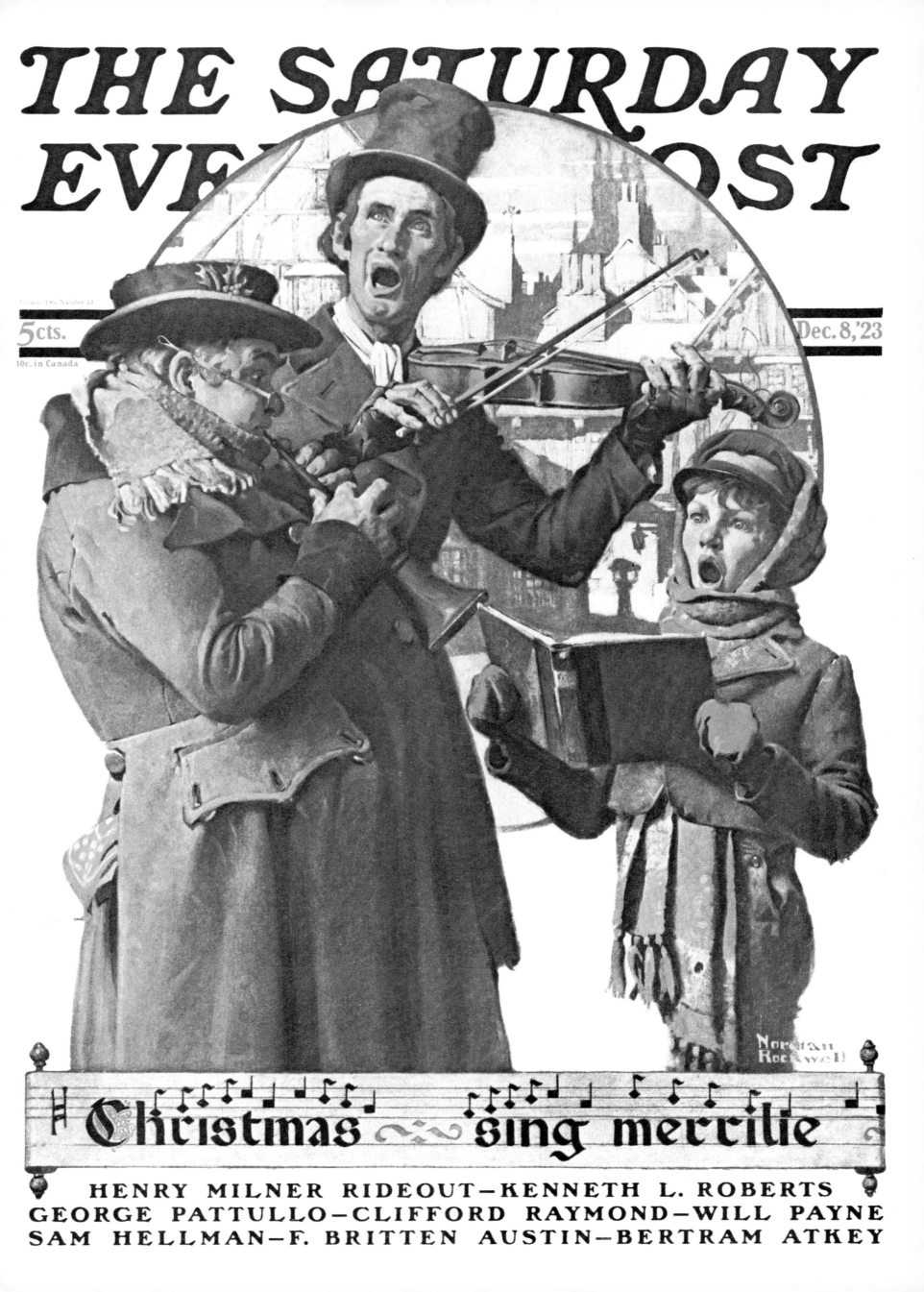

"Needlepoint"

Costume pieces were standard fare for *Post* covers. In the days before mass media, news and fiction were not widely separated. The young woman in period dress and her occupation—also authentic—was as much news as the photo journalism that was to replace her with so-called relevant themes in the 1940's. World War II, still two decades off, created the modern environment, made many machines into antiques, an idea inconceivable to the pre-war world. Historical tales abounded within the pages of the *Post* and other popular magazines. The photograph was still in its infancy as far as being reproducible in mass circulation magazines, and lead times were so long currency had to take a backseat to what editors conceived was the staple of the readers' diet: art and literature.

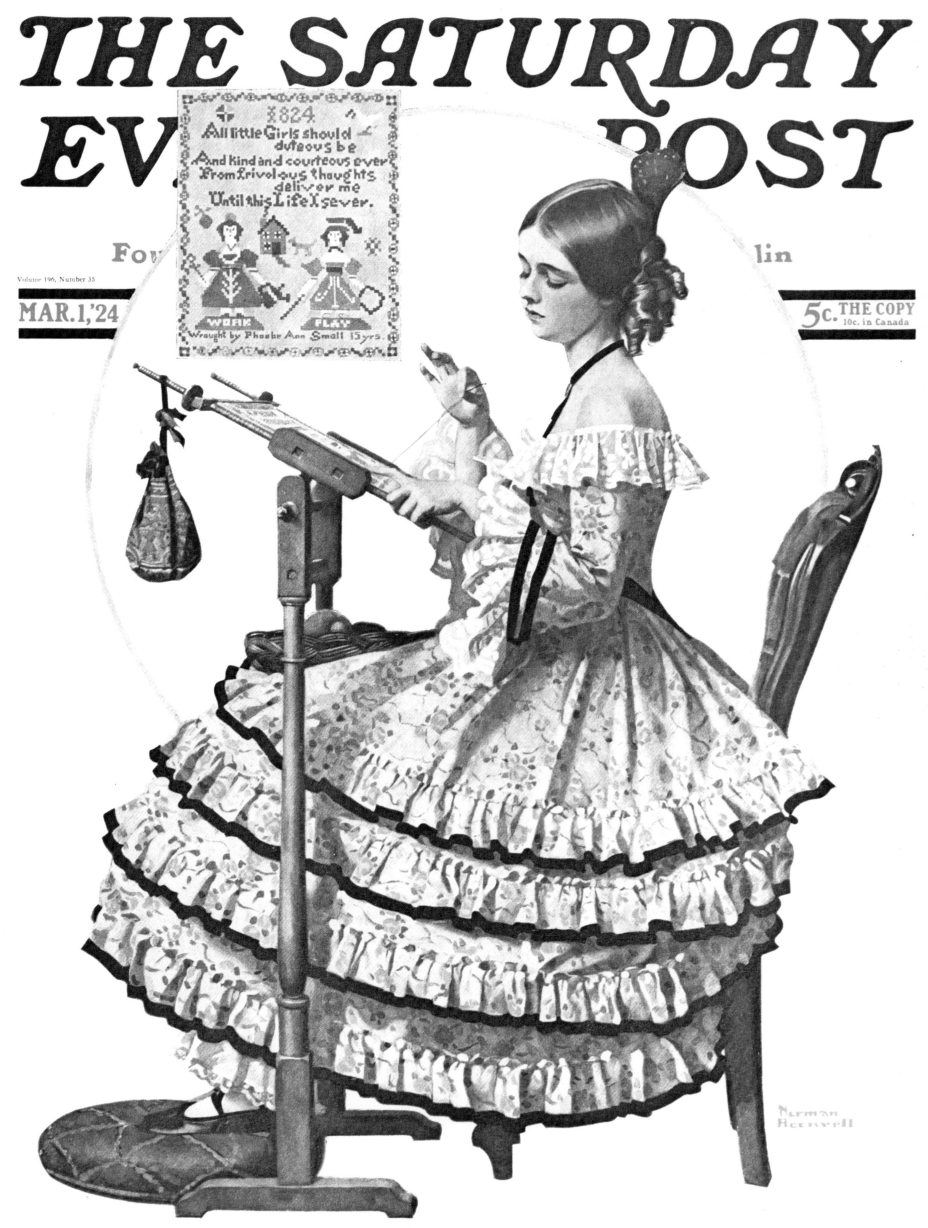

THE SATURDAY EVENING POST

Volume 196, Number 35

Fou̶lin

MAR. 1, '24

5c. THE COPY
10c. in Canada

1824

All little Girls should
duteous be
And kind and courteous ever
From frivolous thoughts
deliver me
Until this Life I sever.

WORK PLAY

Wrought by Phoebe Ann Small 15 yrs.

George Agnew Chamberlain — Michael J. Phillips — Austin Parker — Elsie Singmaster
Major Hugh B. C. Pollard — Felix Isman — Norval Richardson — Kenneth Coolbaugh

"Cupid's Visit"

Every New Year Leyendecker painted a cherub engaged in constructing a prophecy of what might happen in the coming year. The cherub's flesh was as smooth as a balloon's skin, and the confidence of his expression was irresistible to a country built on faith and hope. Other illustrators tried to create their own little bundles of joy which, in other magazines, might result in bundles of bank notes, but no one succeeded quite as well as Leyendecker. Rockwell here has a go at handling the ethereal. Spring buds lap around the young man's legs and he is receptive to Cupid's message. But if Leyendecker could handle predictions, nobody could handle dreams and fancies like Rockwell. The concept is believable; the dazed expression appropriate.

THE SATURDAY EVENING POST

Volume 196, Number 40

Fou... ...lin

APR. 5, 1924

5c. THE COPY
10c. in Canada

F. Britten Austin—George Weston—Sewell Ford—F. Scott Fitzgerald
Richard Matthews Hallet—Sam Hellman—Felix Isman—Hugh Wiley

"The Thoughtful Shopper"

More and more Rockwell was deserting the comic situation and delving into human emotions: dreams, reminiscences, delight in the business of being young and alive. In this staple of the cartoonist's art, a man, for the purposes of appraisal, has been decked out in a woman's clothes. Shakespeare delighted in the idea; Dagwood Bumstead must have done it a thousand times. It never palls as a source of amusement. Although it usually occurs between husband and dress-making wife, or at least between people linked romantically, here it is the funnier because we witness just how much humiliation a man will endure to make a sale. Money, in a sense, is pitted against human dignity. One hat is left in the clerk's hand, which means he may go one chapeau more, but the plaid beribboned straw in the customer's lap may be the straw that breaks the camel's back.

THE SATURDAY EVENING POST

...trated Weekly
Fou... ...728 by Benj. Franklin

Volume 196, Number 44

MAY 3, 1924 5c. THE COPY

Beginning **POCONO SHOT**—By John Taintor Foote

"Escape To Adventure"

The clerk at his stand-up stool desk survives mainly in Dickens, but in the early years of the century he still existed in hundreds of small business firms. Here he dreams of adventure in far-off lands as does the ticket salesman in the April 24, 1937 cover. But in the 1937 cover we see none of the dream. The eyes have to carry us away to what he is thinking. It is the more effective because the viewer has to imagine, too.

Part of the 1924 story lies in the cover which follows, "Thoughts of Home," in which a pirate dreams of a snug cottage in the Cotswolds. Adventure seemed a great deal more real to Rockwell's readers before the Americanization of the world brought about by the G.I. occupations following World War II. Travel was still a prerogative of the rich, one that Rockwell's expanding income and fame made available to him, and the harbors of the Orient could be seen, or imagined, full of sailing ships. The pirate in the following cover is a complete anachronism though it is easy to see the detail and costume are authentic.

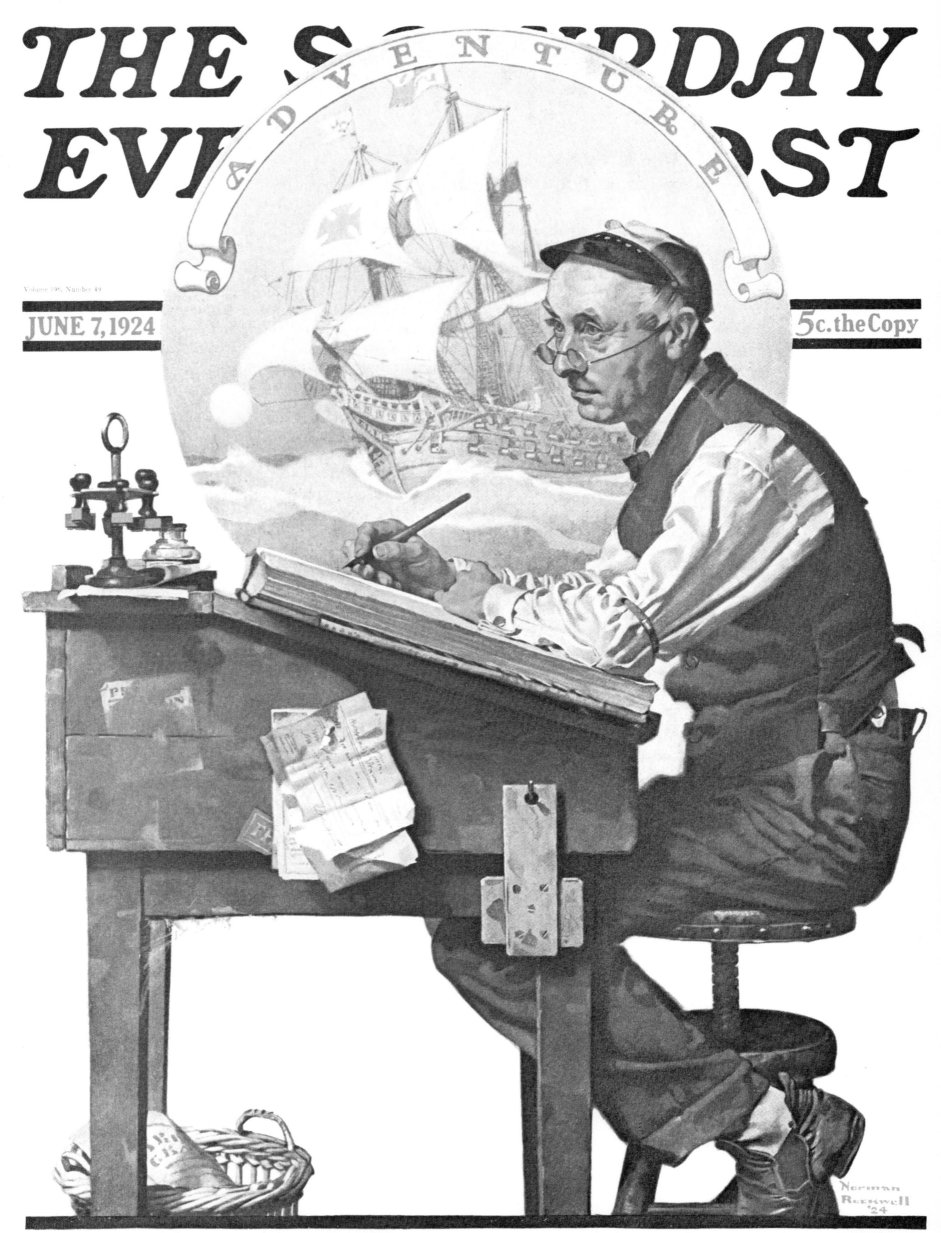

THE SATURDAY EVENING POST

ADVENTURE

Volume 196, Number 49

JUNE 7, 1924

5c. the Copy

Norman Rockwell '24

Arthur Train—Ben Ames Williams—Josephine Daskam Bacon—Hugh Wiley
Kenneth L. Roberts—Octavus Roy Cohen—Austin Parker—Victor Shawe

"Thoughts Of Home"

Suffering, not one of Rockwell's fortes, is lightened by the getup of the pirate, the wooden leg, the generally run-down air of swashbuckling. As Rockwell associates Christmas with England he often suggests home is in the same place. His family was English, and his mother claimed descent from a certain Sir Norman Percere, his own middle name, which Rockwell made fun of in a 1920's *Country Gentleman* cover. Dissatisfaction is a deeply human trait. Rockwell manages to soften its edge with irony in the juxtaposed covers, but the expression in the characters' faces leads us to think they are not mere complainers. Each has learned the reality of his life, and has considered the reality of the dream too. What would life hold for the thin, bespectacled, scholarly clerk under the rough demands of the sea? What sort of farmer and homebody would the surly pirate make? The curl of his lip answers the question as do the weak chin and soft eyes of the clerk.

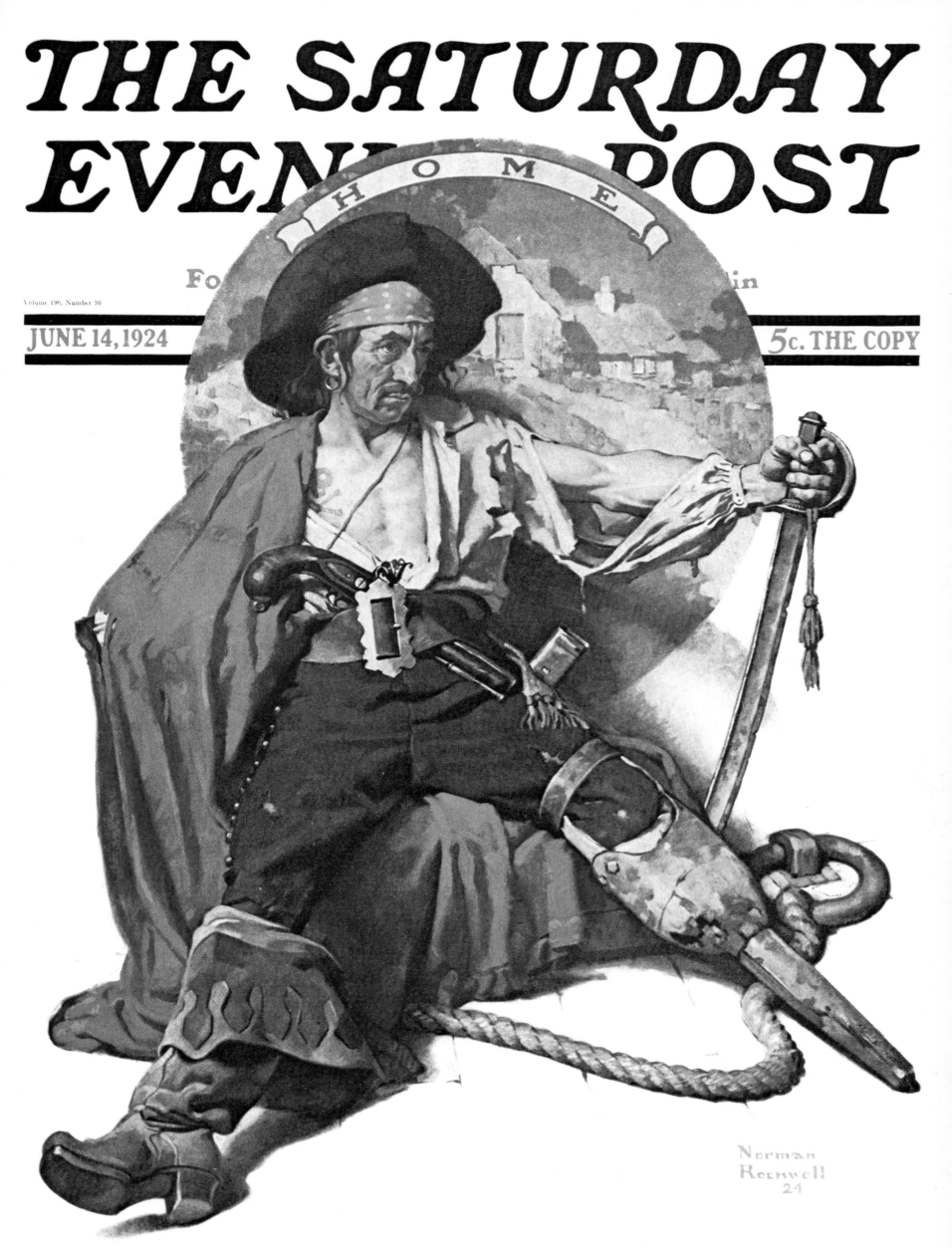

THE SATURDAY EVENING POST

Volume 196, Number 50

JUNE 14, 1924

HOME

For ... in

5c. THE COPY

Norman Rockwell 24

Bertram Atkey — Ben Ames Williams — Mary Roberts Rinehart — George Pattullo
Robert S. Winsmore — Marjory Stoneman Douglas — Roland Pertwee — R. G. Kirk

"Speeding Along"

The speedometer says 1904, but the real time is 15 mph. The costumes, the fright in the woman, the confidence in the man and the nonchalance of the bell are painted slightly tongue in cheek. The structure of the horse-drawn vehicle is still the model for the motorcar, and the seat resembles the spring board in a buggy. But there is no mistaking the klaxon, the acetylene lamp or the hand brake as signs of the time. Rockwell had purchased a Wills St. Clair Grey Goose and delighted in speeding about the streets and country roads in search of models and ideas and bits of costume and props. He admits coming up with ideas was perhaps as hard as finishing the picture. Although the covers had only a seven-day life and mistakes could soon be forgotten, the life of the magazine could not be ignored. The cover sold the magazine; not just the issue on which it appeared but in the months and years to come. Trivia had to be treated seriously.

THE SATURDAY EVENING POST

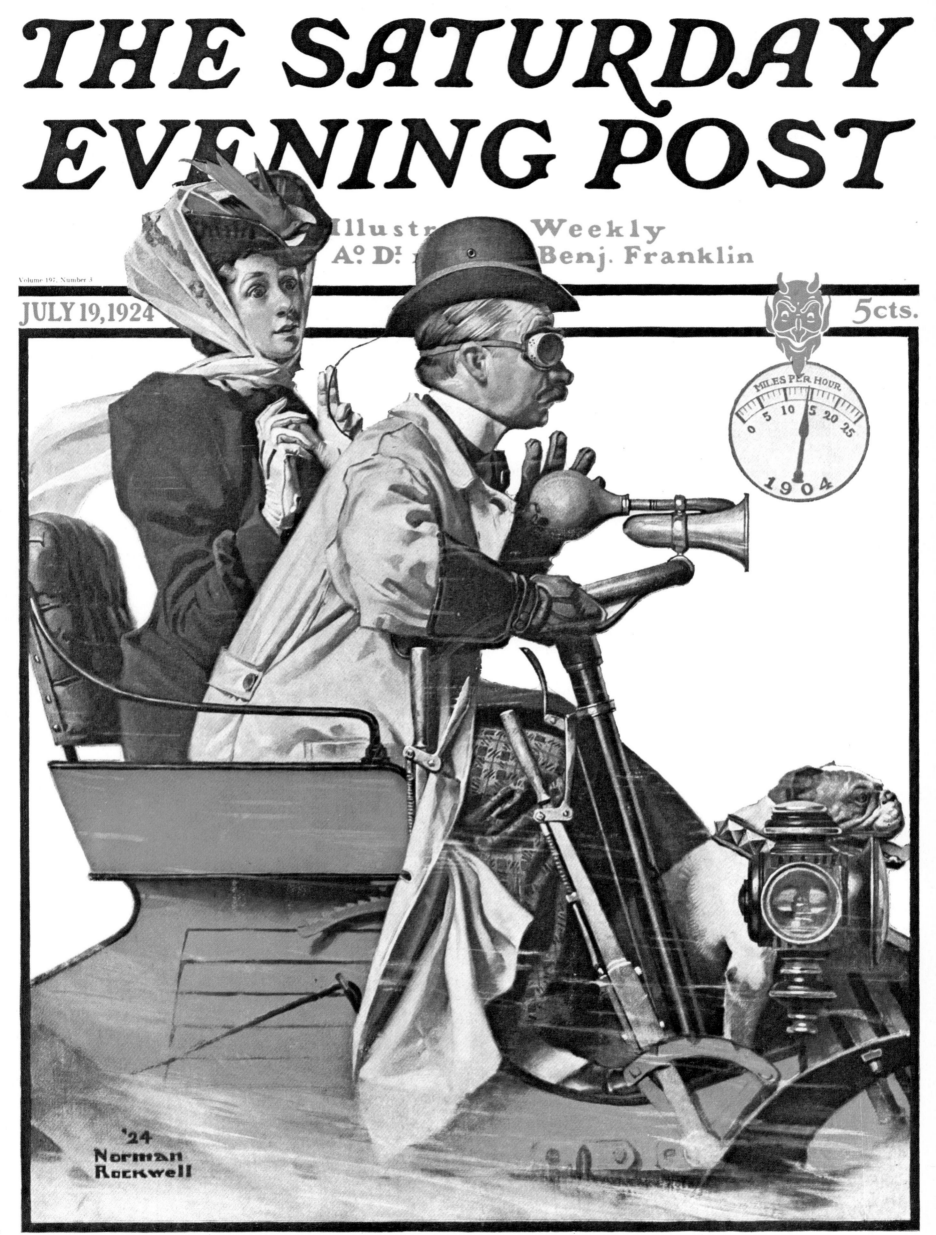

Volume 197, Number 3

JULY 19, 1924

Illustrated Weekly

A° D? ... Benj. Franklin

5 cts.

MILES PER HOUR.
0 5 10 15 20 25
1904

'24 Norman Rockwell

Ben Ames Williams—Harry Leon Wilson—James Hopper—Elizabeth Frazer
Garet Garrett—Ellis Parker Butler—Dana Burnet—Frederic F. Van de Water

"Serenade"

If a compass point were marked somewhere near the girl's shoe, the bellows of the concertina would be seen as the side of another circle, a circle which expands and centers the respectable action of the couple's knees. He leans in; she retains the strict posture of her puritan forebears. The boy's hat suggests another circle and creates with the old-fashioned lamp a well-detailed still life, a feature which more and more would make its way into Rockwell's compositions for the magazine. Before, it was enough to suggest. Now he discovers the value of objects as storytelling devices. This is to reach its apex in the famous "Saying Grace" in which, without romanticizing everyday objects, yet by representing them in pure, almost surrealistic accuracy, he causes them to take on a spiritual connotation. But Rockwell, like other classic humorists, can make light of his abilities, and proceeded to do so in his April Fool covers in which the art of still life is tortured and turned upside down. "The illustrator is subject to furious criticism if his paintings of objects vary from the actual," Rockwell once noted, "unlike the fine artist who may interpret things as he pleases." Once Rockwell painted a picture of an obscure and by then obsolete type of steamboat and made a small error in painting the joints of the walking beam. Few people alive could ever have seen a boat like it, but he received fifty letters commenting on the mistake.

"Pals"

Rockwell built himself a studio in New Rochelle behind his new house at 24 Lord Kitchener Road. It was all early-American, modeled partly after the Wayside Inn at Sudbury, Massachusetts. *Good Housekeeping* rhapsodized it was the perfect setting for a great American artist. Rockwell and his architect spent the night in the Wayside Inn to gain authenticity. Rockwell slept in a bed where Paul Revere supposedly had slept. The next morning he remarked to the desk clerk he could see why Paul Revere rode at night so much.

Nothing was omitted and much committed to make the studio authentic. A fireplace was built with imitation bread ovens and a crane from which dangled an iron kettle to create the kind of atmosphere that would have delighted Ben Franklin, Henry W. Longfellow and any mortgage loan officer, for the whole affair topped the scales at 23,000 pre-inflation dollars.

Rockwell's style, however, was unaffected by his new environment. Dogs, hoboes, boys, clerks, Christmases were the mainstays of the nostalgic covers the *Post* readers demanded. Hoboes were to be Rockwell's subjects in this and his following cover. He delighted in them, and, within the limits of his $45,000 a year salary, tried to imitate their lives, bumming around with friends in Europe in a rented Rolls-Royce, and gorging himself in smart restaurants in London and Paris.

THE SATURDAY EVENING POST

SEPT. 27, 1924

5c. the Copy

Former Speaker Joseph G. Cannon—Lucy Stone Terrill—Courtney Ryley Cooper
P. G. Wodehouse—Octavus Roy Cohen—Will Payne—Stephen Morehouse Avery

"The Hobo"

The model for this hobo was James K. Van Brunt. "The day he turned up at my studio," Rockwell said, "was one of the luckiest days of my life. 'James K. Van Brunt, sir,' he said saluting me and bowing all at once. 'Five feet two inches tall, sir. The exact height of Napoleon Bonaparte.'" He was a veteran of Antietam, Fredericksburg, and the Wilderness, had battled the Indians under Crazy Horse and Sitting Bull, and had fought the Spaniards in Cuba. His most outstanding (or far-reaching) feature was his mustache. "Eight full inches wide from tip to tip," he told Rockwell. "The ladies, Sir, make much of it." "What a face!" Rockwell thought at the time. "That knobby nose, thick and square at the end with a bump in the middle; those big, sad, dog eyes which, however, burned with a fierce, warlike sparkle; that mustache. And all crammed together in a small, narrow head so that if you glanced at him quickly that was all you saw—eyes, nose and mustache." Rockwell worked out the sketch for this cover that night. After that, Van Brunt was such a regular that the *Post* editors complained Rockwell was overdoing it.

"Grand Reception"

In the 1920's politicians were taken much less seriously than they are today. A man was elected president because he looked like a president, which meant he photographed well cutting ceremonial ribbons. Politicians wore top hats and smoked cigars and did little else. Aplomb and pompousness were their stock in trade, and no matter how small the turnout, the same-length speech was delivered and the head was held as high as it might have been for an audience of screaming millions. Small towns gave them plenty of occasion. Every conceivable national day was commemorated. Death in vain was unknown. Memorial holidays abounded. Young girls in white dresses laid rosy wreaths before marble monuments, and the moths never got a chance to nibble uniforms, so serviceable were they for the remembrance of things past.

THE SATURDAY EVENING POST

An Illustrated

d A°. D¹. 1728 ... nklin

Volume 197, Number 19

5c.

NOV. 8, 1924

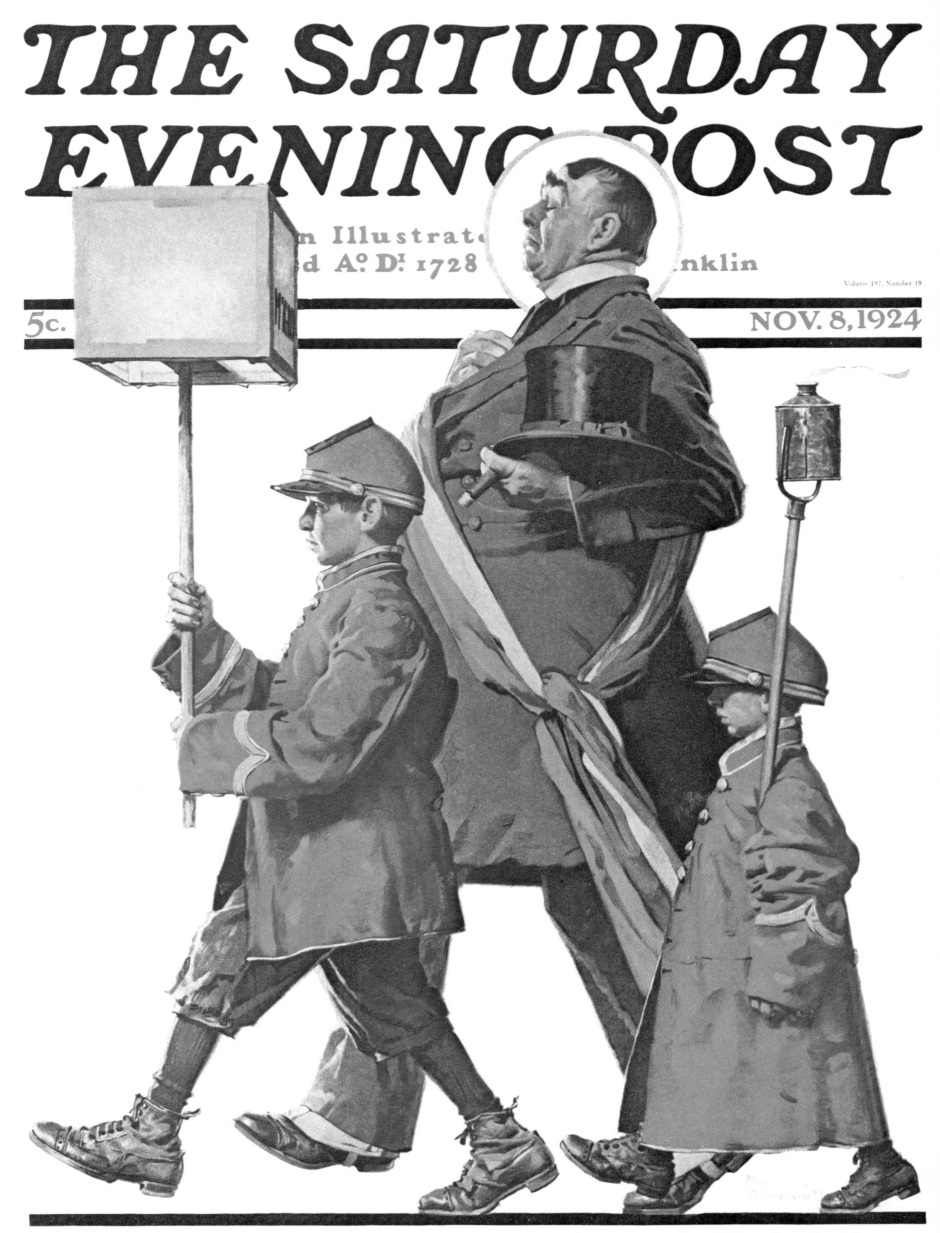

"Santa's Good Boys"

Rockwell's belief in the great be-
lief of magic is presented in concrete style. It is, after all, no less a mira-
cle that the boy is chopping and hauling firewood than that Santa really
exists. We have met the boy before, and he was not chopping wood, yet
sincerity marks his action here. He is not just performing for the Christ-
mas myth, he is building the work ethic, an ethic Rockwell believes in
and has practiced with furious diligence his whole life.

Other *Post* artists had done Christmas covers, including Leyen-
decker. The Christmas covers would run from the first week in December
through the day itself—and sometimes, as in Rockwell's January 8, 1927
cover, beyond—and a similar idea by Leyendecker shows a boy (again
one of the little devils we have met on other covers) who has suddenly
sprouted wings against a calendar with December 25th circled in red.
The wings are plausible, but there is no real awareness of the world of
make-believe in the Leyendecker piece. Rockwell once said that to Leyen-
decker every cover was a technical problem, an exploration of technique.
Rockwell has gone beyond, has entered into the mind and spirit of chil-
dren. His scale—the tininess of the boy, the magnitude of Santa Claus—
stresses the relation a child has between size and value.

THE SATURDAY EVENING POST

An Ill— Weekly
Founded A— Benj. Franklin

Volume 197, Number 23

DEC. 6, 1924

5 cts. THE COPY

GOOD BOYS

CHRISTMAS

Norman Rockwell

"Crossword Puzzles"

The model for the storekeeper was J. L. Malone. He posed for the May 3, 1924 cover of the girl choosing a hat. Rockwell liked his calm voice and liked to have him read aloud while he was painting. Sometimes he would read as long as eight hours. Other models and his wife, too, read to him, usually from Dickens, Tolstoy or other classic novels. The other model here is the ubiquitous Van Brunt. Crossword puzzles were fairly intellectual games—something the *Post* would ordinarily have scorned as too narrow for its readers, but the subject is treated with a sort of universal easiness. The old stove, the country store atmosphere, the dog and the unfilled market basket make it Everyman's territory again. "The *Post* logically looks for covers which will interest a fair cross section of this vast audience of families of every means and position," Rockwell said in 1946. *Life* and *Judge* portrayed chess players on their covers but the *Post* in these years seldom went beyond checkers.

THE SATURDAY EVENING POST

Founded A. D. 1728 by Benj. Franklin

An Illustrated Weekly

Volume 197, Number 31

JAN. 31, '25

5c. THE COPY

Mary Roberts Rinehart
Stewart Edward White — Richard Washburn Child — Richard Matthews Hallet
May Wilson Preston — Octavus Roy Cohen — Nina Wilcox Putnam — Kenneth L. Roberts

"The Self Portrait"

Every bureau or secretary in every parlor in the country had a picture of a grandfather posing in his Prince Albert coat, boiled collar effectively cutting off circulation, silk hat, usually a prop from the photographer's studio, laid nonchalantly by. Rockwell has this to say about picturesque clothing. "You can't age clothes artificially. Unless they have been faded by wear, sweat, dirt and sunlight, they don't look natural when you paint them." The last thing grandfathers wanted to do in the 1890's, though, was look natural. In 1943, Rockwell's collection of costumes was destroyed when his studio burned. People who had read the news sent him bits and pieces of what they thought were colorful clothes. Packages arrived from all over the country. Soon, he remarked, he had enough clothes to outfit the entire town.

The expression on the boy's face, serious eyes, but also twisted a bit as if he smells something bad, may have been called up by the army of the coat's previous owners. When Rockwell was working at the old Metropolitan Opera House as an extra, the older students who got him the job advised him to bring a suit of long underwear. He wondered why, since it was July, but found out when he saw how battle-weary the costumes were.

THE SATURDAY EVENING POST

Volume 197, Number 42

APR. 18, 1925

Fou

5 cts.

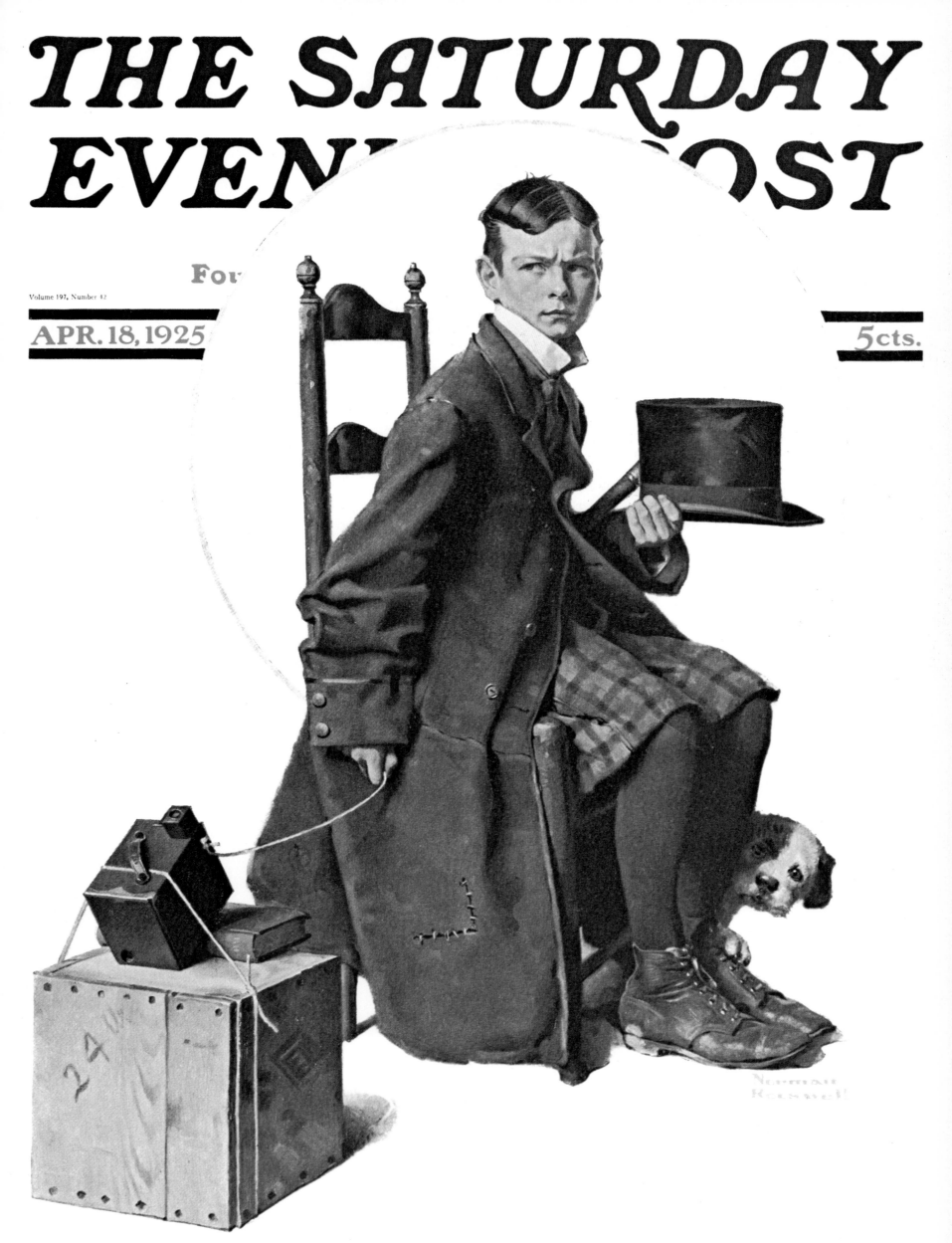

"The Flutist's March"

Rockwell often found he needed one more look at his subject before sending off a cover, so he chased the model down to his lair. Many were unemployed actors, men who lived out their soliloquies in garrets surrounded by bits and pieces of Shakespeare and vaudeville and failure. It is perhaps as close as Rockwell ever comes to regret, these old Thespians with their lost lives. When the doors were opened on their rooms he found worlds paralyzed under glass bells. Once he visited Van Brunt. "You see," said the model, "I have everything here right before me. And when I want, I can recall anything I like and think about it and remember what a good time we had, Annabella [his wife] and I. Or the excitement of a scout in 1862 or a skirmish on the prairie with Crazy Horse. Everything. It's all here." Sometimes Rockwell discovered them remembering, sometimes acting, sometimes, as here, playing or listening to music. Variations of this cover appear later in Rockwell's work, notably the chamber music concert in the rear of Shuffleton's barber shop, April 29, 1950. The plantation desk, the old swivel chair, the lamp, the galoshes, umbrella and hat give us the man as well as the scene. It is a careful character, a man used to saving stitches by precautionary action.

THE SATURDAY EVENING POST

Volume 197, Number 46

MAY 16, '25

5c. the Copy

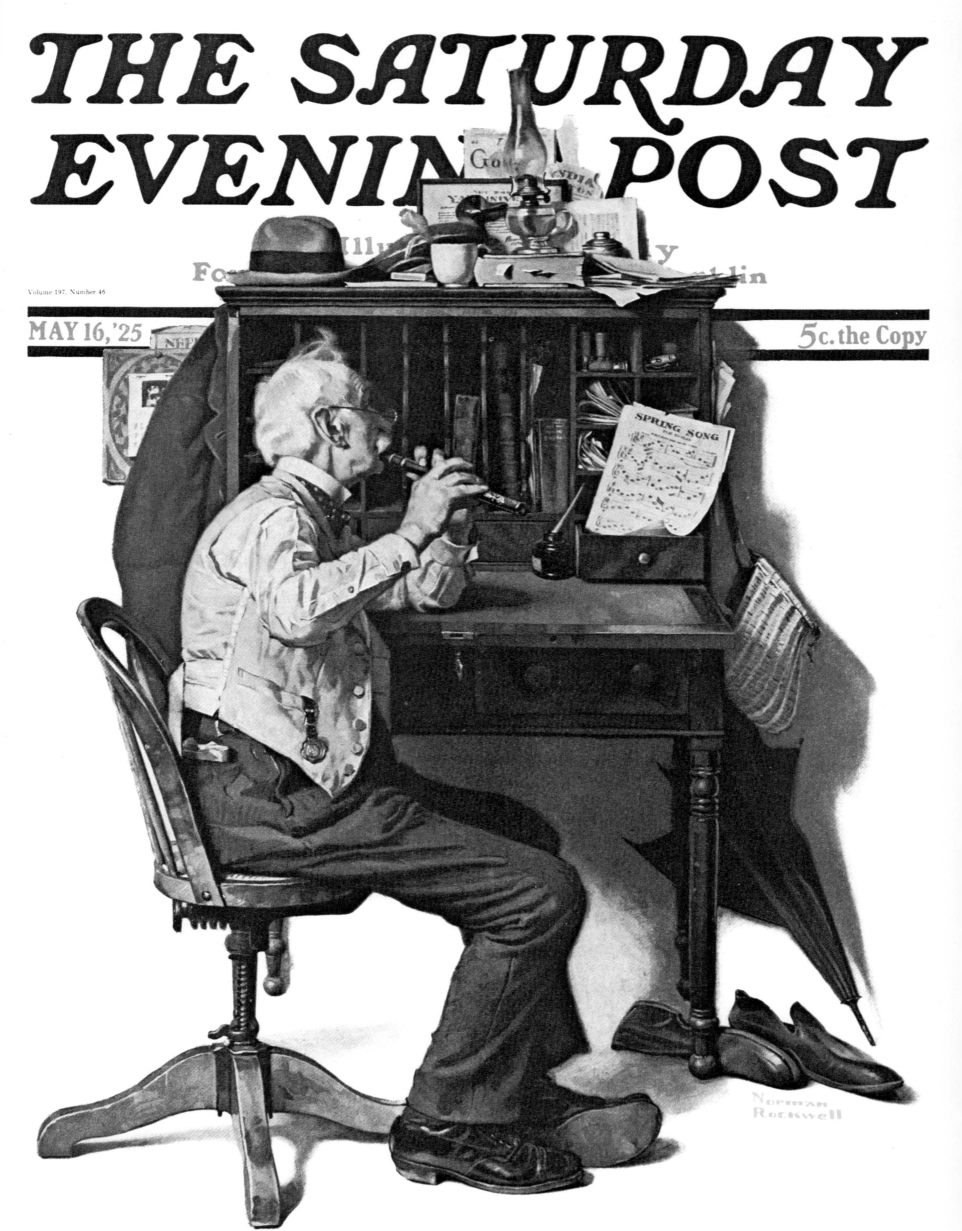

Norman Venner—Garet Garrett—Austin Parker—Jay E. House
Wyncie King—Sewell Ford—Dana Burnet—Fanny Heaslip Lea

June 27, 1925

"Candy"

The wing chair is authentic, an early American piece from the studio, but the comment on contemporary society, the modernity of the arrangement and costume are not typical of Rockwell's work at the time, and do not ring true. Rockwell and his wife were having trouble. "We got along well together," he wrote, "never quarreled or made a nuisance of ourselves. We gave parties, belonged to a bridge club. Everybody used to like us together. We just didn't love each other, sort of went our own ways. She didn't take any interest in my work. . . . But it was my fault, too. When I realized that she didn't love me and, later on, that I didn't love her, I didn't say, 'Let's quit.' I didn't say much of anything. So the marriage lasted fourteen years."

It is difficult not to read something into this cover, as much because Rockwell's narrative abilities itch to make themselves known as because he was having domestic spats. He has done much to disguise the fact, but Rockwell has never liked the idea of sitting around. The dress and shoes and hair look affected and lack the sincerity of his usual work. Coles Phillips and Ellen Pyle and other *Post* cover artists of the time believed in the concept of the pretty girl cover. Rockwell did not; and Rockwell's belief came to be a guiding principle in cover selection. The *Post* found the magazine sold better on the newsstand with nostalgic scenes of American life than with pretty girls.

THE SATURDAY EVENING POST

Fo klin

Volume 197, Number 52

JUNE 27, '25 5c. the Copy

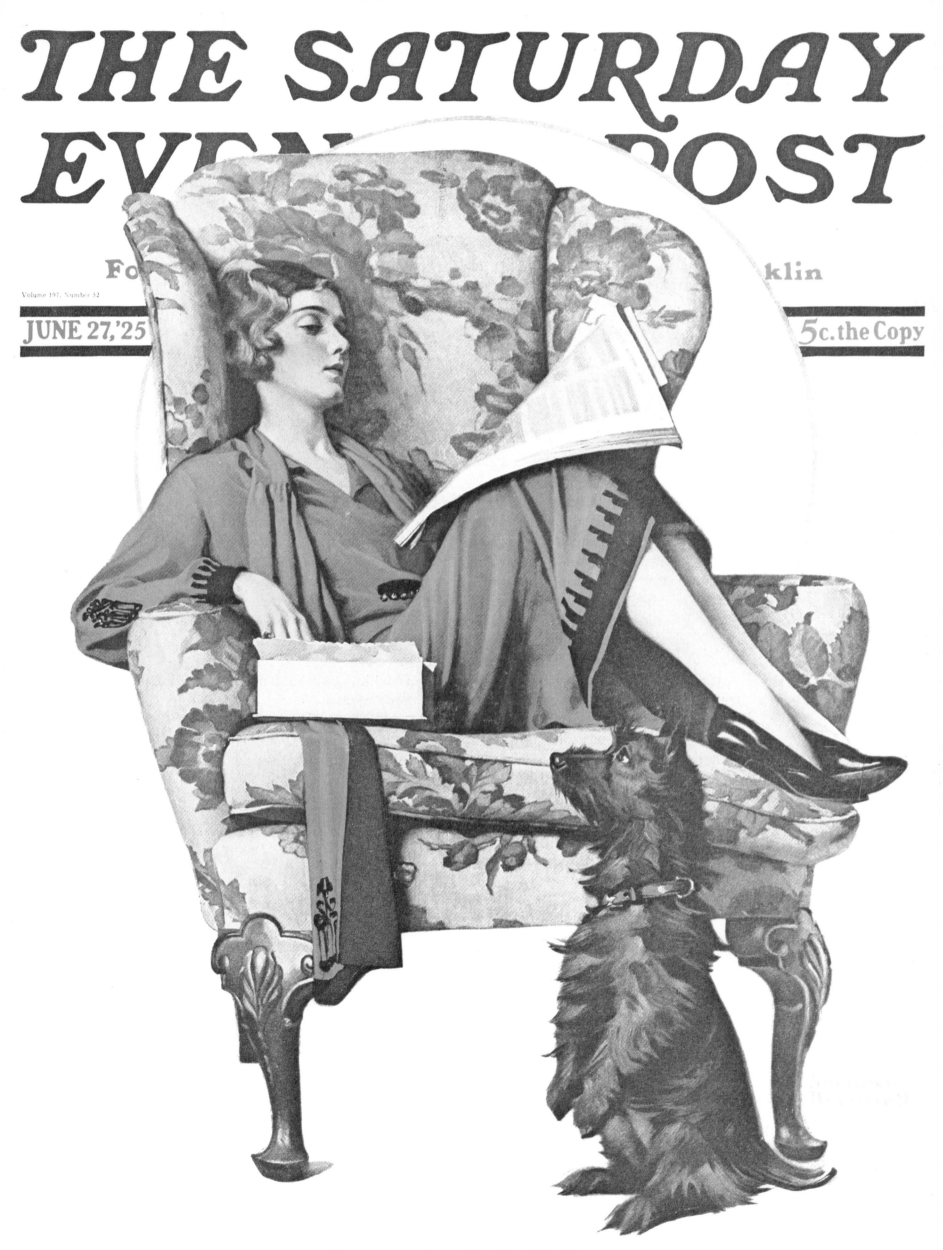

Beginning **SPANISH ACRES**—By Hal G. Evarts

"The Country Gentleman"

"...there was a narrow shelf crowded with shiny glass domes of every size beneath which lay a curious collection of objects; a cigar butt, a bit of cracked brown leather, a piece of charred wood, a handful of steel shavings, a seashell, and many others, all set on neatly labeled blocks of wood." Rockwell, in his autobiography, *My Adventures as an Illustrator,* describes the apartment of one of his models. "He led me to the corner of the room nearest the door, and pointing to the label on the block of wood under the cigar butt, said, 'Read this, Norman, outloud.' I read, 'This cigar was smoked and dropped by General Ulysses S. Grant on the night of ...during a dinner party given in his honor at the 7th Regiment Armory in New York City.'" The splendor of the clothes, which have seen better days, contrasts with the parsimony of the surreptitious action of pulling in the cigar butt and creates amusement without destroying the dignity of the subject in this cover. We admire the character's technique. We like his daring. He has elevated an action which most people might consider beneath them, no matter how badly they might want a pre-Castro Havana.

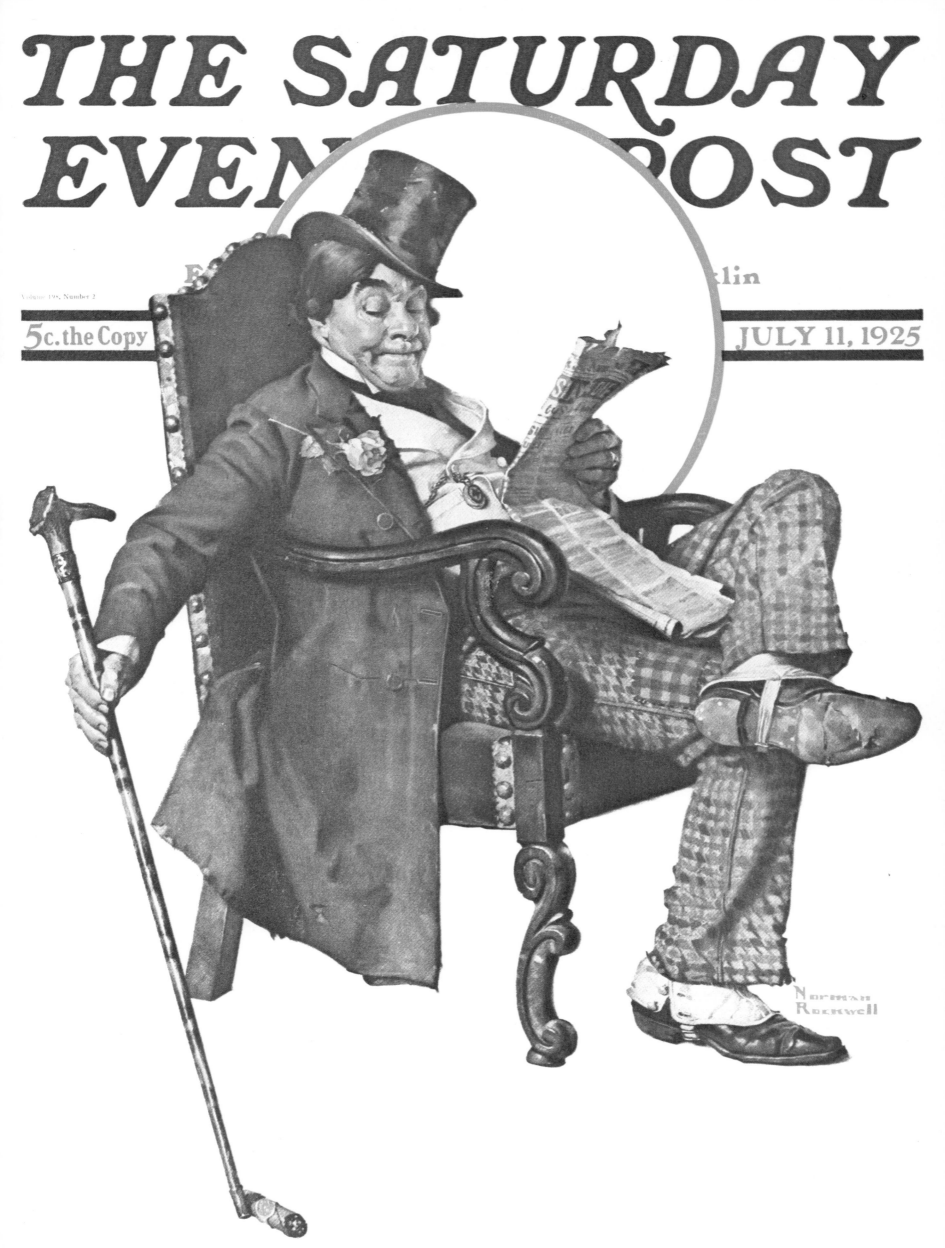

THE SATURDAY EVENING POST

Volume 198, Number 2

5c. the Copy

...lin

JULY 11, 1925

Norman Rockwell

Isaac F. Marcosson — Beatrix Demarest Lloyd — Horatio Winslow — Corley McDarment
J. Clinton Shepherd — Forrest Crissey — Beatrice Grimshaw — Will Levington Comfort

"Hot Spell"

All through the Forties and Fifties this anecdotal scene persisted. The grocery order, trunk, or package marked "rush" suffers through a variety of activities including the afternoon snooze. Illustrators were always hard pressed to come up with cover themes for late summer. Everybody had left town. "Even the farmers." And resort jokes were waning. Americans were discovering the idea of vacationing at home, which meant no vacation at all, for the money had gone for a car or one of the other instruments which eliminated the serving class. The serving class, however, did not like to think of itself as eliminated and took itself more and more seriously at less and less serious jobs. Like sitting on a trunk that automatic dollies would lift soon enough. Rockwell adds a rooster to suggest a rural depot but the times were changing and the "rush" was moving to the highways from the tracks.

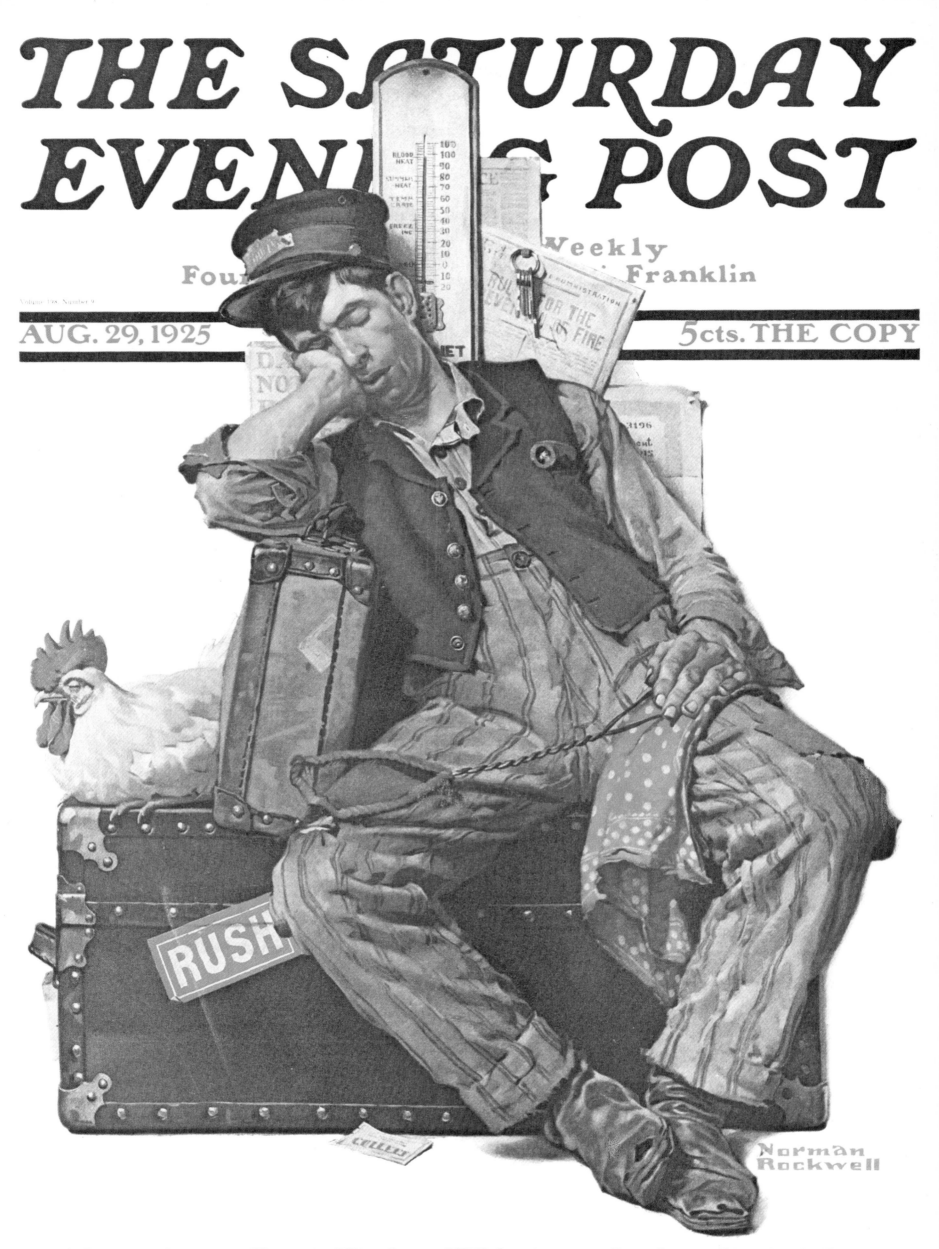

"Moonlight Buggy Ride"

Rockwell hauled this buggy into his studio to get the right effect, the right shadows, the right tilt to the bodies. "Imagine my doing that," said Rockwell. "I worried about growing old, and wondered how long I would be in the game. I still worry and wonder!"

Photographs exist of Rockwell posing this young couple. John James Audubon used to force his bird skins onto spikes to create naturalistic poses with the wings outstretched. Rockwell looked for the same relation between the pose and the final effect and even posed the expressions of the models' faces. His is not an imagination of interpretation, it is an imagination of representation, of how to make subjects appear as real as the models for the subjects without using artistic trickery.

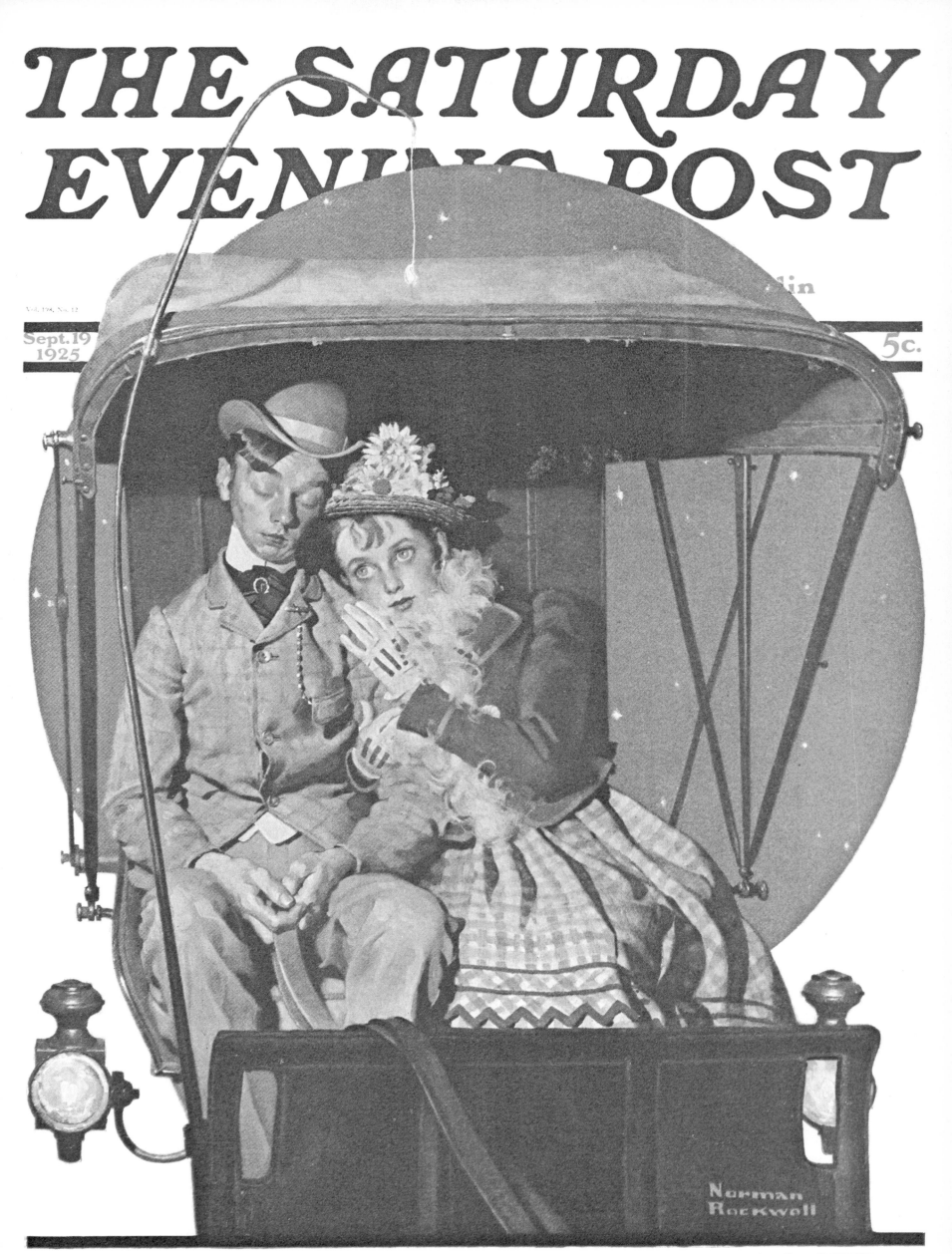

"Fumble"

This is Rockwell's first real sports cover. Baseball appealed to him more than football and, beginning with the 100th anniversary of the game for which he did the July 8, 1939 cover, he painted several memorable scenes which showed baseball greats— Ted Williams, Red Schoendienst—in action, or, more exactly, reaction. Catching figures in action and more specifically at the moment of impact, as here, is next to impossible because the moment is too fast to freeze. Still, Rockwell has made a success of the moment, caused the ball to fly with the wind that got knocked out of the model, captured impact without suggesting pain or ineptitude. In the days before the carefully uniformed midget footballers of today, fragments of uniforms were highly prized and worn more as badges of honor than for the protection they might offer players. The old style ball with its lacing—it seemed to have been laced from within by gnomes who lived inside, and stuffing the rubber bladder back in the leather was one of life's most delicate operations—the helmets and the boots suggest that the last thing Rockwell wants to do is ennoble the gladiatorial contest.

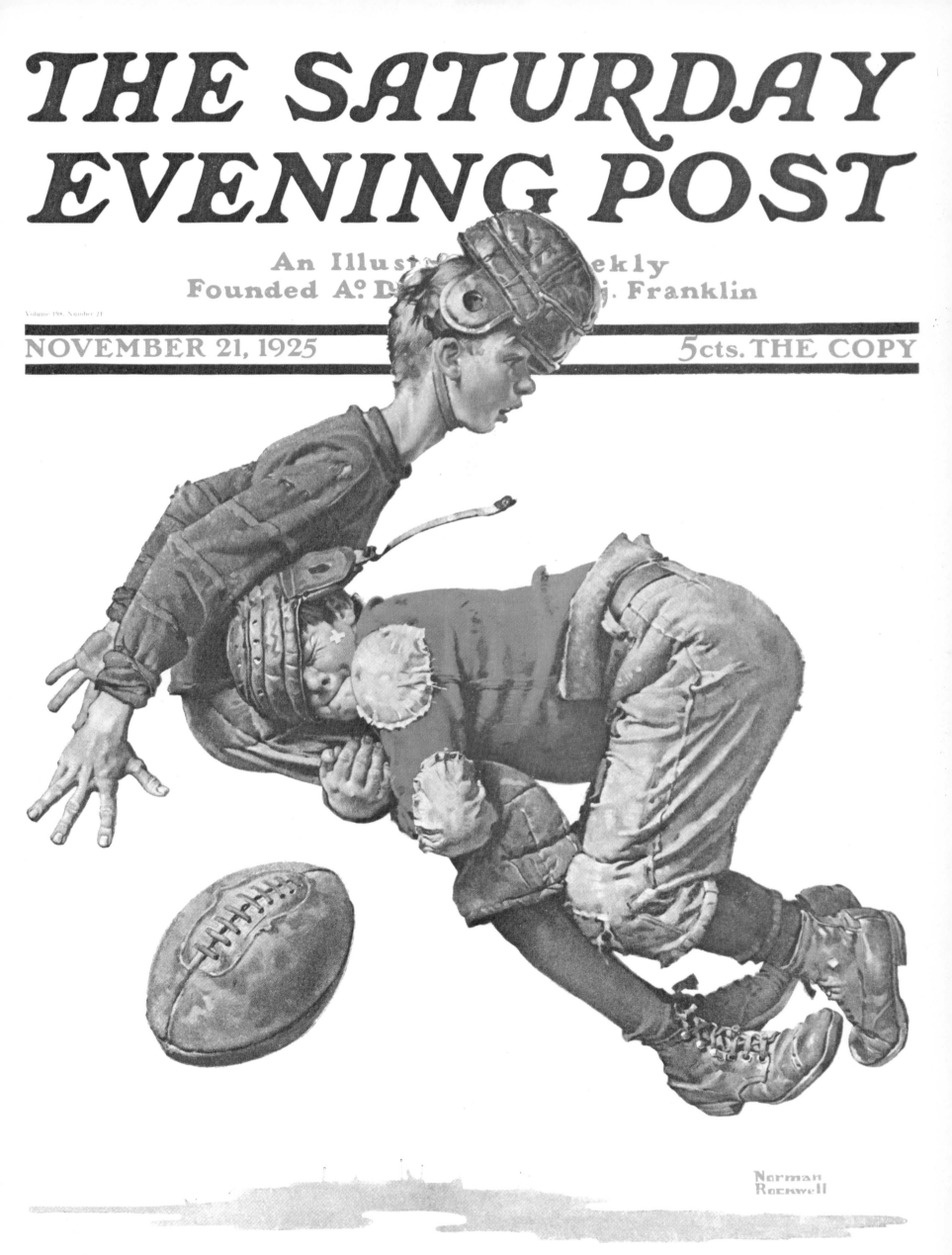

"The London Coach"

The air of expectation, the boy's face, the carpetbag, the box on his lap, the raised whip lead the viewer forward to something that is going to happen later, a dramatic incident we will share: Christmas. The boy is the same lad who appeared on the 1923 Christmas cover and the coachman, resplendent in a blue great coat, his whip cracking through the winter air, will adorn the 1929 cover. We have seen them before in literature, too. In Dickens and in Christmas carols. Rockwell's power of literary allusion is so strong he conjures up our other senses as well as our knowledge of Christmas. We hear the rumble of the wheels, the whip's crack. The clean cold air stings our faces, and we smell the evergreen boughs of trees that line the snow-covered roads. David Copperfield, Mr. Pickwick and little Paul Dombey are on their way home for that joyful day. The coach box is incribed London; at Christmastime it is the mental destination of the English-speaking world. We are hurtling toward the happiness of December 25th as fast as the pair on the box. It promises holly and silver bells and blazing hearths and peace on earth. To suggest this, another artist might have turned to a religious scene, but Rockwell bows to the secular considerations of camaraderie, overindulgence at the groaning board, and the moment when the year dies and man takes stock of his successes and failures, his place in the birth of the New Year.

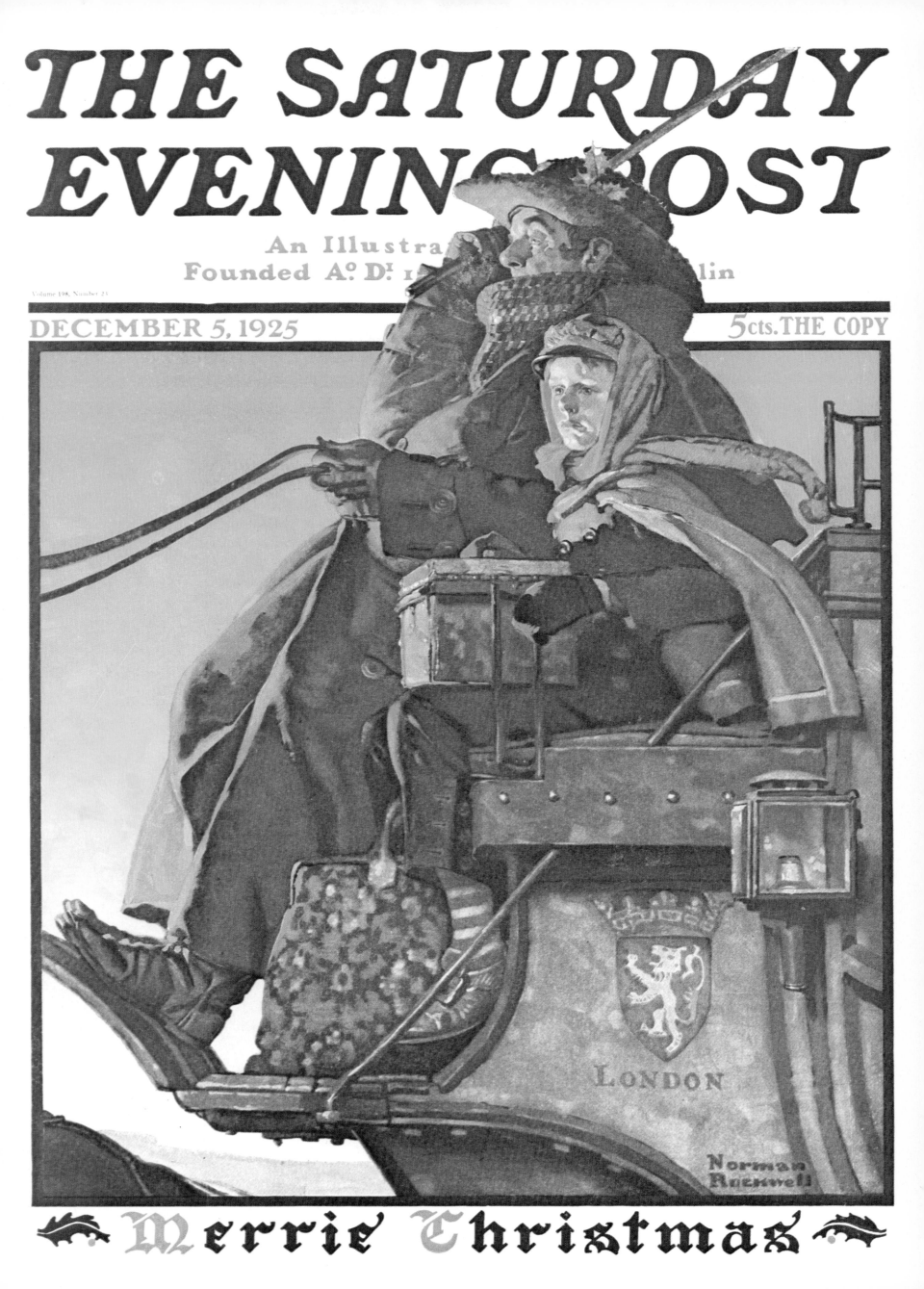

"Look Out Below"

Rockwell first demonstrated his talent for drawing at the age of six. His father was an amateur artist who copied illustrations from books as a hobby. His maternal grandfather was an Englishman who immigrated to Yonkers in the middle of the nineteenth century to make his fortune painting portraits. Failing that, he turned to painting favorite dogs, roosters and horses of sportsmen who had brought to America the British tradition of valuing animals more highly than spouses. The artist-grandfather, one Thomas Hill, devised an assembly-line method of lining up his dozen children and having each child paint a detail—whether tree, feather, eye, lake, hill or cow. Rockwell believes his passion for detail may have been inherited from Hill, and Hill's atelier. Certainly Rockwell never fakes a detail. In this orange-crate chassis with the baby carriage wheels, the sense of actuality races with the sense of speed. Cartoonists' gimmicks—the scattered chicken with its feathers flying, the whirring wheels, the streak effect of the car, the dog hanging on for dear life—abound. But it is Rockwell's last illustration in the early style. He was changing; and the *Post* was too. Exactly a month later, the first cover in full color appears.

THE SATURDAY EVENING POST

Volume 198, Number 28

Weekly
Benj. Franklin

5 cts.

JAN. 9, 1926

Norman Rockwell

F. Scott Fitzgerald—Beatrix Demarest Lloyd
David Jayne Hill—F. Britten Austin—Richard Connell
Kenneth L. Roberts—Jerome D. Travers—Thomas McMorrow

"The Old Sign Painter"

Lorimer chose Rockwell to paint the first color cover. The subject took in the patriotic obligations of the month, the identity of the magazine and its association with Ben Franklin and the Colonial period, the tradition of humor. The model was James K. Van Brunt, whom Lorimer had asked Rockwell not to use so often. "I think you're using that man too much," said Lorimer. "Everybody's beginning to notice it. Maybe you'd better stop for a while. That mustache of his is too identifiable." Rockwell told Van Brunt what the editor had said. "If you take off your mustache I can use you again. Otherwise, I just can't." "Why?" said Van Brunt, "Why, well. No.... No. I couldn't do that." "Gosh," said Rockwell (a favorite word), "I guess I won't be able to use you then." Van Brunt returned in two weeks and said he would shave off his mustache if Rockwell would give him ten dollars. "I guess the notoriety he'd gained from posing for me had overcome his pride in his mustache. And then posing gave him a new interest in life, something to do. So I paid him the ten dollars and he shaved off his mustache. It upset me; it was like the felling of a great oak or the toppling of a statue which had been for years a monument to man. When I saw the result I was even more upset. Mr. Van Brunt's lower lip stuck out beyond his upper lip by about an inch and was just as identifying as the mustache." The cosmetically lovely face on the signboard is hardly a mirror for the worn but plucky face of the sign painter, who, perhaps due to the influence of the contents of the pewter jug, has got the stem of the wineglass in the picture a little crooked.

THE SATURDAY EVENING POST

Volume 198, Number 32

Fo... ...klin

5 cts. FEB. 6, 1926

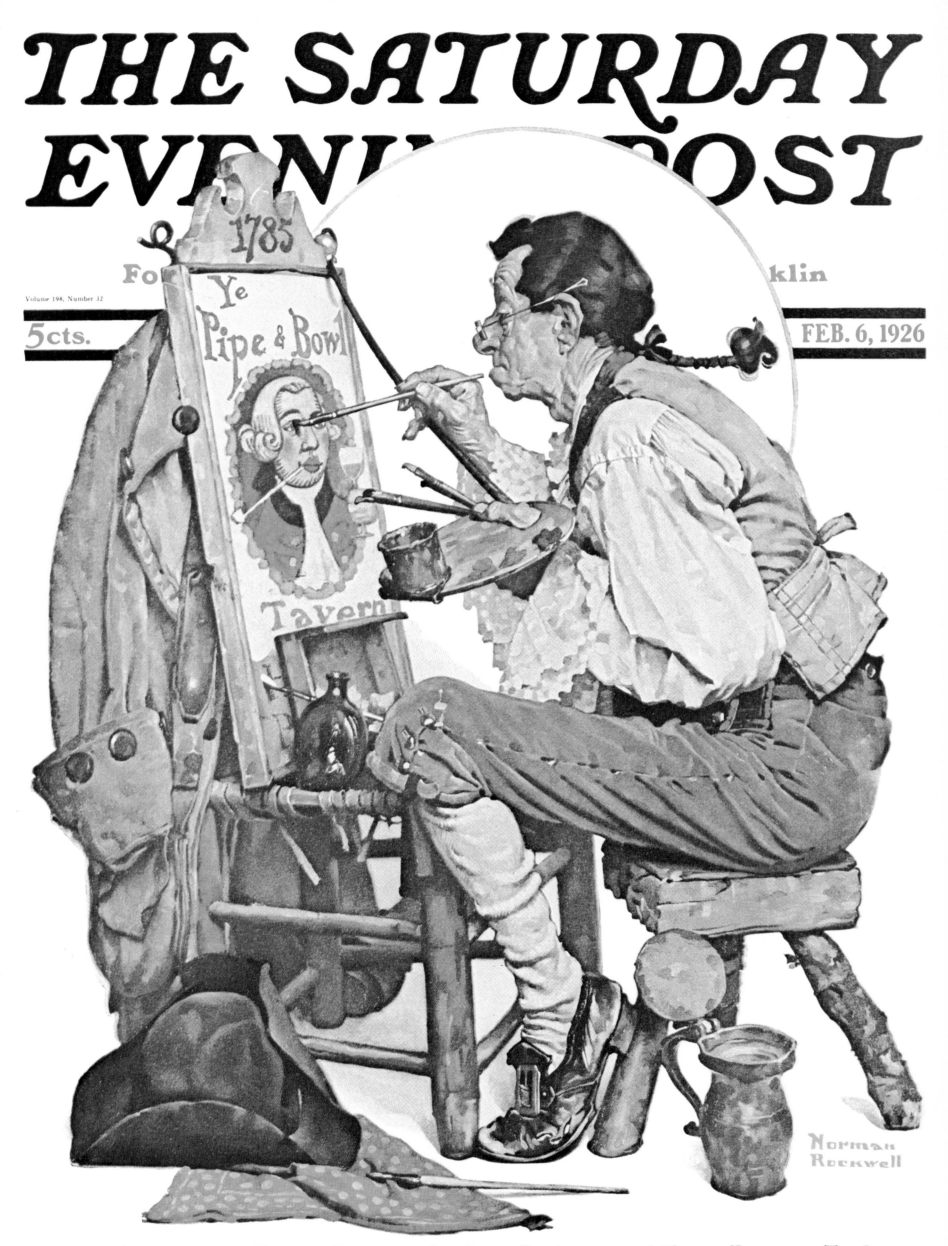

1785

Ye
Pipe & Bowl

Tavern

Norman
Rockwell

"The Phrenologist"

Faith and hope confront the possibilities of the human head. Phrenology as a "science" was introduced by a Viennese doctor, one Franz Joseph Gall, in the 1790's, and although it was banned in Vienna in 1802, it still was being practiced in rural U.S.A. in 1926. The analysis of the contours of the skull to determine a person's talents and characteristics was perhaps an abstract pleasure to balance the concrete delights Rockwell found in examining the human topography with his paint. The examiner is again Van Brunt . . ." because I knew Mr. Lorimer would begin to object if I used him soon again, I thought up ways to hide his mouth. . . . I posed him with his hands in front of his mouth. Next, I used him in a painting of an old scholar standing before an outdoor bookstall absorbed in a book. Really absorbed in it—his chin, mouth, and nose buried in it, in fact." (August 14, 1926.) He was trying to grow his mustache back, and Rockwell recalls in his autobiography that Van Brunt spent "hours in the studio combing it and almost every day he'd ask how it was coming along. I always said, 'Fine, it's coming along fine.' But the truth of the matter was that it wasn't going too well. I guess it takes years to grow such a magnificent mustache and there just wasn't time. And then he was an old man, over eighty years old; perhaps the vigor of youth had given it that special luxuriance. In the end it never attained its former sweeping plumpness, its majestic swoop at the ends."

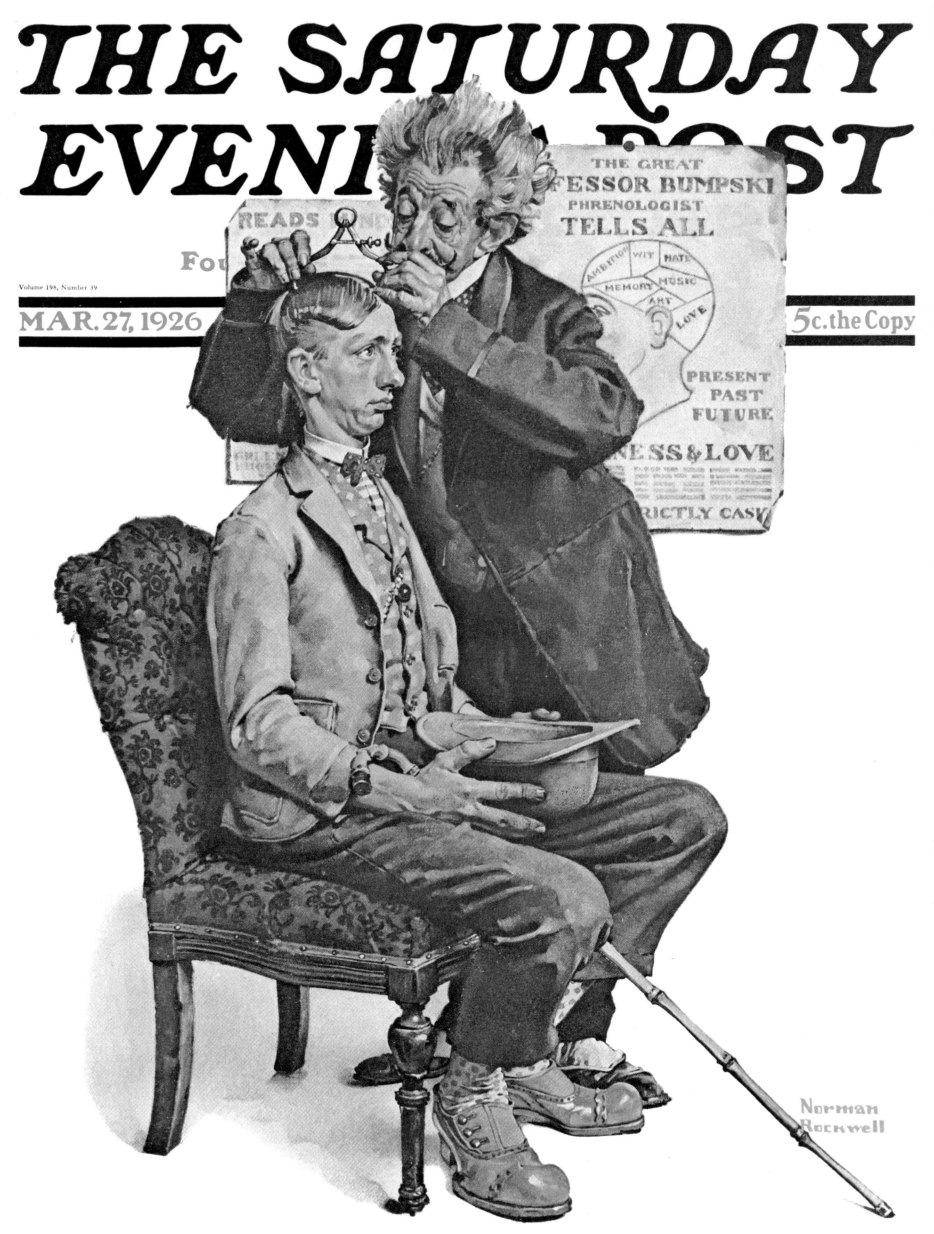

THE SATURDAY EVENING POST

Volume 198, Number 39

MAR. 27, 1926

5c. the Copy

**Alice Duer Miller—Edith Wharton—Wilbur Hall—Joseph Hergesheimer
Harvey W. Corbett—Sewell Ford—Thomas McMorrow—Agnes Burke Hale**

"The Little Spooners"

When I was younger I went to France to paint. Like many young artists I thought I needed stimulation —something outside of myself and my environment—to make my work more interesting and important. But after seven months in France I realized that exotic and unusual things had not changed me. Indeed. I could not work as well in France as I could at home among the ordinary, familiar things. I know now that all I need in my work is at hand. Whether I make the best use of it depends entirely upon my ability to see, to feel, and to understand."

But Rockwell goes beyond what he sees here to meet the demands of a popular periodical. Young people this age don't really spoon although sitting together on the wayward bench with the puppy making his piscatorial comment, they make a nice picture. Despite the age and anatomical variance between the activity and the participants it remains one of the artist's most popular covers, reproduced on calendars, greeting cards, china plates and any other surface large enough to support the image.

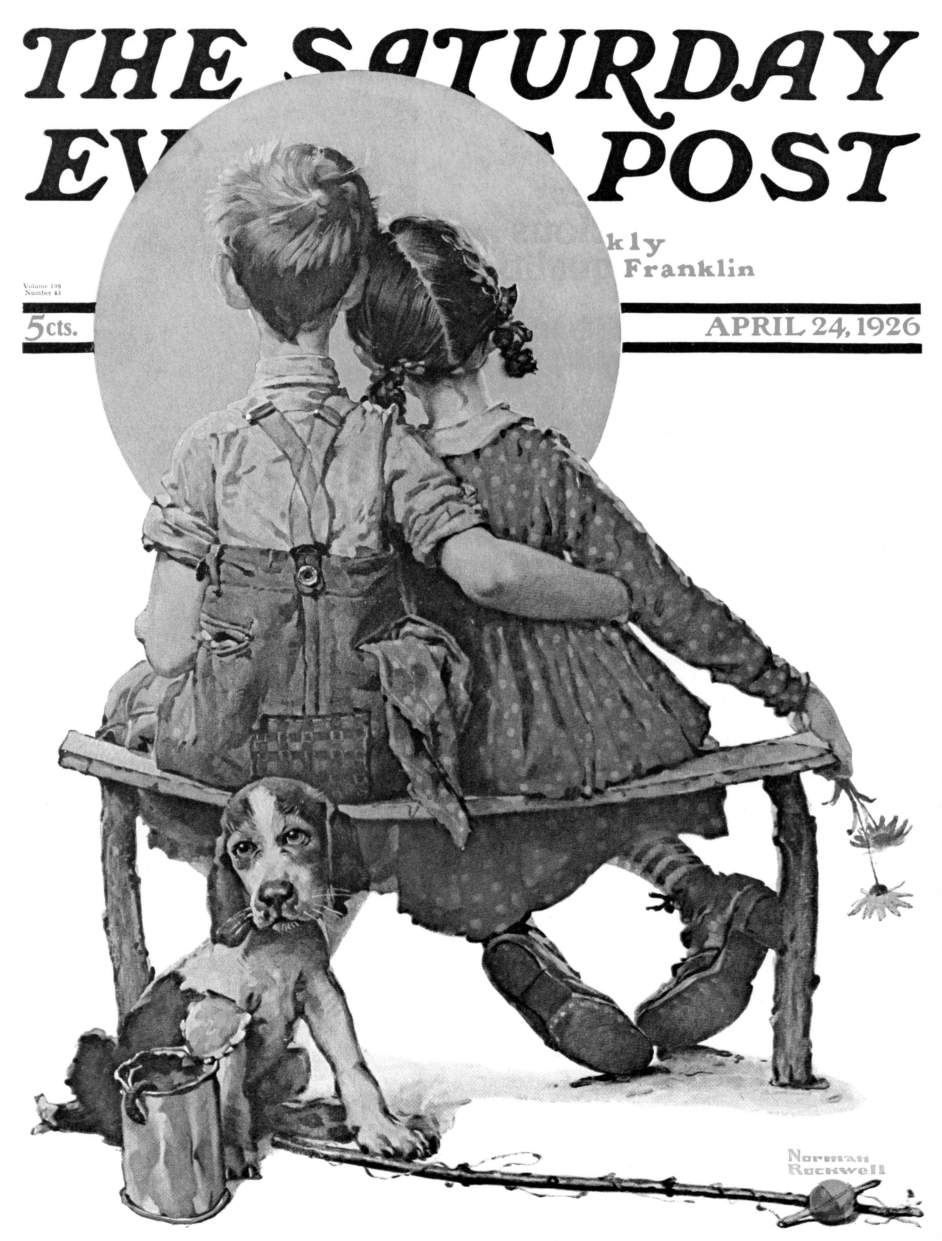

"Ben Franklin"

The colors in the painting commemorating the 150th anniversary of the signing of the Declaration of Independence are unusual for Rockwell, for if the artist likes ruddy countenances, he also works in ruddy colors, rusty shades of red, yellow, brown. Here, he has made a fairly drastic departure from his usual palette. Pale blues dominate Franklin's clothes and the seal behind his head. The whites of vest, stockings and cuffs have taken on a pink hue. The same tones in the inkwell, shield, signature and lips, either because of the variances of early color processes or the results of the juxtaposition with the blue, also look pink, inappropriate for patriotic matter in theory, though in effect, a warm and homely portrait which still maintains great dignity. The circle with the great seal—or variation thereof—haloes the head, and the eagle's wings give Franklin the appearance of a Wagnerian opera hero. All of Franklin's achievements are mirrored in the book, in the sky background of the seal with its ribbons and stars, giving a hint of his achievements with static electricity, and in the elegant clothes of his diplomatic missions to England and France. The image of Franklin we know today developed fairly late in his life. He wore powdered wigs and velvet breeches for most of his years, and it was only with the rise of Rousseau's concept of democracy that Franklin adapted his dress to his early homespun homelies.

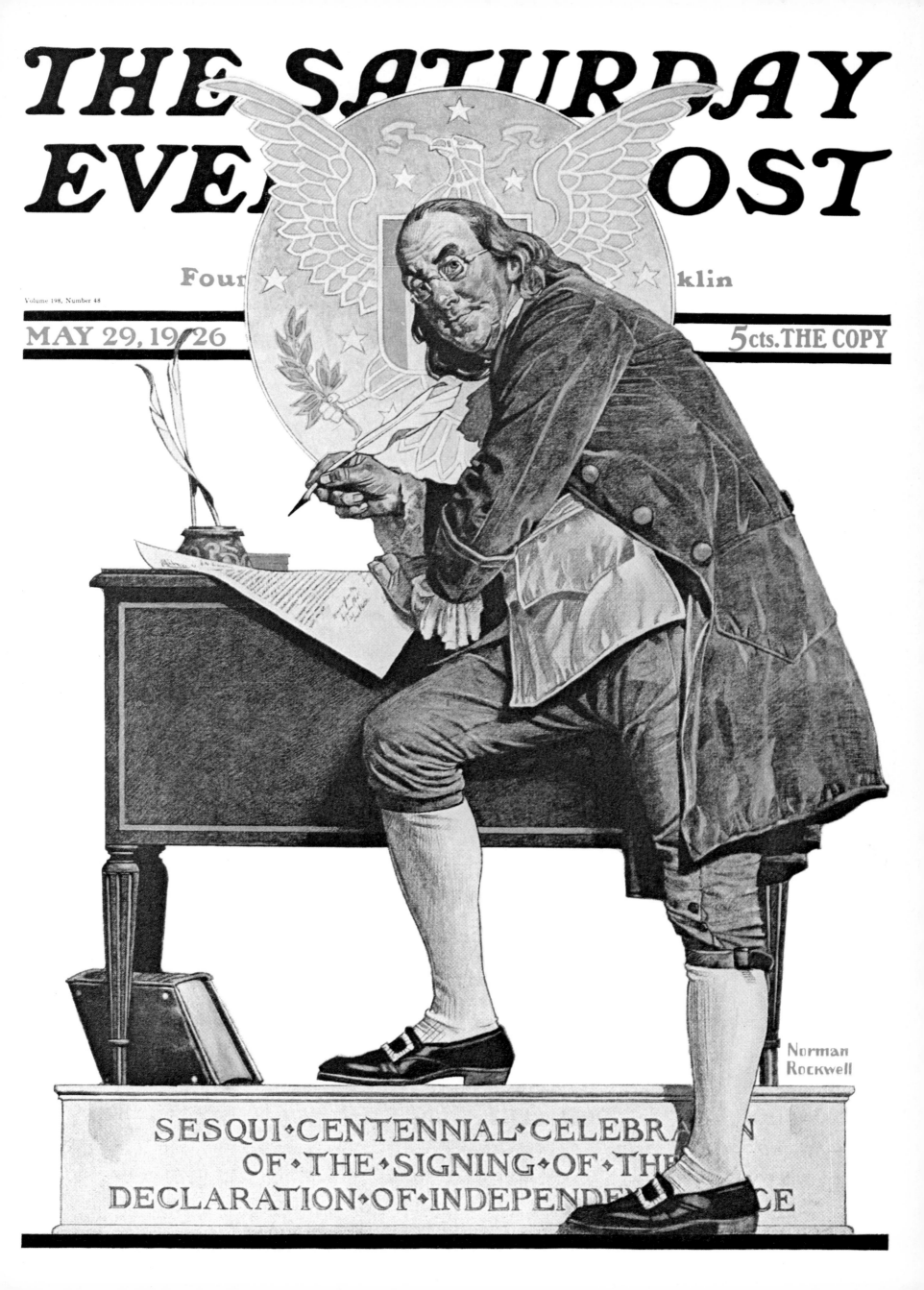

"First in His Class"

"**I** have always felt that a cover which provoked *only* an instantaneous reaction was a failure," Rockwell said in 1961. He goes back in time as well as memory in his schoolmaster cover. School, because we are young or innocent or both or neither, burns itself into the mind with the intensity of a brand. Rockwell himself was never overly fond of school. He quit high school in his sophomore year. He had, even then, created his own kind of discipline, and the heavy load he carried at the National Academy of Design and the Art Students League—working almost full time and going to school almost full time never dampened his enthusiasm for work in general or his own calling in particular. Here he has caught a sort of idiomatic horror of school, the tedium, the trauma of fights with peers and superiors, the danger, even of succeeding, for surely, after the awards, this young man will endure more than the torments of his friends. A fairly similar cover (September 14, 1935) shows a schoolmistress, switch hidden behind her back, accepting a young student who promises to be a match for her. The mother is blissfully unaware of the conflict to come. Only the teacher and pupil know the realities of regimentation. Rockwell didn't need regimentation; no one who has ever endured it wanted it. But once endured, one wants to remember, wants a record of it, and the record has to be more than the diploma; it has to be an image—real or imagined—like this cover, a picture to match against the illusions and dreams of youth.

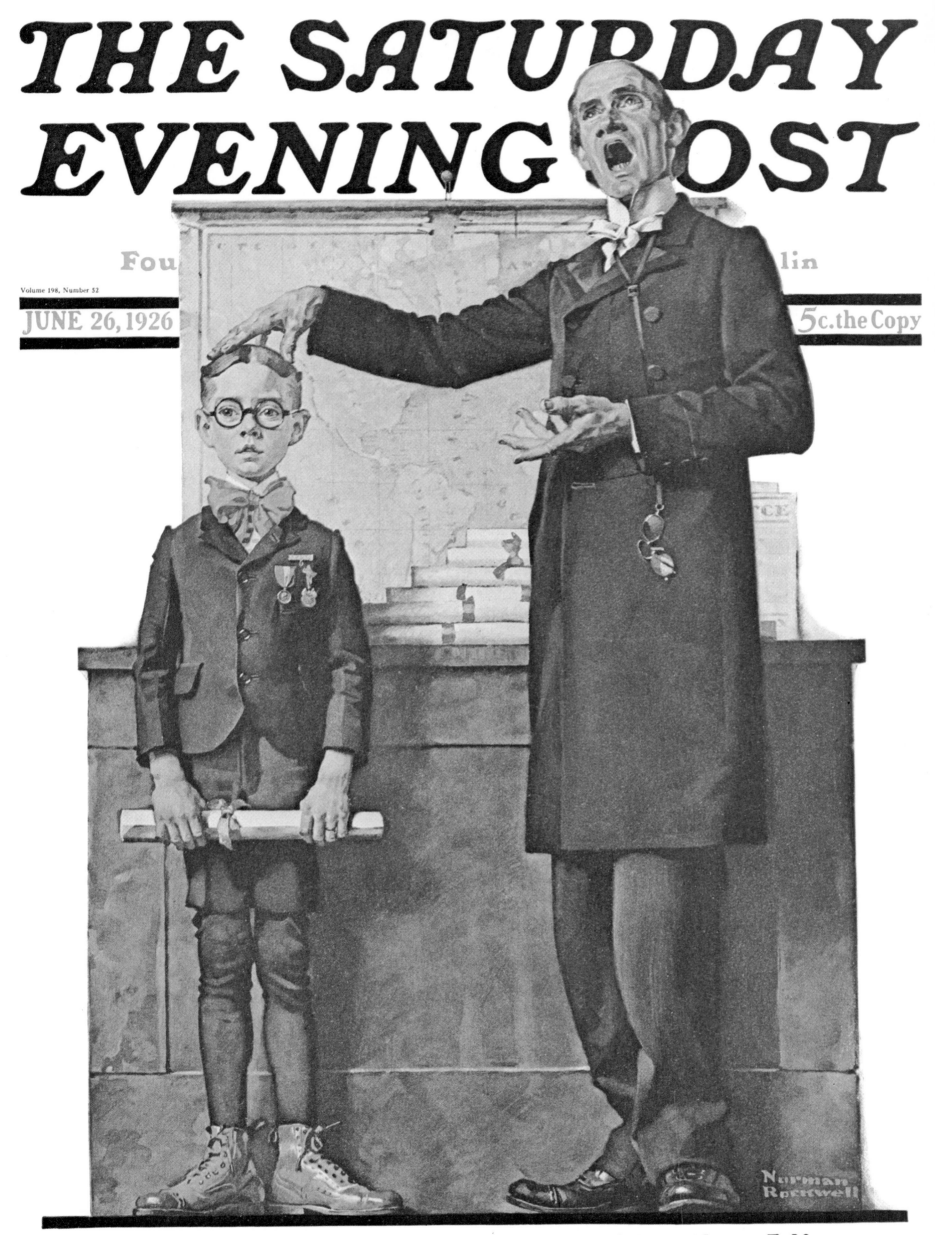

THE SATURDAY EVENING POST

Fou————lin

Volume 198, Number 52

JUNE 26, 1926

5c. the Copy

Earl Derr Biggers—Austin Parker—Frank Ward O'Malley—Isaac F. Marcosson
Edwin Balmer and William MacHarg—Stephen Leacock—Henry Milner Rideout

"The Bookworm"

An artist's attitude undoubtedly has an impact on his work no matter how professional he is. Rockwell's characters are harmless in many instances, dreamers, absentminded, but rarely mean. Desire often triumphs over duty, but it is never passionate desire. The body is as neatly circumscribed within the limits of decent behavior as is the logo of the magazine cover. Rockwell's life was anything but priggish. He golfed, sailed, joined clubs, had his own bootlegger, partied and traveled. It was not a life of dissipation; it was an exploration of self and surroundings. When he painted Van Brunt with his nose in a book, the inspiration had come from the bookstalls along the Seine in Paris. He had adapted it for his audience—those turned, kitchen-table legs are pure Americana—but the ideas, the thoughts that fed his fertile mind, came from the larger view he was picking up by seeing the world. He may have found his work in his own backyard, but he arrived there by going around the world, and his gentle attitude is not the small attitude of the small town, it is the better-world vision.

THE SATURDAY EVENING POST

An Il... ...OKS
Founded A... ...klin

Volume 199, Number 7

AUGUST 14, 1926

5c. THE COPY

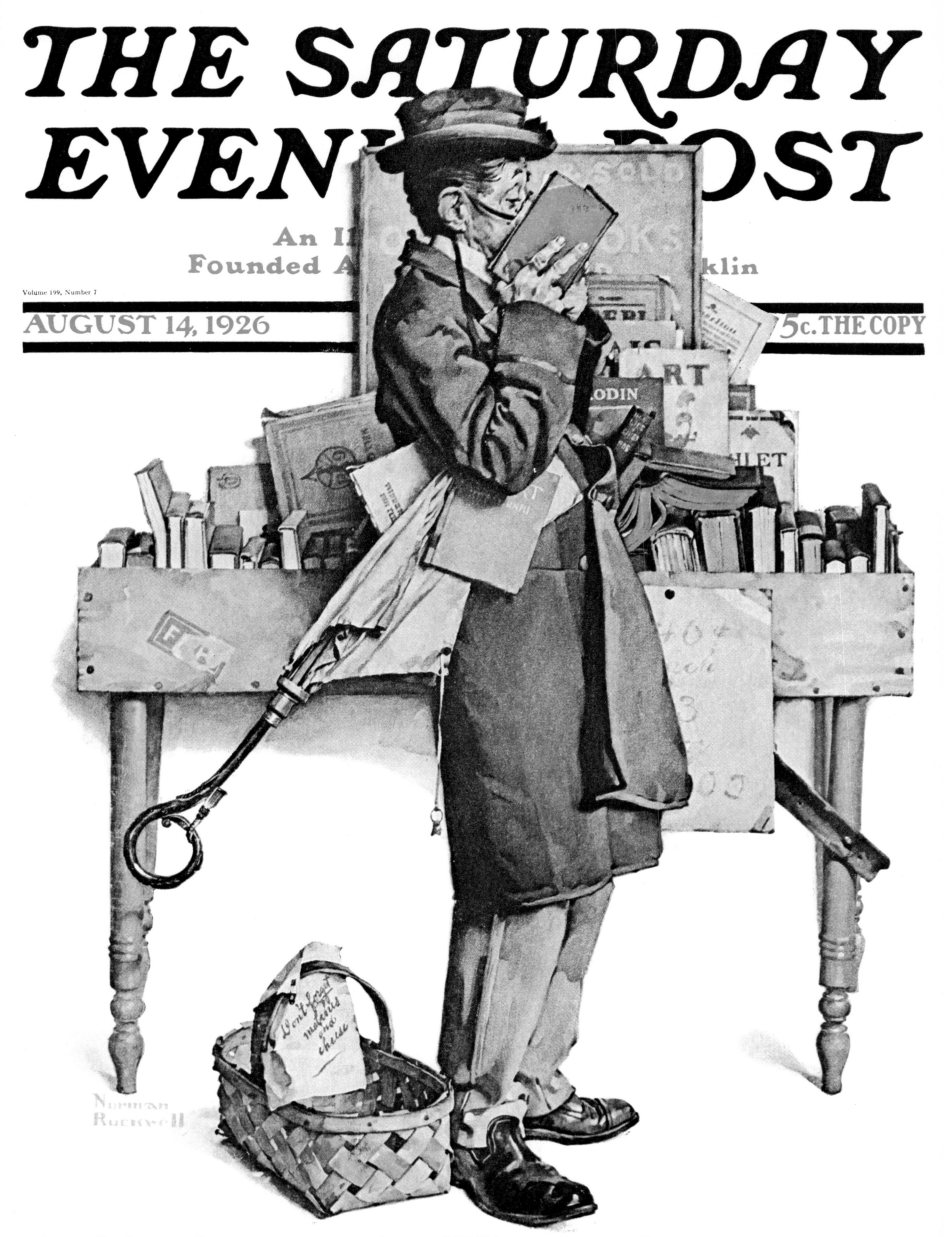

"Contentment"

The best cartoons are those without captions, say cartoon editors. The laugh depends on the action, on the face's expression, on its having happened or threatened to happen to you. Many other *Post* artists resorted to a printed explanation of what was going on with their covers; Rockwell rarely succumbs. "Vacation" (June 23, 1923), "The Pioneer" (July 23, 1927), and "Adventure" (June 2, 1924) are examples. Looking at these covers today, we wonder whether in fact they needed the inscribed legends. "I am never quite satisfied with a painting of mine," Rockwell says. For years Rockwell has attended a life study class in Stockbridge, Massachusetts, where he now lives. "We begin about nine-thirty and work until noon. The model poses for twenty minutes and rests for ten....One doesn't have time to do a finished portrait, but that's all to the good as far as I'm concerned. I have a tendency to overwork a painting. In sketch class I can't do that." Yet it is the depth of paint as well as the depth of feeling that distinguishes Rockwell from all other American illustrators. As he has lingered over his pictures, so the viewer feels inclined to linger, to discover new things each time he looks at a cover.

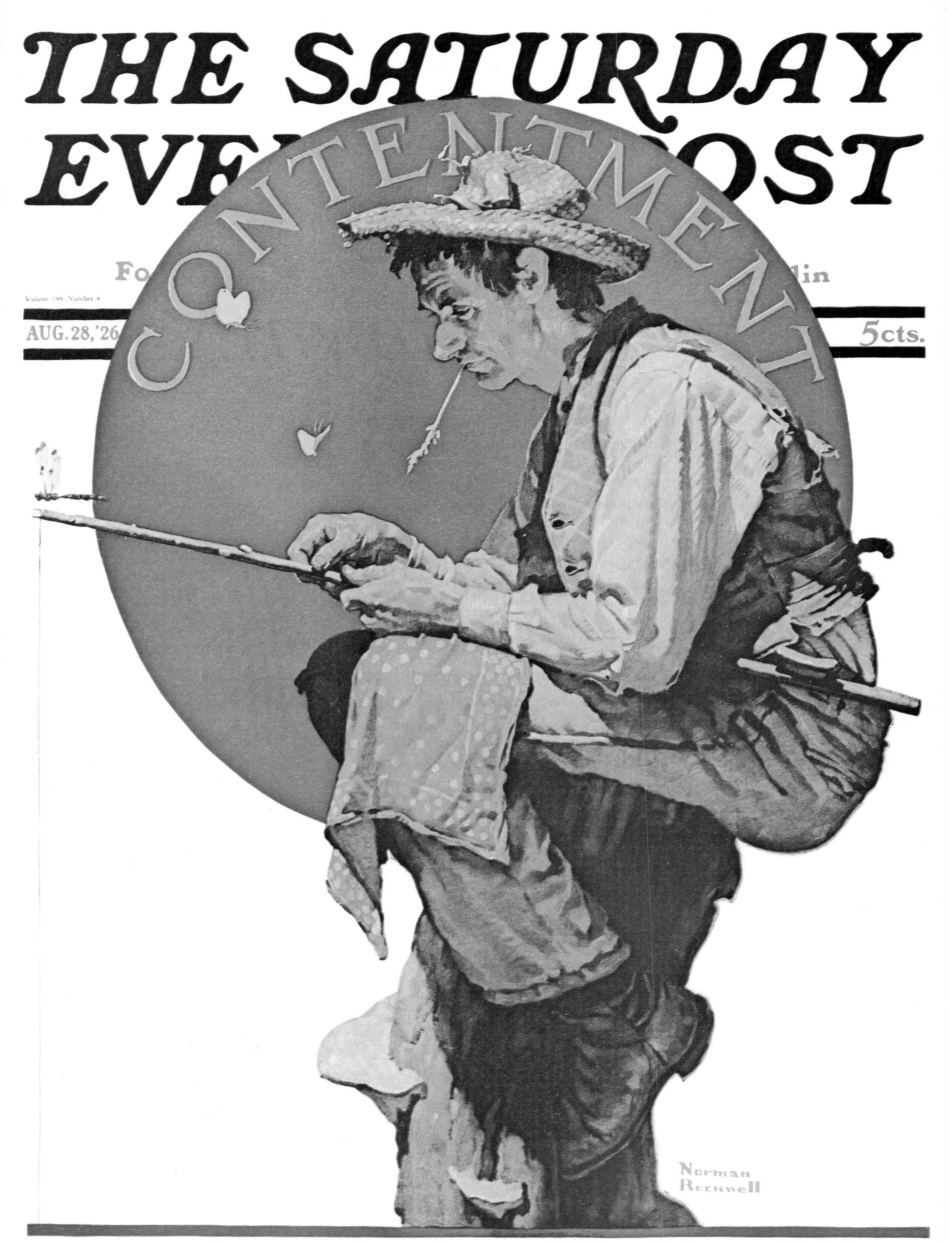

THE SATURDAY EVENING POST

AUG. 28, '26

5 cts.

CONTENTMENT

Norman Rockwell

Juliet Wilbor Tompkins—Garet Garrett—William F. Sturm—Will Rogers
Horatio Winslow—Wythe Williams—C. E. Montague—Luther Burbank

"The Defeated Suitor"

In the January cover following this one, the pattern—both of the design and the story are alike. Wisps of symbolic foliage are scattered about the disillusioned subjects who believed in love and Christmas coming every day, something Rockwell occasionally demonstrates he believes himself. He ponders many times whether a subject is enough to make a cover. He had doubts about this one, but technique and white space save it. White space, or lack of conflict or other subject matter, indicates we are looking at something less than the Sistine Chapel, or, in Rockwell's own oeuvre, the "Four Freedoms." Superior technique—superior in emotional content as well as in painting and drawing skill can carry off minor subjects. Deadlines force artists and writers to perform. The natural inclination of artistic and creative people seems often to be to stare out of windows, or at blank pages and canvases, and to leave them blank until the wolf at the door, or the battle ax wife, or the raging editor bends paint to picture or hands to typewriter. Sometimes, these deadlines create the regularity that makes a professional, nothing more, and professionals can consistently turn out pedestrian and sterile pictures and stories. This was never the case with Rockwell. He knew how to paint, knew the tricks as well as the techniques to conquer both serious and minor problems, how to create the weekly picture as well as how to build in his own style and message, the larger, lifetime portrait. And he knew how to work, how to prime the pump with his mind and his brush. In other words, if the good cover idea came to him, he was sitting before his easel, not sailing out into a distant sunset.

THE SATURDAY EVENING POST

An Illustrated Weekly
Founded A.D. 1728 by Benj. Fr...

Volume 199, Number 14

OCTOBER 2, 1926

5c. the Copy

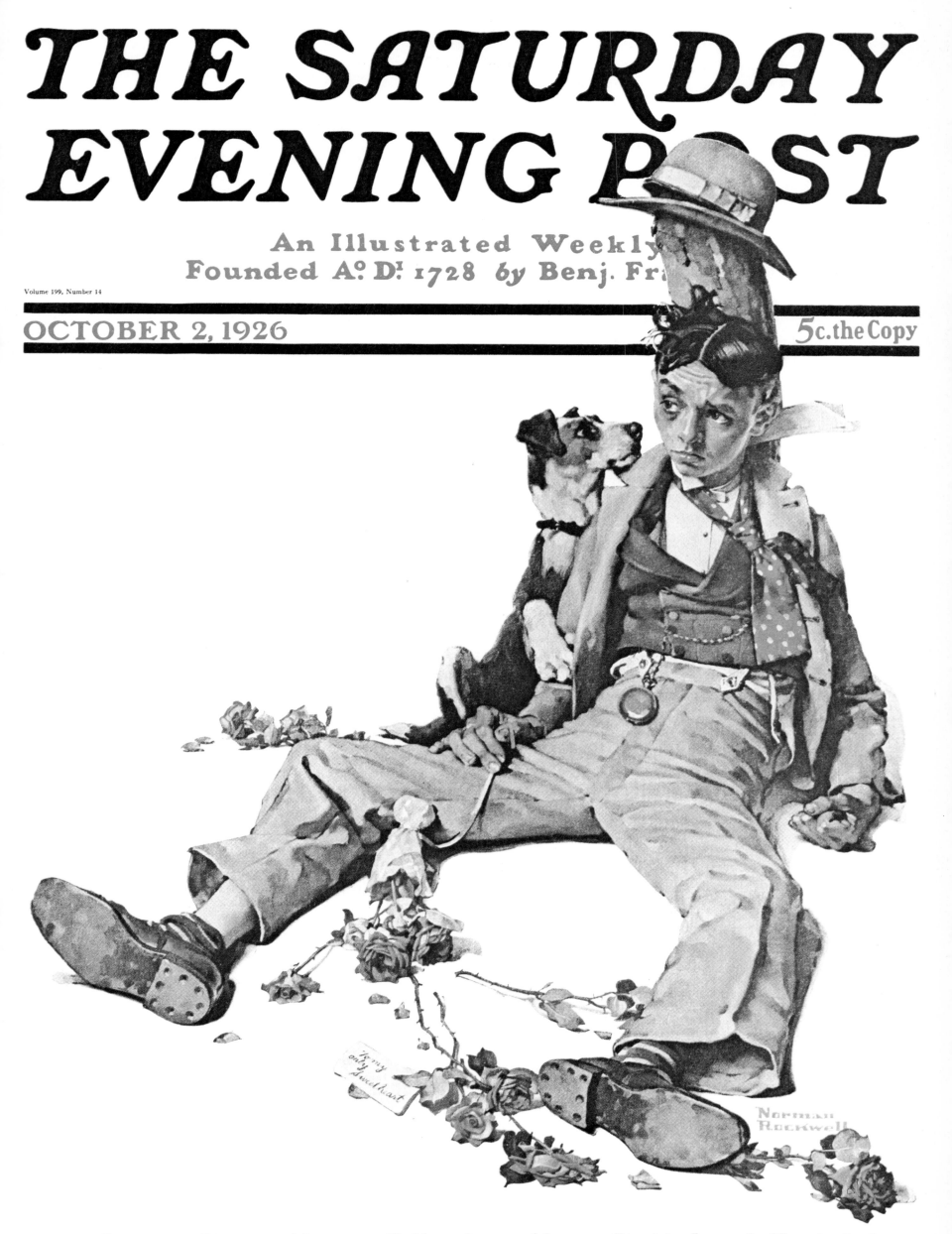

"Santa Planning His Annual Visit"

Thomas Nast, the political cartoonist, gave America its vision of Santa Claus, made him the fat, red-suited bearded, benevolent deity children mail their letters to in December. Nast was a contemporary of Rockwell's (barely, since Nast died in 1902) but the vision persisted and Rockwell saw it as a child, in New York newspapers and in *Harper's Weekly,* for which Nast worked. There was a certain Germanic hardness in Nast's work—perhaps because of the medium—engraving, etching. Rockwell has softened the character as well as the vision, has rounded the edges, relieved the figure of any thoughts of senior citizenry and social security. Santa Claus is pure wisdom and kindness, and somehow made realistic for a cynical world to believe in. "I like to paint my own ideas, tell my own story," Rockwell says. He often tells his story, however, by elaborating on the previous notion we all have of a character or story. There is, especially in his Christmas cover, a desire to intensify the vision, to make the story so believable there is the willing suspension of disbelief literary critics speak of. Nothing in this cover creates doubts. The socks, slippers, the book, the quill behind his ear—an anachronism considering the magnifying glass—the globe, the belled garter, and the halo are real, both as objects and parts of the legend. The old Italian masters picture another saint, St. Jerome, in his study using some of these same elements. In those masterpieces, we see Jerome busy with his books while the lion he has endeared to himself by removing a thorn from its paw, bides its time by the hearth with all the confined domesticity of a house cat. Rockwell too has tamed a myth, taken a saint and put him down on mortal level.

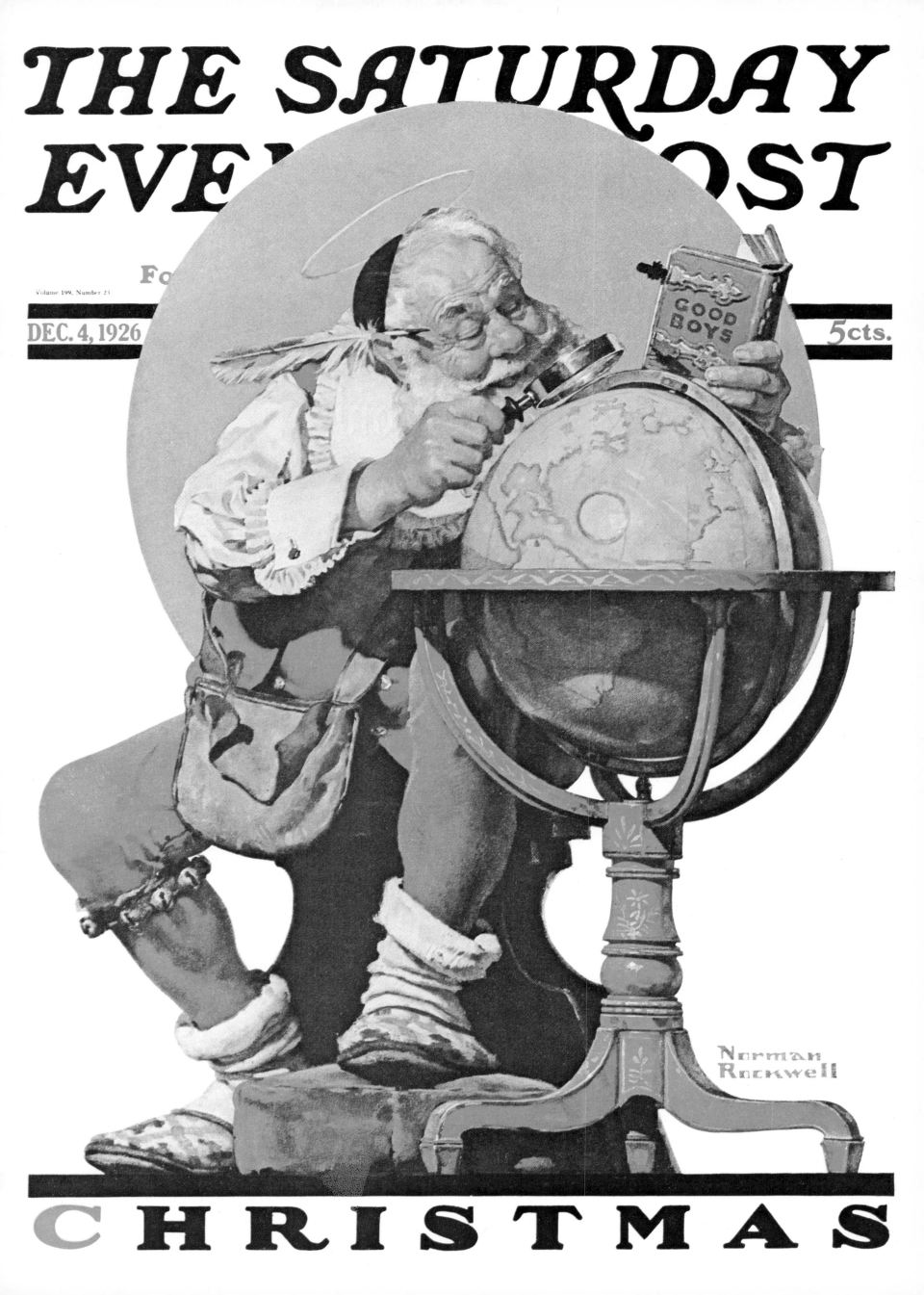

THE SATURDAY EVENING POST

Volume 199, Number 23

DEC. 4, 1926

Fo

GOOD BOYS

5 cts.

Norman Rockwell

CHRISTMAS

"Back to School"

Leyendecker's annual cover of the cherub would have appeared the preceding week, and Christmas and the holiday spirit were still too strong to give way to winter scenes; it was too early to begin Valentine's Day covers or Easter. What was left? Rockwell answered in what has become a classic post-Christmas cover. Nast had engraved a boy breaking into tears because of a sign in a toy shop proclaiming "Christmas comes but once a year, therefore let's be merry," with the caption beneath "The Dear Little Boy that Thought Christmas Came Oftener." The boy is rather loutish-looking in Nast's picture, while Rockwell's is irresistible. Going back to school, the end of Christmas, the sunset of childhood, are mournful subjects, not too mournfully treated here. One wonders whether the moon-eyed Keane moppet pictures of the 1950's can be blamed on Rockwell. Certainly this cover borders on and enters the range of sentimentality. There are exaggerations, there is an unfair appeal to feeling rather than a rational approach, but art is not a reasonable subject, and Rockwell is a master at ambushing emotions his audience imagines are secure and well contained.

THE SATURDAY EVENING POST

ed Weekly
by Benj. Franklin

Volume 199, Number 28

5c. the Copy

JANUARY 8, 1927

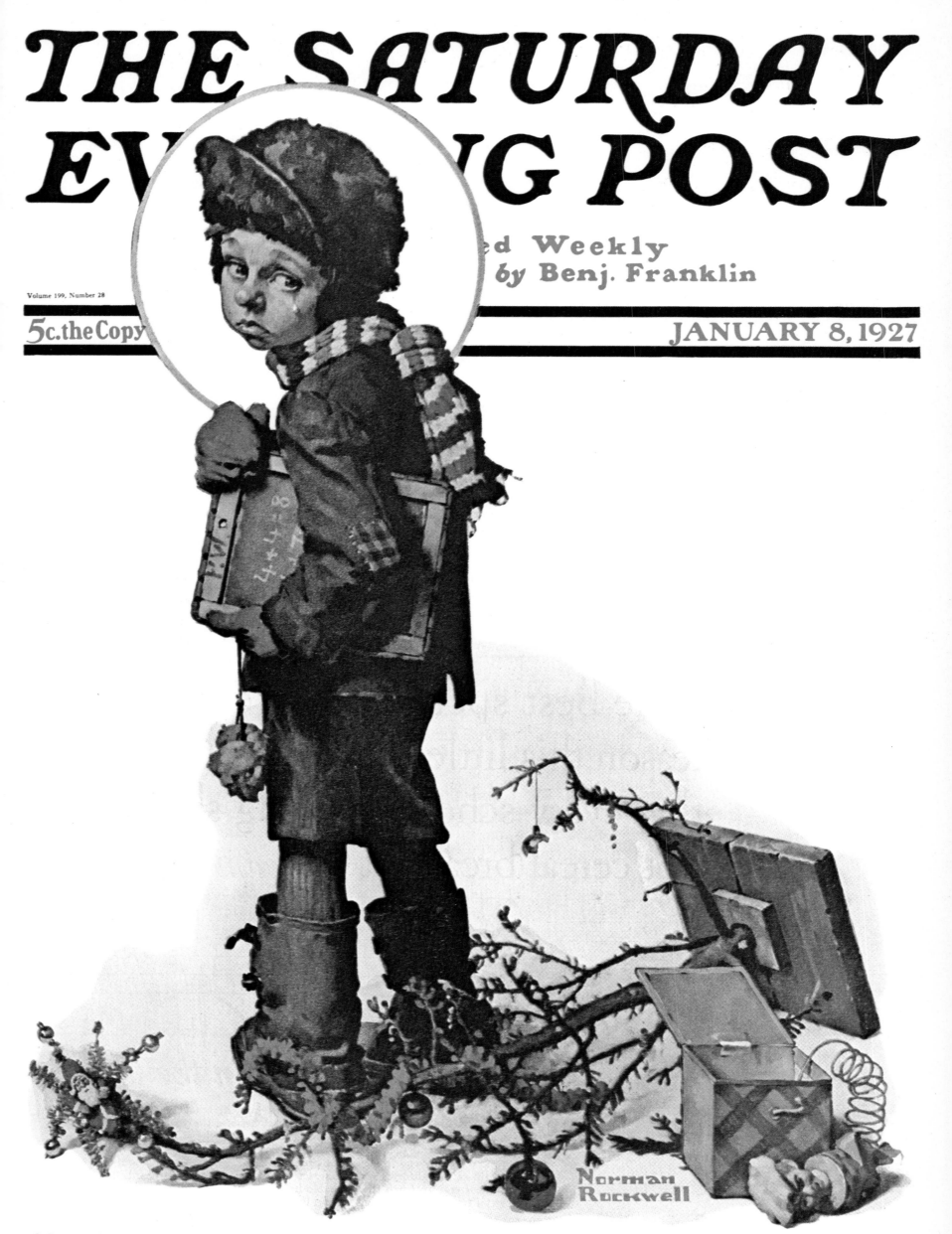

Norman Rockwell

**Alice Duer Miller—Will Rogers—Wallace Irwin—Stewart Edward White
Arnold Bennett—George Rector—R. G. Kirk—Cornelius Vanderbilt, Jr.**

"The Law Student"

The burlesque which characterized most of Rockwell's—and the *Post's*—cover art was on the way out. Rockwell was discovering another scenario, that of nationalism and heroics. The nation began to take itself seriously. U.S. sport figures, explorers and presidents were measuring up to the prophecy of the founding principles. No one stirred the American imagination more than Lincoln. His humble beginnings, his noble countenance, his championing of the underdog, made him Everyman's ideal. "I have always been fascinated by Lincoln," Rockwell says, "and over the years have attempted a number of paintings of him. Some years ago I completed one of him delivering the Gettysburg Address, but since then, for one reason or another, I have failed to finish any of the paintings I started." He painted a head of Raymond Massey as Lincoln for the theater program of Robert Sherwood's *Abe Lincoln in Illinois*. He has used Mathew Brady photos for this cover, and some years later, Rockwell made the charcoal sketch of Lincoln posing in Brady's studio. The President's head is fitted into the metal clamp behind the famous Brady posing chair, the photographer stands, watch in hand, lens cover removed as the image of the great Emancipator is burned forever into the glass plate. The stark simplicity of the scene intensifies the drama. In this Lincoln birthday cover, Rockwell has taken the unobvious way out of the assignment. Lincoln's image inspires the young grocery clerk to better himself, to reach out for the President's example of dauntless energy and fair play. The earnestness of the young man's face leaves no doubt as to the outcome of his efforts.

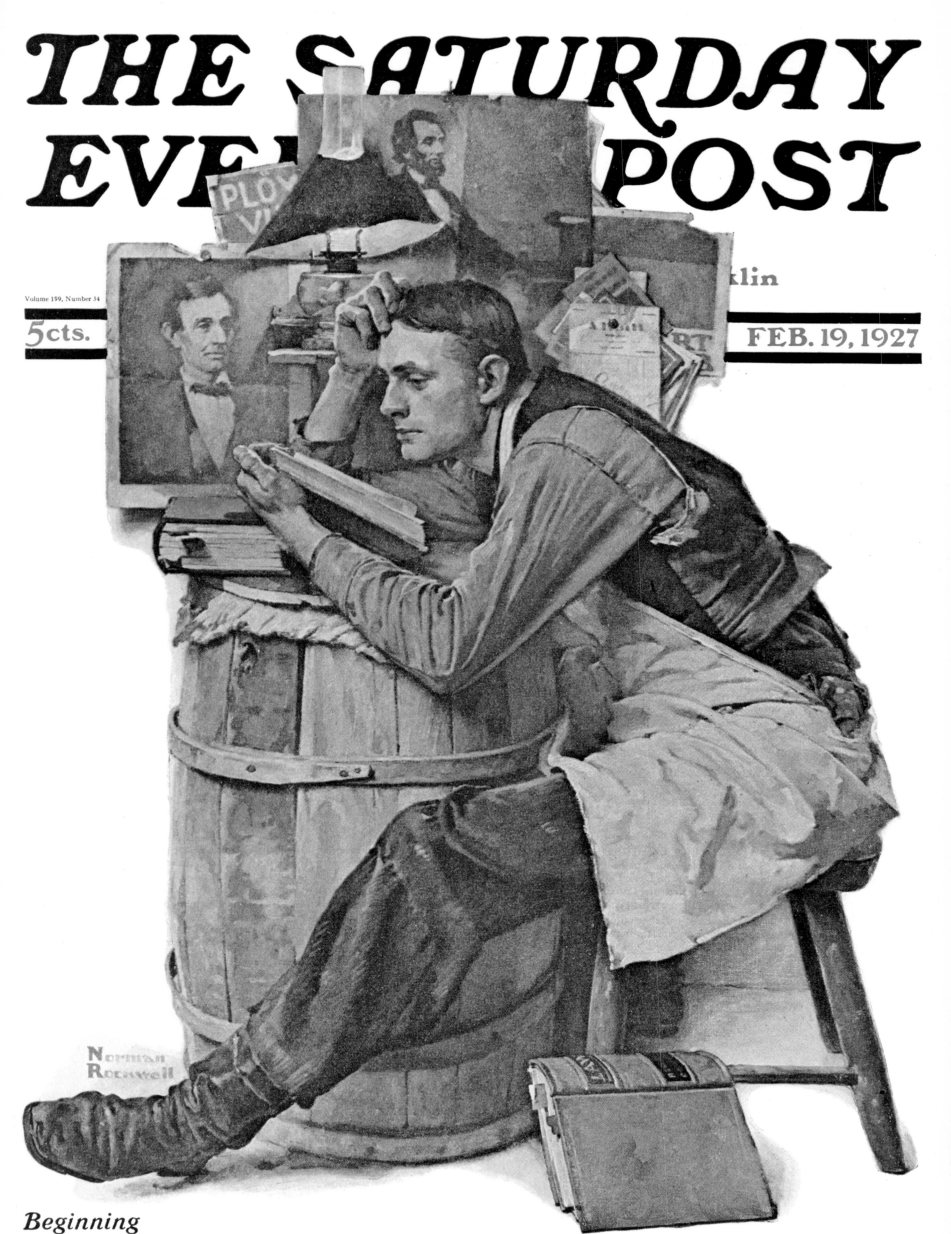

"The Plot Thickens"

Pop Fredericks, the seasick voyager of the September 8, 1923 cover, makes another appearance as the burly literary critic here. The other reader's name appears as the author on the book cover. Fredericks posed as the doctor in the most popular cover Rockwell ever painted, "The Doctor and the Doll" (March 9, 1929). Fredericks, using his histrionic abilities, appeared alternately frightening and friendly. "Many of the professional models were people who couldn't earn a living any other way, failures really, because modeling wasn't a very lucrative trade. You started out as a model for the art schools and then graduated to being a model for individual artists. Ten, twenty years later you were still posing for artists and earning not much more than when you began," Rockwell once wrote. Perhaps no artist ever personalized the anonymity of his models so thoroughly as Rockwell did. He made their faces as recognizable as those of our national heroes. They became heroes in their own right, too, for they anchored the foundation of the country's past, made the beginnings into a respectable history.

THE SATURDAY EVENING POST

Vol. 199, No. 37

5 cts.

Weekly
Benj. Franklin

MARCH 12, 1927

Booth Tarkington — Norma Talmadge — Thomas Beer — George Rector
Elbert H. Gary — Bertram Atkey — Floyd W. Parsons — Charles Brackett

"Springtime of '27"

Illustrating for young people's magazines—*Boys' Life, St. Nicholas*—as Rockwell had, gave him a strong sense of fantasy. In the days before children were exposed to social relevance, children's minds were allowed to personify animals and to believe in sprites and elves. Imagination was no crime in painting just as it had never been one in literature. The anatomy of the animals dancing around the boy's feet is sound, though somewhat comic in the way their "hands" are held. He was to follow this type of cover with others in the Thirties (April 8, 1933—on the same subject, spring, and August 5, 1933, titled "Summertime").

Rockwell was by now the *Post's* star. Lorimer demanded absolute loyalty to the magazine, and Rockwell's work for other publications or for advertisements sometimes was cleared through Lorimer. When the magazine *Liberty* was founded in Chicago, the art director of the new magazine came to New Rochelle and offered to double whatever Rockwell was getting from the *Post*. Rockwell agonized over his decision, asked his wife, who said, "Yes, take it," asked his friends, who echoed Irene's advice, then went to Philadelphia. He told Lorimer about the offer. Lorimer's only response was to ask him what he had decided to do. Rockwell said he had decided to stay with the *Post*. Then Lorimer said he had decided to double Rockwell's price.

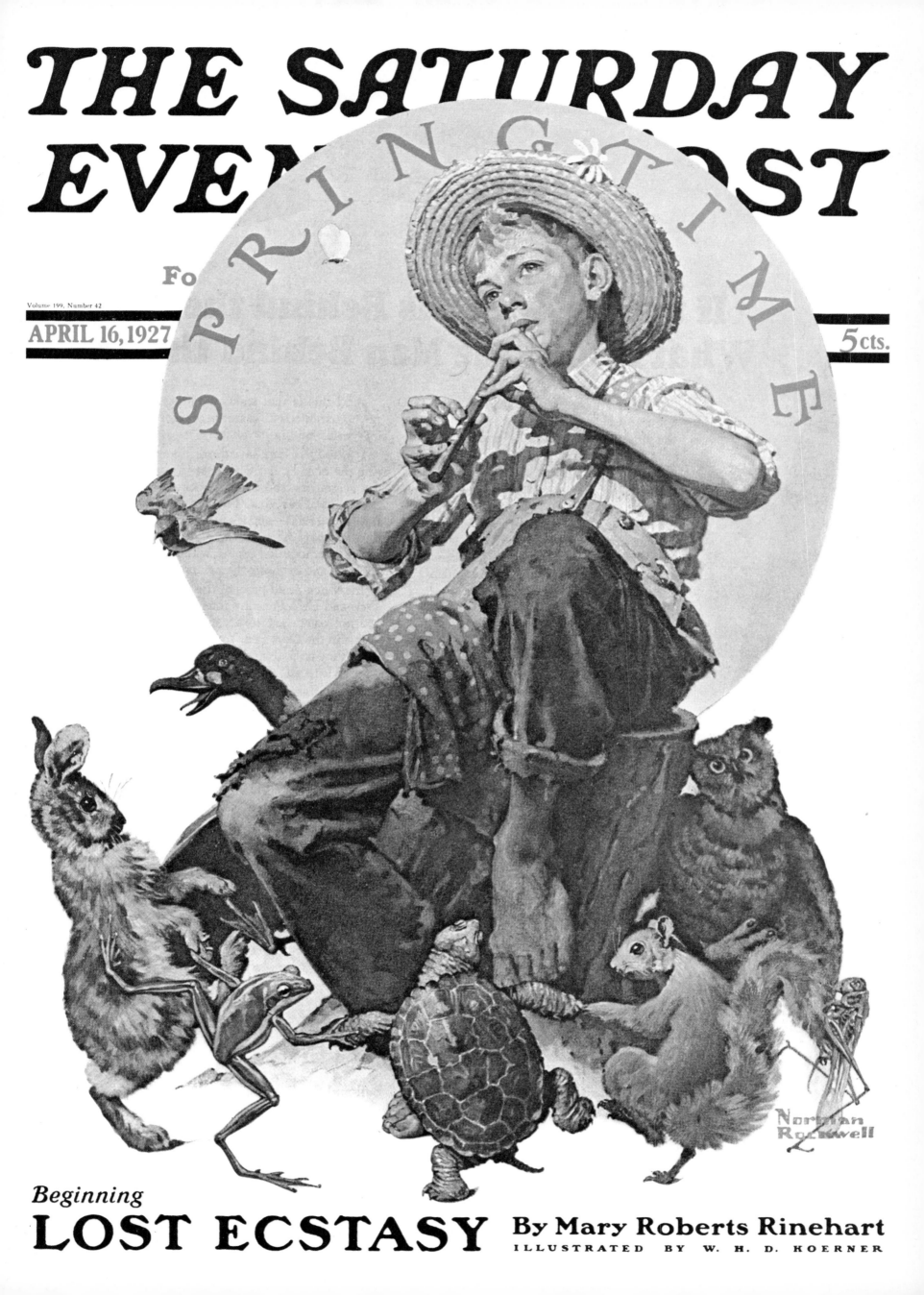

THE SATURDAY EVENING POST

SPRINGTIME

Volume 199, Number 42

APRIL 16, 1927

5 cts.

Norman Rockwell

Beginning

LOST ECSTASY

By Mary Roberts Rinehart

ILLUSTRATED BY W. H. D. KOERNER

"The Young Artist"

When Rockwell finally entered into the spirit of the 1920's he did so with miniature models. Slickers were the rage through several generations of teenagers, and each generation loved to embellish their garments with earthshaking aphorisms like "She's my baby." The intense colors of the girl's clothes—the red tam, skirt, heart, paint can, and blue slicker—and the drab colors of the boy's point out the way the new four-color process for printing magazine covers was changing Rockwell's style. He was able, with color, to paint in a broad area fairly simply—the raincoat in this case—and to use the color as a contrast between the detailed development of the models' faces and expressions. The face told the story more and more as the props began to be less significant. Action is beginning to come from within rather than without, motion and development are internal rather than external.

THE SATURDAY EVE POST

Fo lin

Volume 199, Number 49

JUNE 4, '27 5cts. THE COPY

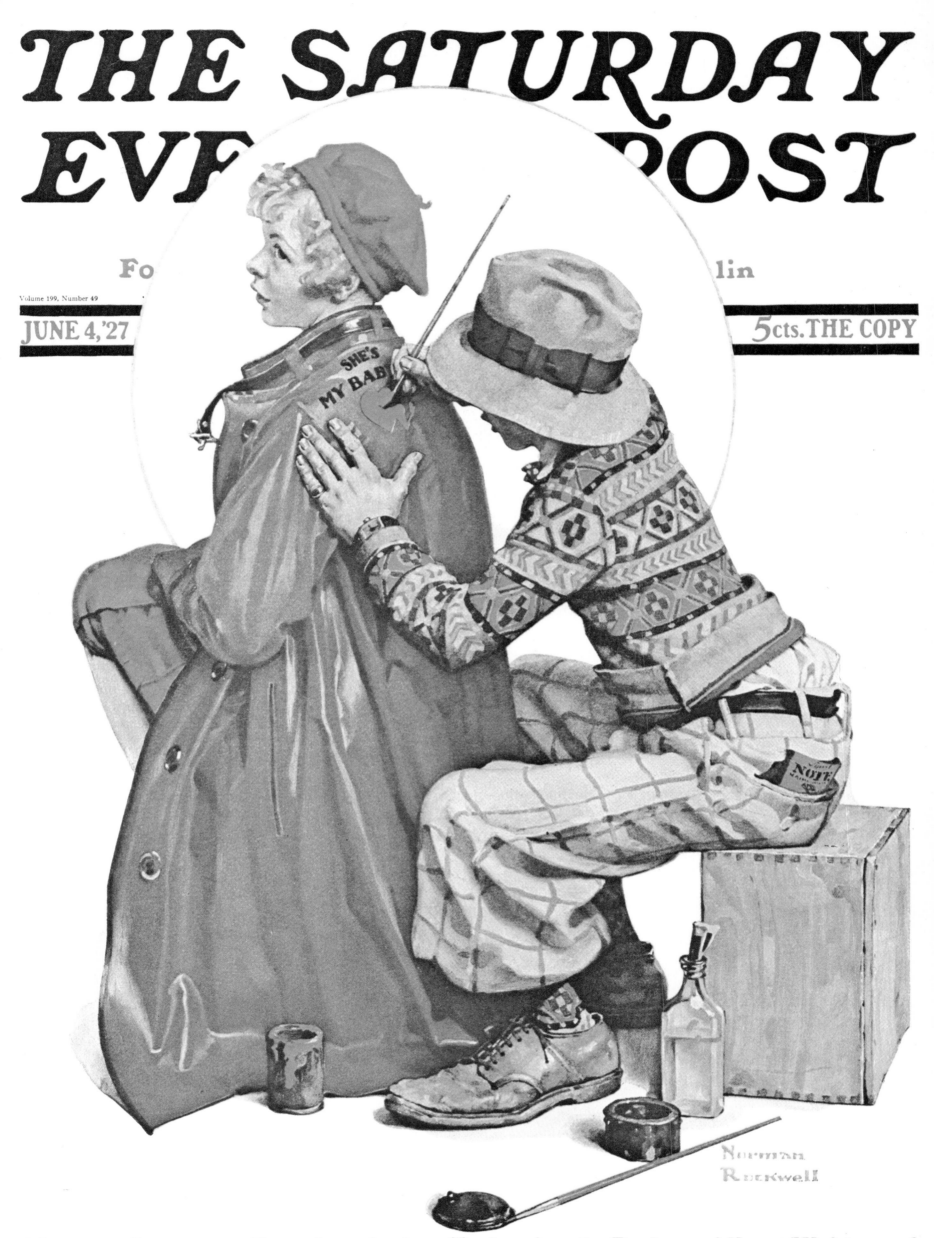

"Charles Lindbergh"

"**L**indbergh had just made history because of his dramatic plane flight across the Atlantic when this July 23rd cover was started," Rockwell wrote in his autobiography. "The day after ... I called up the art editor at the *Post*. 'How about a cover on the pioneers of the air?' 'Okay,' he said. 'When can you get it to us? It'll have to be fast or we'll miss the boom; it won't be news.' 'Tomorrow afternoon,' I said. I hired a model, dug up an aviator's cap, and set to work. Twenty-six hours later I finished the cover, sent it to Philadelphia, and staggered off to bed." The face—not Lindbergh's as has often been said—is one of the noblest Rockwell ever created. The symbols—the ship, the Conestoga wagon, the plane—are not really worthy of it. The face looks out to the future, assuring you it can fly from New York to Paris or to the moon for that matter on nothing but a ham sandwich and be surprised when it arrives that anyone wants to make a fuss of the accomplishment; in short, the image of the amazing Lindy himself. Rockwell has demonstrated his unique ability to create an image of a national achievement, to personify it and make every citizen feel he is a part of it. In the Four Freedoms and in the career of his World War II hero, Willie Gillis, Rockwell focused into the model, the American dream.

THE SATURDAY EVENING POST

Volume 200, Number 4

5 cts.

Fo

JULY 23, '27

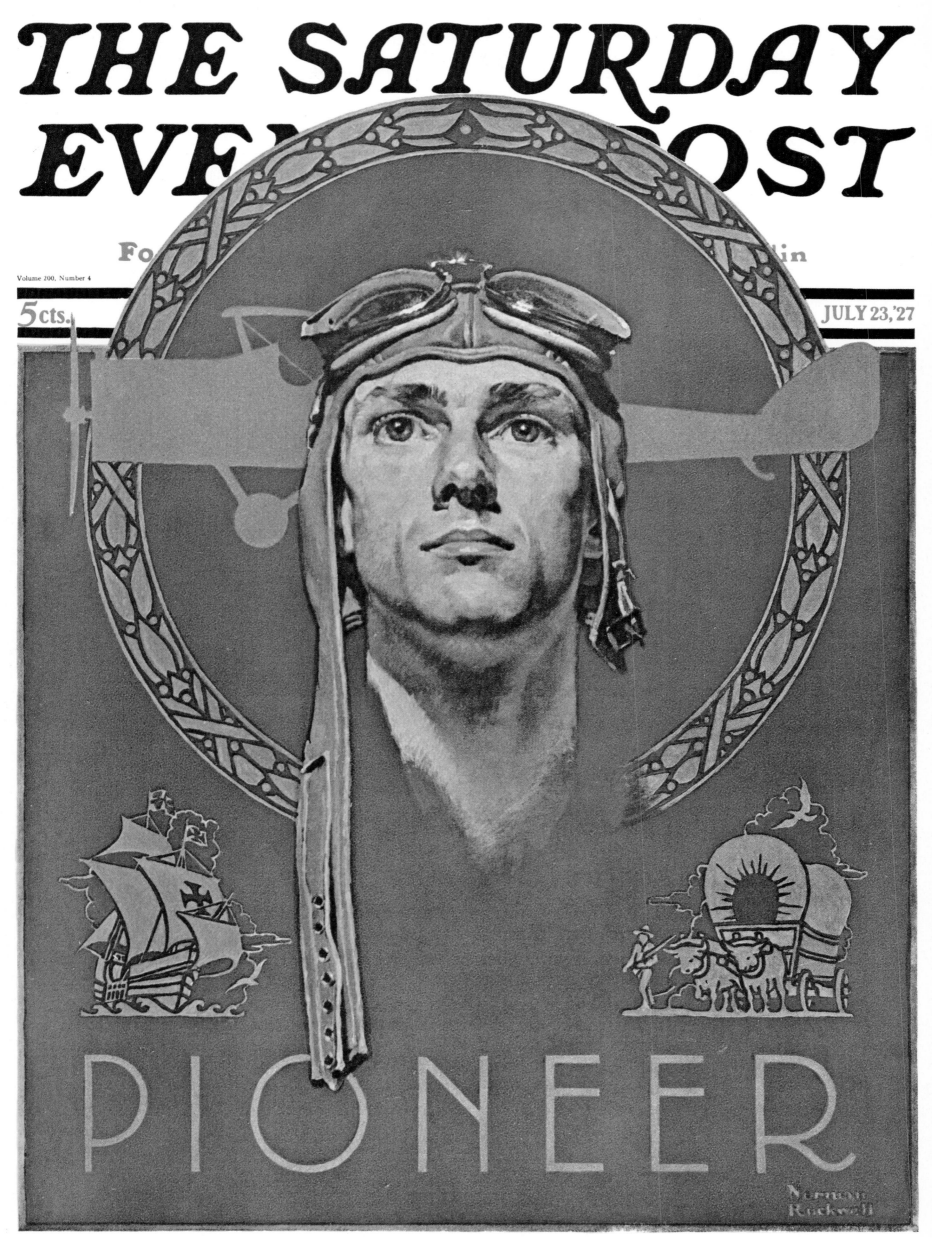

PIONEER

Norman Rockwell

"Dreams of Long Ago"

Van Brunt was discovered in this pose listening not to "Dreams of Long Ago," but to "Jeanie with the Light Brown Hair." "The door was ajar and I could hear a gramophone playing softly," Rockwell said "so I rapped and went in. For a moment he wasn't aware that I had entered. He was sitting in a wicker garden chair gazing at a few kernels of dry, yellowed popcorn which he held in his open palm. His face wore a sad, dreamy expression. Embarrassed at catching him in such a private mood, I remained silent and looked about the room. It was very small, really no more than a cubbyhole. The wicker table beside Van Brunt's chair held a pot of crepe-paper roses and an ancient gramophone, its battered brass trumpet stuffed with more morning glories. The needle was scratched and bumped through 'Jeanie with the Light Brown Hair'. . . .I coughed and Mr. Van Brunt looked up, startled. When he saw me his face lighted up with pleasure. He rose and saluted me. 'Welcome to my little garden, Norman,' he said. 'My garden of mementos. You see this popping corn? It's from a bag I bought my wife, Annabella, at the World's Columbian Exposition in Chicago in 1893. When I look at it,' he said, walking over to the shelf and carefully placing the kernels under a glass dome, 'I remember our trip and the Exposition and her.'" Rockwell captured the scene without making Van Brunt appear ridiculous, working sympathetically with the subject while catching the bittersweet amusement of the old cowboy's memories. The cover has appeared on record jackets and sheet music and captured forever the feelings of Van Brunt for his wife Annabella and for an era that nobody had bothered to consider in historical perspective.

THE SATURDAY EVENING POST

Volume 200, Number 7

AUG. 13, 1927

5c. the Copy

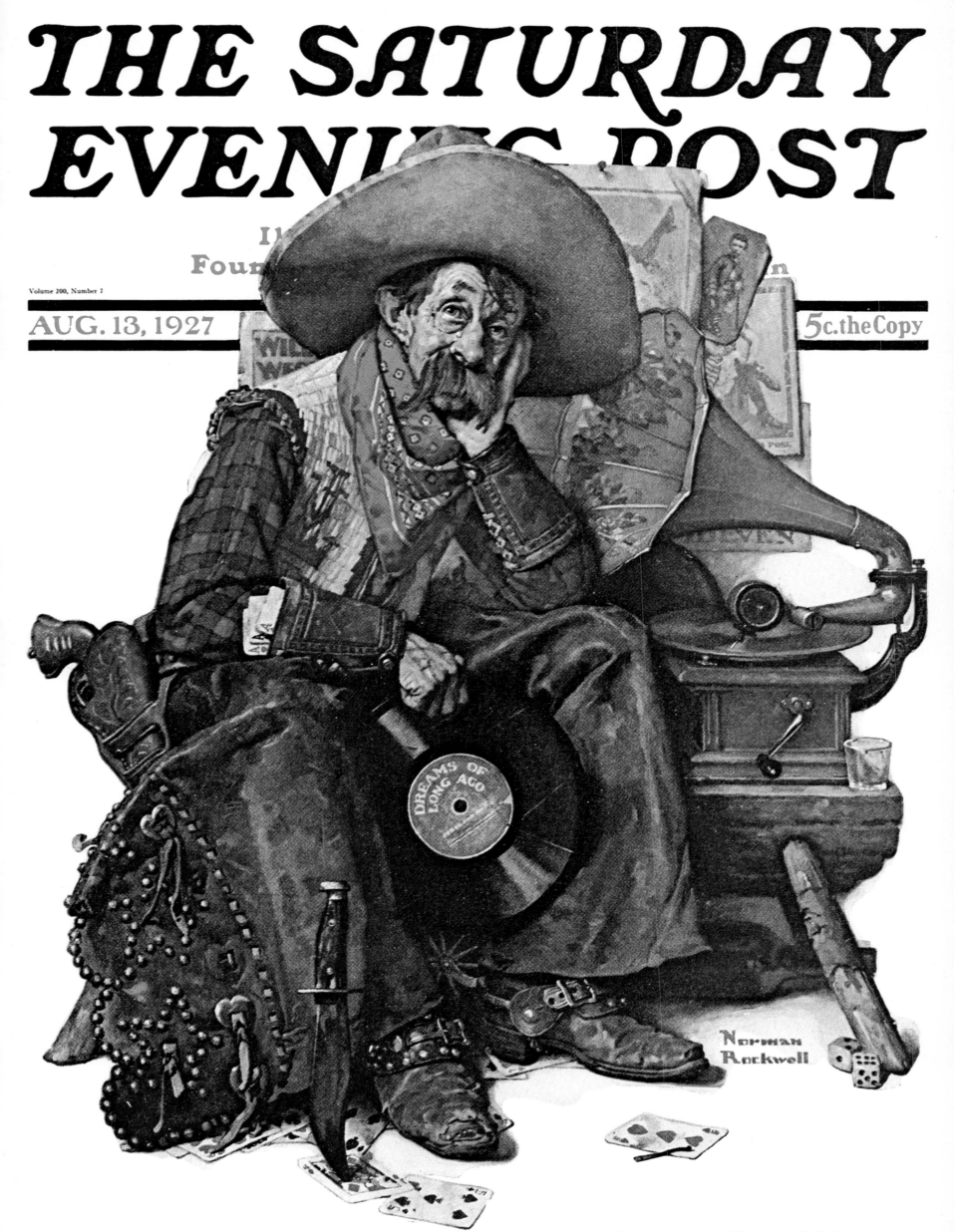

Norman Rockwell

"The Silhouette Maker"

The poster effect—stark figures outlined on a white ground, which was to be popular in the 1930's *Post*— is given a preview here. The silhouette artist's leg blends into the chair, the lady's feet rest on a footstool, exactly balancing the composition. All narrative details are sublimated to the design. The impact is graphic; the contrast between the aging, effete artist supplies the emotion.

In most American department stores in the Twenties there was a silhouette artist who, for a dollar or two, would cut out a portrait of a child or sweetheart on black paper. Silhouette cutting fascinated Rockwell. He painted another picture—also a Colonial costume piece which did not appear as a magazine cover—and in the cover which followed this one, two silhouettes are propped up on the mantelpiece. Silhouetting was a peculiarly American art, an intimate art, which managed in outline to hint at personality as well as anatomical structure, and to create an inexpensive remembrance of a loved one for people who could not afford an oil portrait. The intimacy—the silhouettes were necessarily of small size—of the art form appealed to Rockwell who liked to investigate private moments in people's lives, not to expose them, but to make them more enduringly private.

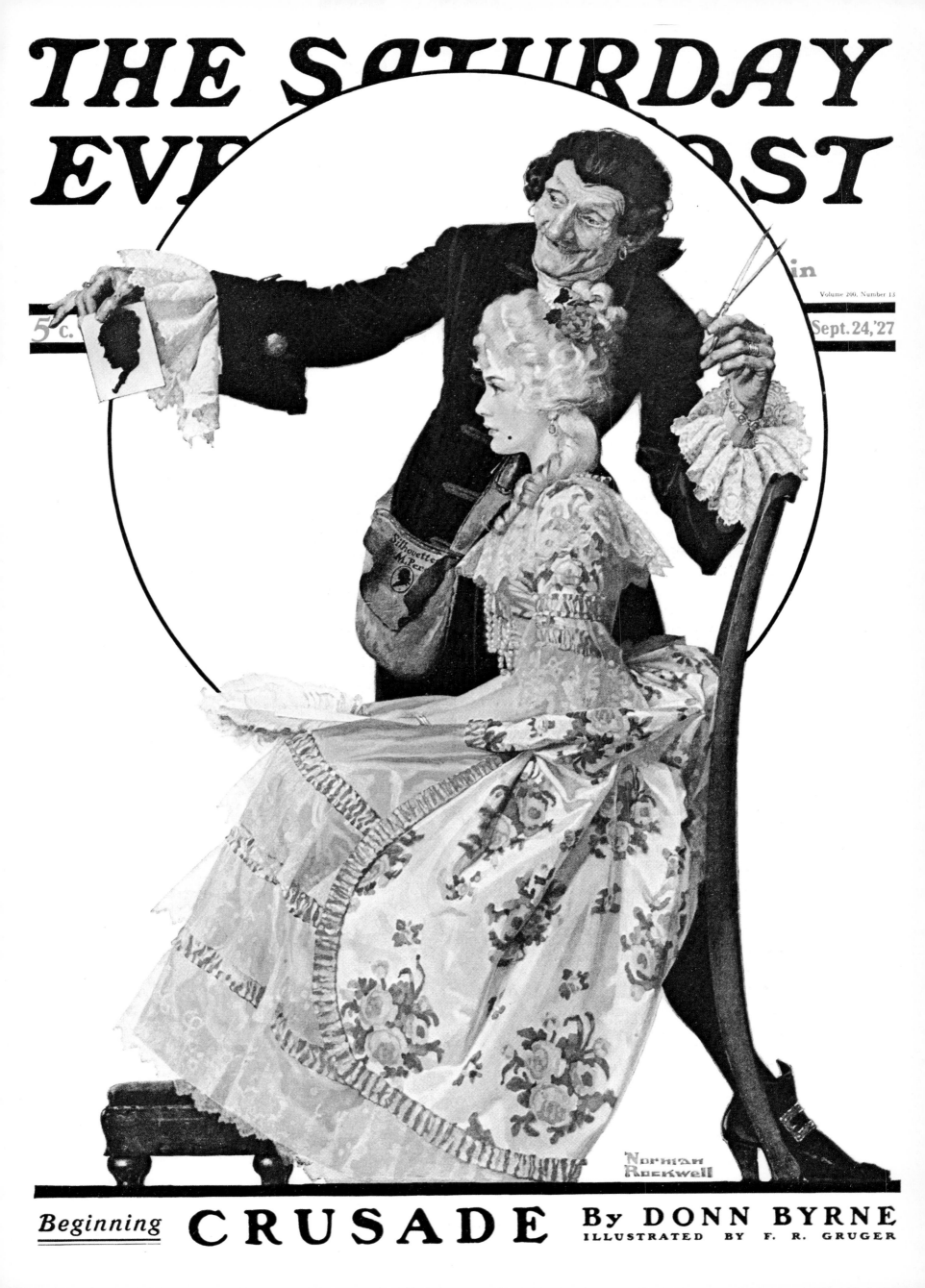

"Tea for Two"

It seemed all the contributors to the *Post* had middle names in the 1920's: Ben Ames Williams, Octavus Roy Cohen, Kenneth Allan Robertson, Nina Wilcox Putnam. They poured forth, week after week, character stories and tales of adventure and homelife that kept America glued to the pages of magazines the way they would be glued to television sets in the 1950's. But there were people in the Twenties who didn't read. And television wasn't the culprit. It was a breed of mindlessness which Rockwell condemns by not considering it worthy of notice. These people exist, but Rockwell has wiser and better people to depict on his covers, a population that has by its yeoman habits built the solid middle class that put together a national image. The old-shoe comfort of this scene, the hat and umbrella which tell us the gentleman is a caller, not a mate, almost exudes a contented sigh. We feel as snug as the cat in the lady's lap. Harmony, unity and peace are expressed by the closeness of the group, the proximity of the subjects to the fireplace. This couple has lived, modestly, and they have nothing to hide. Their existence has been a cozy chair, an easy cup of tea, and a cheerful busyness.

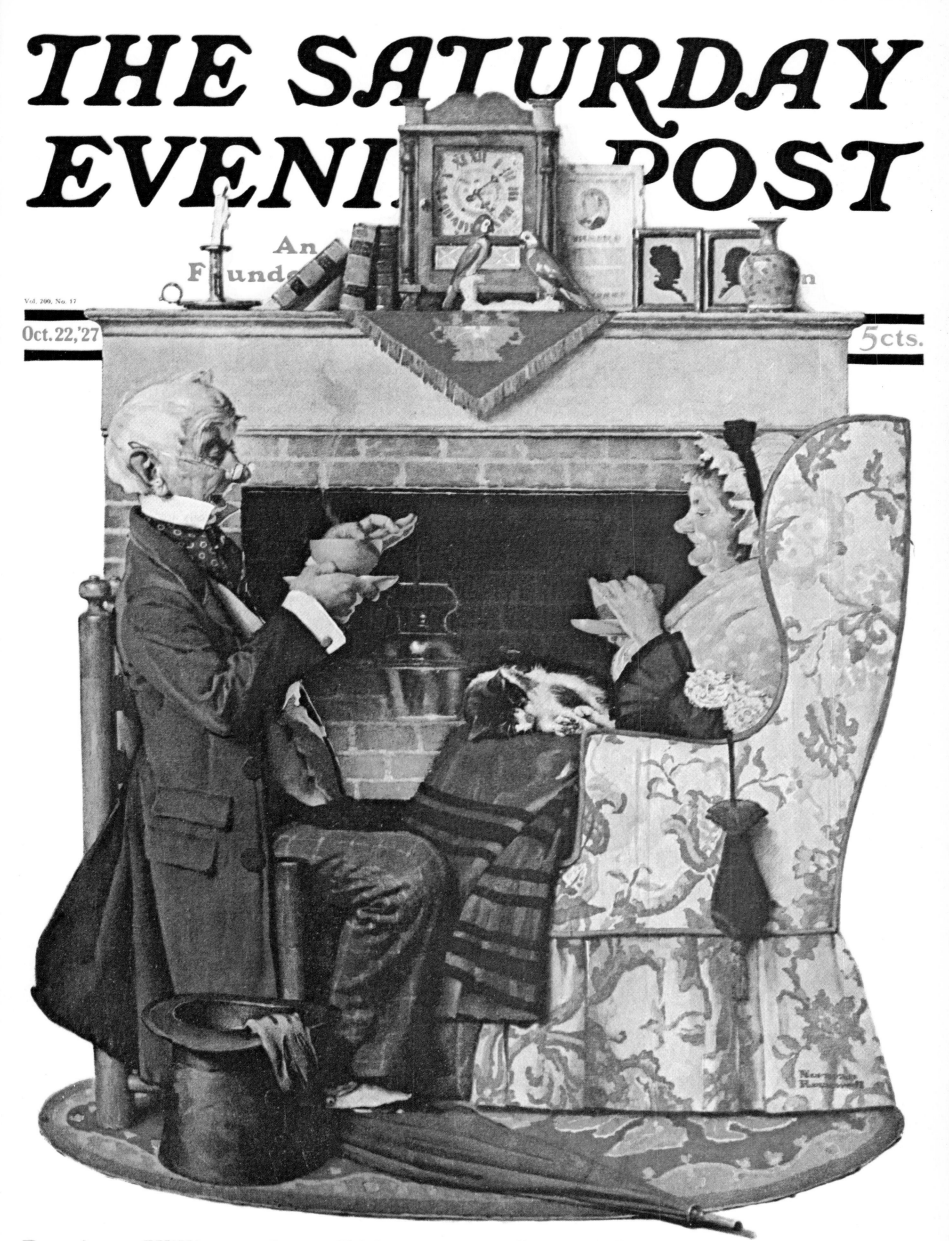

THE SATURDAY EVENING POST

An
Founde

Vol. 200, No. 17

Oct. 22, '27

5 cts.

Ben Ames Williams—Isaac F. Marcosson—Octavus Roy Cohen—Sophie Kerr
Kenneth Allan Robinson—Nina Wilcox Putnam—Day Edgar—Frank Condon

"Christmas 1927"

It is hard to tell in this cover where the glow comes from that lights Santa's face and vignettes the child he is holding in his fingers. Perhaps it shines from good deeds, from the benevolence children believe in and assume is the world's normal behavior. Nobody but Rockwell could have caught the essence of childhood in such a tiny figure. The stance, the quizzical attitude of the head, the plucky lift of the figure personify boyhood. Santa Claus looms large in the child's world, and in this painting he fulfills all expectations. The repeat of the Christmas line across the bottom of the cover in SEPCO type, the type in which the famous logo is set and which was invented and patented by *Post* designers, is unusual. Since it is such stylish type, the cover lines were usually set in a type face which complemented the logo. Here it is the same, the "C" being in a contrasting color, and it is highly effective against the soft white of Santa's beard. Portraying an old man so close-up might have had the effect of making him appear sad; the wrinkles might have overtaken the warmth of the season's message, but Rockwell has managed cheerfulness and coziness with light and the miniature charm of the boy's figure as it contrasts with the wide reaching friendliness of the old man. Even Scrooge would find the effect irresistible.

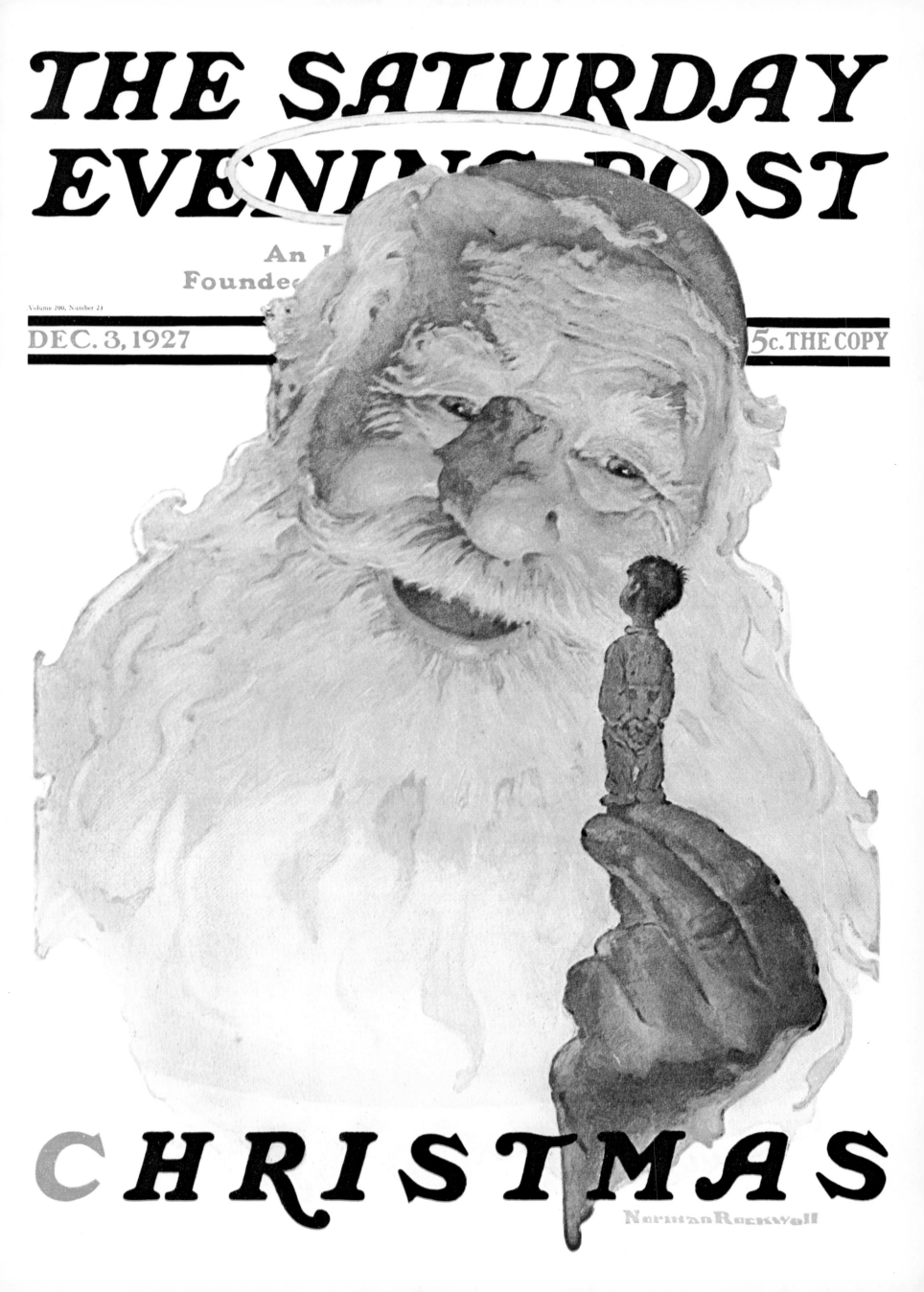

"Uncle Sam"

No other feature of the *Post* draws as consistently large a response as Rockwell covers. The letters range from one-liners exclaiming over the thrill of coming upon the magazine in the mailbox to twelve page epistles recounting complete collections of Rockwell covers. They usually end with the tip that the writer has an aunt or uncle who would make the perfect subject for the next Rockwell painting, and why hasn't the *Post* done a cover on....? Rockwell is, however, his own best source of ideas. He described the process once. "One day after I'd been aimlessly scribbling and sketching and crumpling sheets of paper and gazing at the walls, floor, ceiling, table for four or five hours, I said to myself, This has got to stop; I can't sit here with my mind as empty as a beer barrel at the Elks' club; I've got to start somewhere; otherwise I'll just doodle and muse all day. So I figured out a system. I used it for, oh, twenty, twenty-five years.

"When I had run out of ideas and had to have some new ones I'd eat a light meal, sharpen twenty pencils, lay out ten or twelve pads of paper on the dining-room table, and pull up a chair. Then I'd draw a *lamp post* (after a while I got to be the best lamp post artist in America). Then I'd draw a drunken sailor leaning on the lamp post. I'd think of the sailor. His girl married someone else while he was away at sea. No. He's stranded in a foreign port without money? No. Then I'd think of the sailor patching his clothes on shipboard. That would remind me of a mother darning her little boy's pants. Well, what did she find in the pockets?... etc." What Rockwell is saying is there is no easy way. Each time he sits down to the canvas, it is as though it is for the first time. Experience counts for little in art except in the realm of technique.

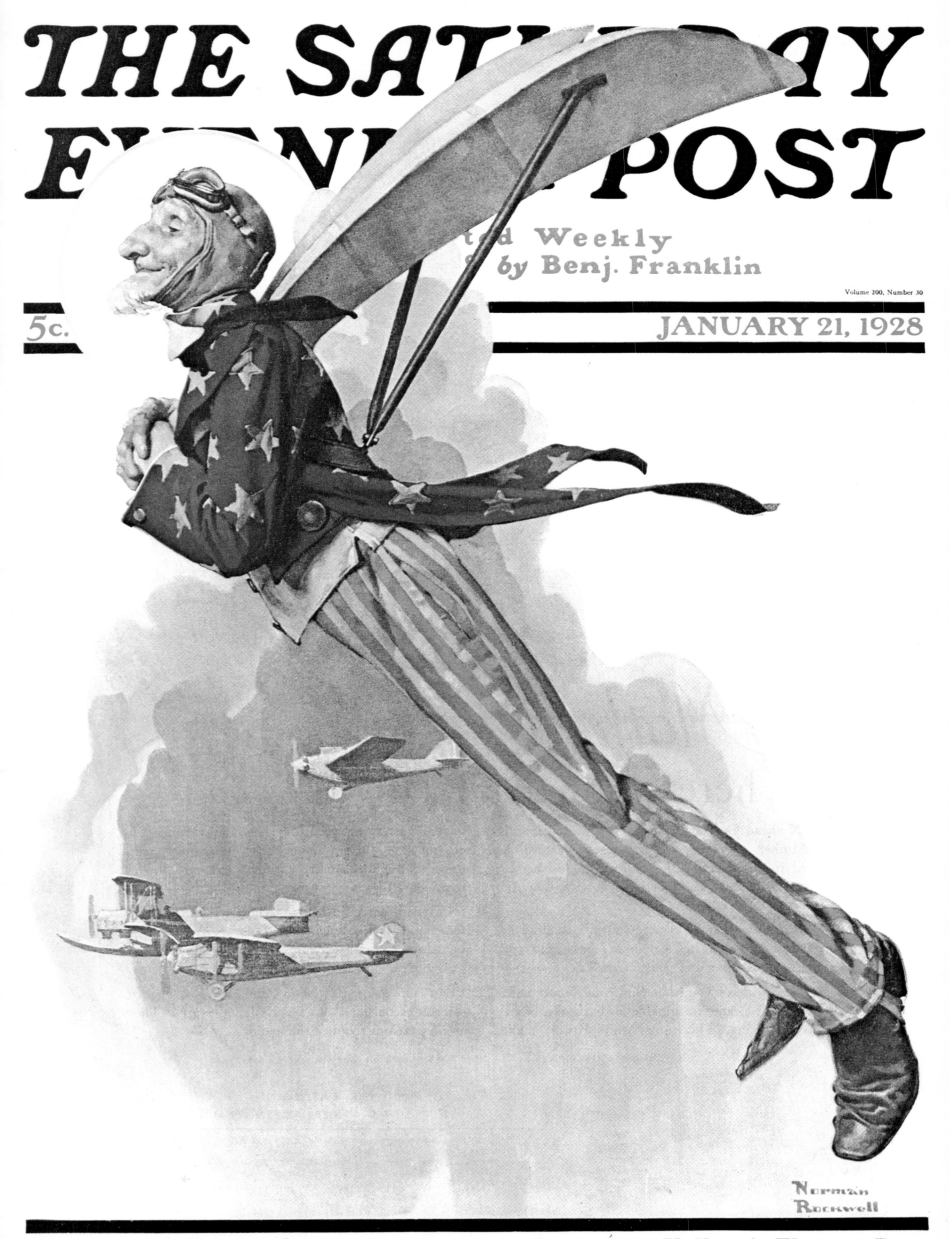

THE SATURDAY EVENING POST

...ted Weekly
...by Benj. Franklin

Volume 200, Number 30

5c.

JANUARY 21, 1928

Norman Rockwell

Will Rogers—F. Scott Fitzgerald—Clarence Budington Kelland—Thomas Beer
E. Phillips Oppenheim—Fannie Kilbourne—S. W. Stratton—Kenneth L. Roberts

"Adventures"

In the January 21 cover, the nation is pictured soaring with Lindbergh's triumph. In the preceding cover Uncle Sam is, on the eve of the Depression, as sublime a figure as Santa Claus. Adventure and progress are the watchwords of the new world. In the "Adventures" cover, the face and figure on the left seem almost to stand for the old world, and the bright promising face of the young man at the ship's wheel, the new world. Rockwell has combined two elements here from past covers. The background which he was in the habit of painting in lightly is deepened and made the subject of the cover. He will do this again the February 16, 1929 and Christmas 1930 covers. In a way, he was testing the limits of the *Post* art directors and the format of the magazine. In a popular journal he was asking how good he could become without obstructing the avowed editorial purpose of light entertainment. The answer emerged as the artist got better and better. Light entertainment was eclipsed by serious and inspiring masterpieces by writers like Thomas Wolfe, J.P. Marquand and John Galsworthy. The magazine's quality zoomed, and it was led by Rockwell's ingenious covers, inventive, endlessly clever, and never egotistical.

THE SATURDAY EVENING POST

Vol. 200, No. 42

APR. 14
1928

5 cts.

10c.
in Canada

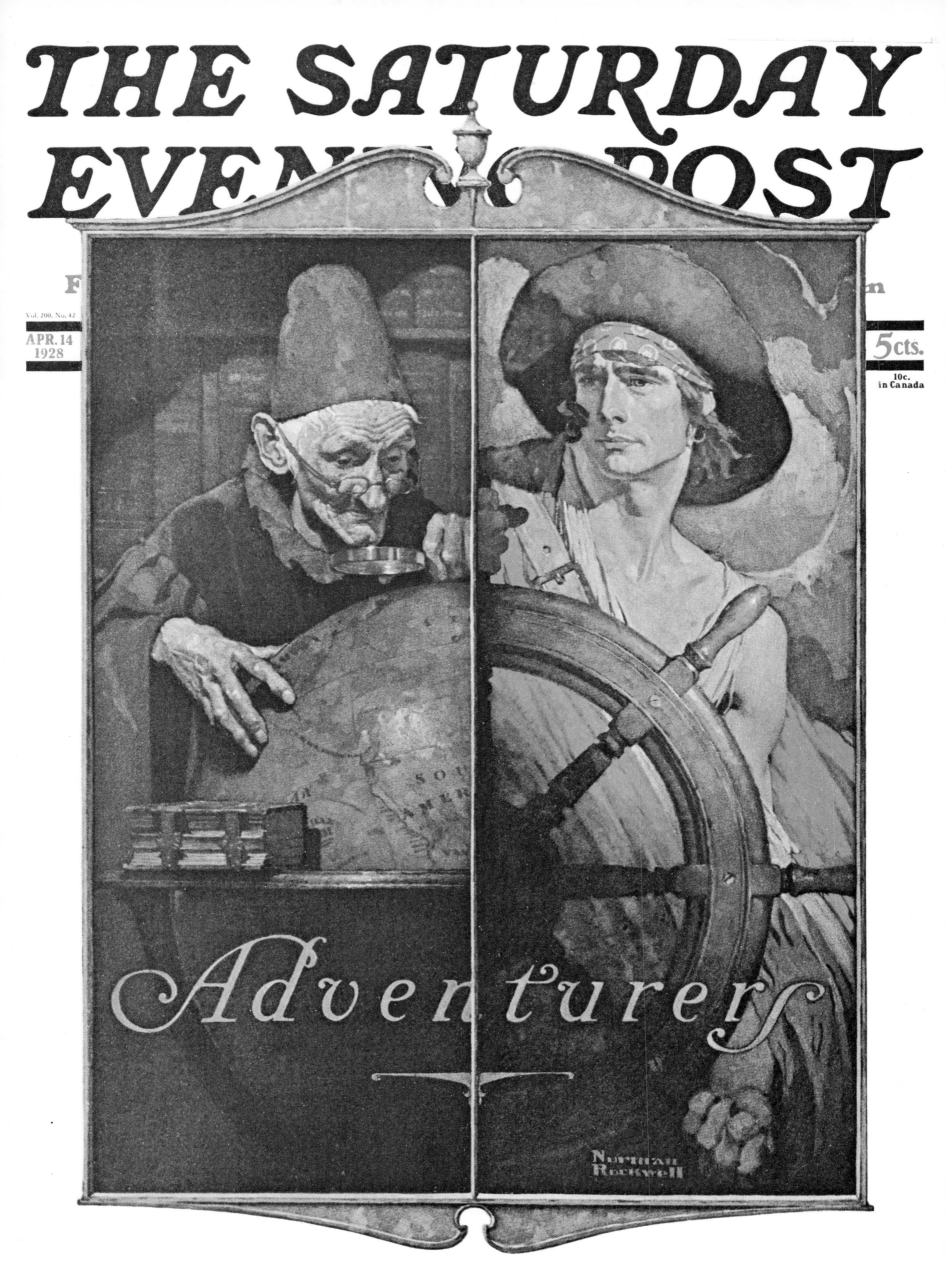

Adventurers

Norman
Rockwell

"The Hikers"

While the heel and toers march blithely on, the shadow of Mussolini and the darkness that was to envelop Europe loom large in the cut line. Journalists and historians often title their books, "While America Slept" or "Before the World Woke Up" and record that no one knew anything of what was coming in Europe, of Hitler or Stalin. But examining old newspapers and magazines, one finds people were well aware of the gathering storm, knew, if not instinctively, at least through what was being broadcast and written, that tyrants were rising with as much speed and predictability as comedians. How does one combat the sort of insanity that seizes the world from time to time? Rockwell's brand of patriotism is perhaps as effective a tool as any other call to arms. He idolizes the good; his own life is honest without being blase or priggish. His voice, though less strident than a politician's, calls us to an exercise in our national capabilities, urges us to consider the best instead of the flashy or showy, demonstrates that the best guardians of our liberty are the men and women who unaffectedly go about their daily business, who work and take time off without making a religion of either.

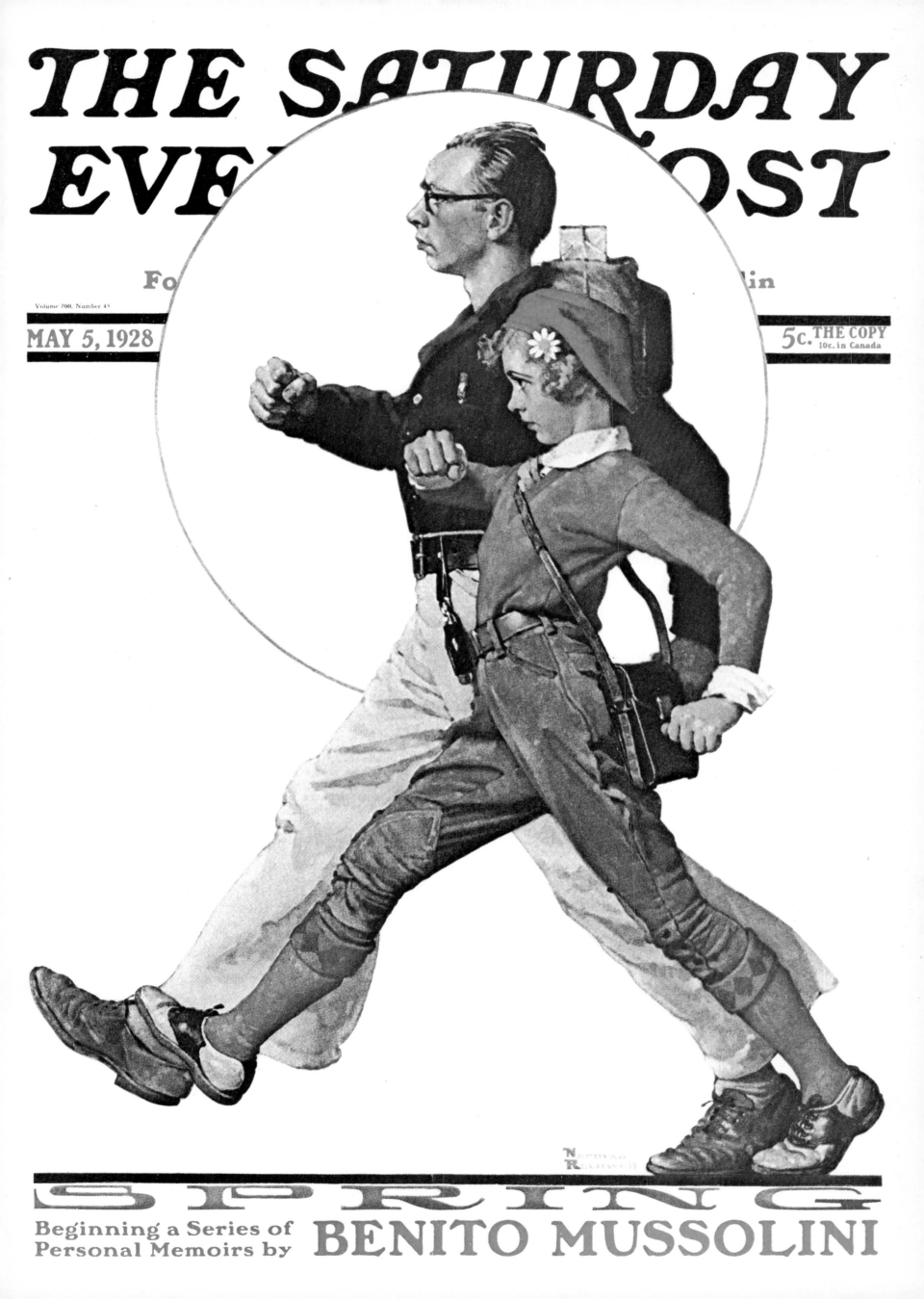

THE SATURDAY EVE POST

Volume 200. Number 45

Fo in

MAY 5, 1928 5c. THE COPY
 10c. in Canada

SPRING

Beginning a Series of
Personal Memoirs by **BENITO MUSSOLINI**

"Gilding the Eagle"

"**T**his Gilding the Eagle cover, while no world-beater, was considered one of my best of this period," Rockwell recalls. It stars Van Brunt and the national symbol. Rockwell characters are bored by the spectacular. Later covers would depict characters setting huge public clocks by their pocket watches or painters hanging from the torch of the Statue of Liberty. Blank expression persists as the characters hang from dizzying heights and surround the national symbols with a work-a-day world security that reassures us the nation is on firm ground.

"Most fine arts painters feel...restrictions constitute pure slavery. An artist friend once said to me," Rockwell wrote years later, "'If the average person liked a painting of mine I'd destroy it.' A young art student remarked once, 'I think I'll take up fine arts. Commercial art is too difficult.' Which is a silly thing to say, because obviously the requirements of fine arts are as exacting as those of commercial art. But they are self-imposed. Fine arts painters, working entirely out of their own instincts and feelings, refuse to allow any restrictions to be superimposed on their paintings by others." "Self-imposed" is perhaps the key phrase that marks Rockwell's work as superior and of the same intellectually high caliber as so-called fine art. He early imposed on his work the attention to detail, the goal of perfection which left no feature on his cover unattended, no corner which was not purposefully touched by his design. He left nothing to chance, and he did this without overpainting or belaboring a canvas or destroying the natural spontaneity of his work. He has worked hard on the pictures, but his work has not been bereft of joy.

THE SATURDAY EVENING POST

An I
Founded

Volume 200, Number 48

MAY 26, 1928

5cts.

10c. in Canada

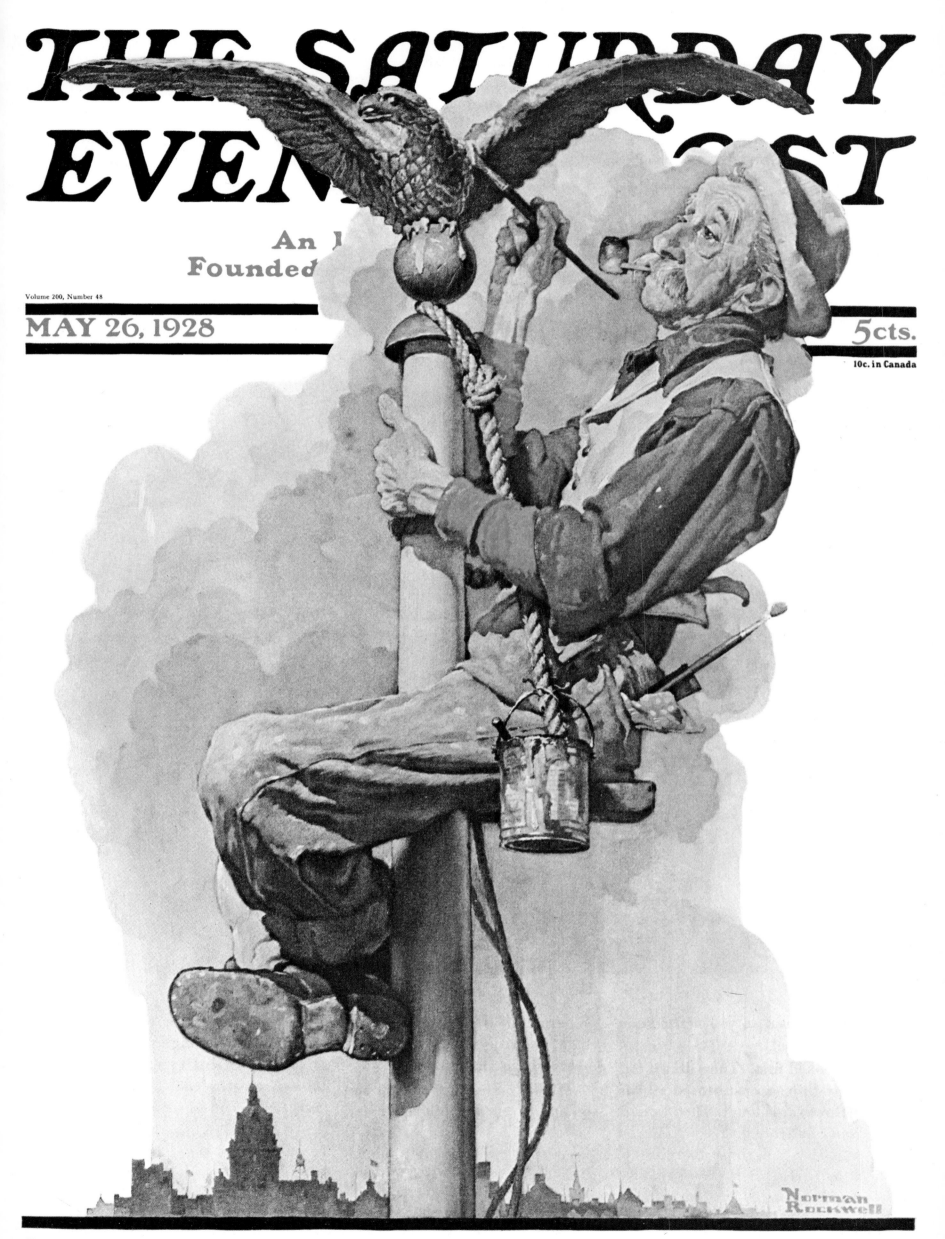

Norman Rockwell

George Agnew Chamberlain—Commander Richard E. Byrd—Margaret Weymouth Jackson
Will Rogers—Dorothy Black—Booth Jameson—Samuel G. Blythe—Richard Washburn Child

"The Wedding March"

Van Brunt in his next-to-last appearance—His last is as three old maids gossiping away (January 12, 1929) bangs out the wedding march with all the ardor of the bridegroom himself. "There was a woman," he told Rockwell, speaking of his wife, "There was a woman. She weighed two hundred and twenty-two pounds exactly. Dandled me on her knee like a baby. She swore that if I got any smaller she'd stuff me in a milk bottle and seal it up and lay me by." "He'd chuckle and go on about her virtues," Rockwell said. "What a good cook and housekeeper she had been, how she had darned his socks. 'A soldier's wife! Rawhide, sir, rawhide to the bone.' Then he'd stop, and all the sparkle would go out of his eyes and he'd look at the floor. 'But tender, Mr. Rockwell, and loving. A wonderful, *wonderful* woman!'" There is the look in the organist's eyes of a man who has known happy marriage and wishes to promulgate the joys of that institution.

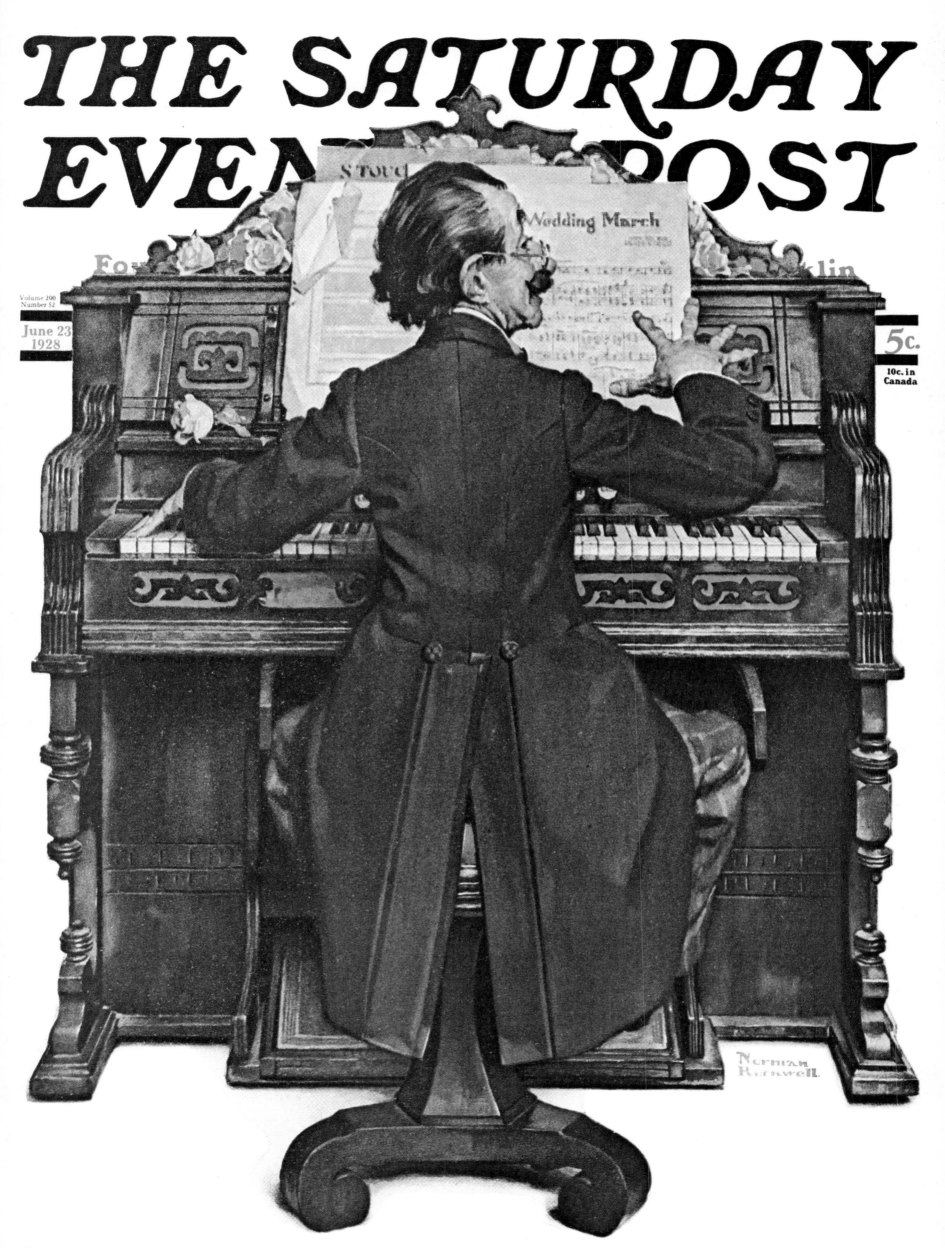

THE SATURDAY EVENING POST

Volume 200
Number 52

June 23
1928

5c.

10c. in
Canada

Benito Mussolini—Thomas McMorrow—Maximilian Foster—William Slavens McNutt
Peggy Wood—Clarence Budington Kelland—Fanny Heaslip Lea—Rear Admiral Magruder

"Hayseed Critic"

Rockwell sketched this young woman twice, both times posing her as an artist pursuing her hobby outdoors (April 12, 1930). Rockwell delights in critics of his work. He is probably the only artist who has ever invited criticism and more often than not agreed with it. When he is having trouble with a picture, he may call in anyone who happens by and ask him what is wrong with it. He has consulted postmen, milkmen, oil-truck drivers, carpenters, plumbers and delivery boys. For a long time the *Post* editors were exasperated by this habit. They felt that Rockwell's neighbors weren't necessarily qualified as art critics and that their ideas and opinions slowed down the completion of pictures scheduled for publication. But Rockwell defended the practice, saying the main reason he asked passers-by to look over his work was to see if the idea he was trying to portray was clear. "If they don't understand the story, I figure I haven't made it clear and that a lot of other people around the country won't understand it either." So his critics are a proving ground for his work—something the subject in this cover wouldn't go along with—and more, these critics assume attitudes and poses that strike flint in the fertile mind of the artist. Soon they appear, not as critics but as subjects, and their neighbors are asked to consider them on canvas, and as time goes by, the criticism is a little more feeling, a little more docile, given in the light of "judge not lest ye be judged." It is not hypocrisy; it is the knowledge that comes of sitting in somebody else's seat, of posing for a picture that will transcend one's own being to become all the people who will look at the painting.

THE SATURDAY EVENING POST

Volume 201, Number 3

July 21, '28

5c. THE COPY
10c. in Canada

Fouklin

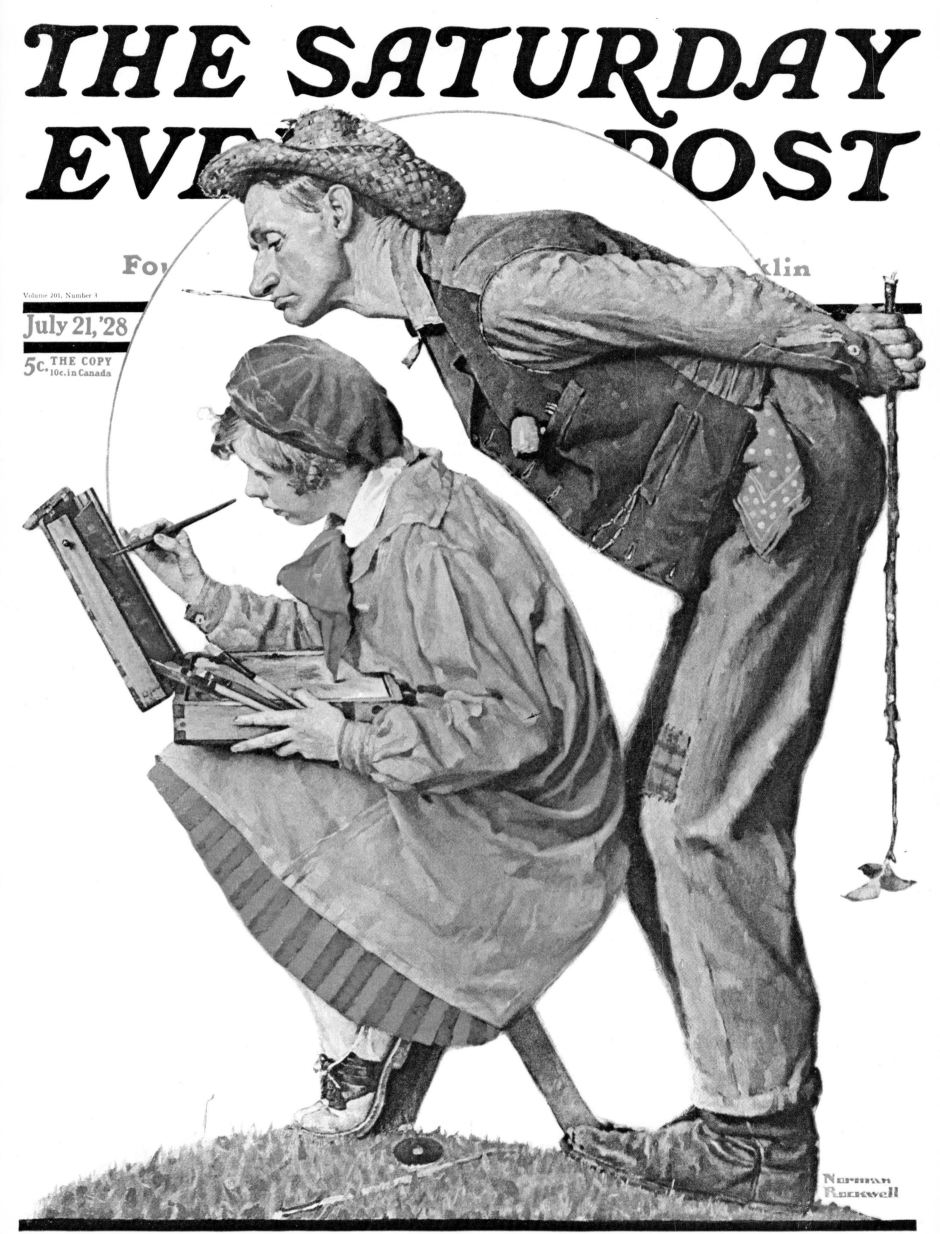

Norman Rockwell

Benito Mussolini—Rob Wagner—George Allan England—James Warner Bellah
Charles Francis Coe—F. Scott Fitzgerald—Maximilian Foster—Donald E. Keyhoe

Now that you have completed the first volume of this collection and have enjoyed Mr. Rockwell's wonderful early years with *The Saturday Evening Post,* when most of his pictures were produced in two colors, you can look forward to the two subsequent volumes, "The Middle Years" and "The Later Years," and live with him through the Depression, the war years, the making of our Presidents, our family life, school years, sporting events, and holidays—a total of sixty years of the genius of this beloved man produced in full size and full color.